Adobe®
Photoshop® Elements 7

ILLUSTRATED

About This Book

Welcome to *Adobe® Photoshop® Elements 7– Illustrated*! Since the first book in the Illustrated Series was published in 1994, millions of students have used various Illustrated texts to master software skills and learn computer concepts. We are proud to bring you this new Illustrated book on Adobe Photoshop Elements 7, the bestselling photo editing software for consumers that you can use to organize, fix, enhance, and share your photos.

Adobe Photoshop Elements 7 is designed for everyday users—not just professional photographers. Yet, the tools provided in Photoshop Elements are powerful and can be used to create exciting projects for print or for the Web. Teaching students Photoshop Elements makes sense because it contains many tools common to Adobe Photoshop, but is available at a much fraction of the price. This book is designed to teach the basics of using Photoshop Elements. It covers getting started with the software, organizing photos, making quick fixes to photos, using editing tools to correct imperfections, using filters, effects, and sharing photos.

The unique design of this book, which presents each skill on two facing pages, makes it easy for novices to absorb and new skills, and also makes it easy for more experienced computer users to progress through the lessons quickly minimal reading required. We hope you enjoy exploring the features of Photoshop Elements 7 as you work through

Author Acknowledgments

Photoshop Elements is one of best-kept "secrets" in photo editing software, and I am happy to showcase many features. Thanks to Marjorie Hunt for bringing version 7 to print. Christina Kling Garrett makes my job easy with supportive product management. Kim Crowley's razor-sharp eye and editing skills improves this book immeasurably new to photo editing in particular benefit from her many contributions. I am always grateful for the great work of reviewers, Jeff Schwartz, Susan Whalen, and John Freitas. Great thanks to many Course Technology colleagues for sharing their kids and pets. I am also particularly indebted to Susan Sermoneta for her New York City photos, and to Pro Andersen of Santa Barbara City College and the Florida Keys National Marine Sanctuary for all things aqua ed kudos to Lisa Tannenbaum for her amazing images and expertise and devoted thanks as always to my partner L
Barbara M. Waxer

Many thanks to all the students who have taken my classes over the years at the University of New Me uing Education Division—and who have taught me far more than I ever could have learned on my own.
Lisa Tannenbaum

Preface

Welcome to *Adobe® Photoshop® Elements 7—Illustrated.* The unique page design of the book makes it a great learning tool for both new and experienced users. Each skill is presented on two facing pages, so that you don't have to turn the page to find a screen shot or finish a paragraph. See the illustration on the right to learn more about the pedagogical and design elements of a typical lesson.

What's New in this Edition

We've made many changes and enhancements to this edition to make it the best ever. Here are some highlights of what's new:

- **Redesigned Unit Opener Page** — The first page of each unit now includes a listing of all the Data Files that are needed for the unit.

- **Real Life Independent Challenge** — The new Real Life Independent Challenge exercises offer students the opportunity to research information that is meaningful to their lives, such as protecting your photos and their copyright online, fixing red eye and other flaws, organizing a small collection of photos, and making a slide show.

- **Content Updates** — In eight units, this book covers new features found in Photoshop Elements 7, including photo sharing for single images or large projects, Guided Edits that provide focused direction, and easy tools for creating stunning new effects and adjustments. Plus, fixes for brighter smiles and bluer skies you just paint on, and other Smart Brush painting options. Coverage also includes new adjustments for perfecting images, such as fixing distortion and enhancing portraits.

Each two-page spread focuses on a single skill.

Concise text i
the basic prin
the lesson and
a real-world c

Hints as well as troubleshooting tips appear, right where you need them—next to the step itself.

Every lesson features large, full-color representations of what the screen should look like as students complete the numbered steps.

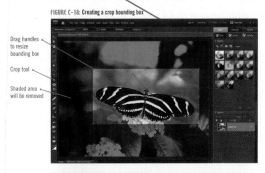

FIGURE C-18: Creating a crop bounding box

Drag handles to resize bounding box

Crop tool

Shaded area will be removed

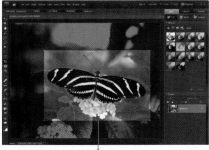

FIGURE C-19: Adjusting the crop bounding box

Drag handle to include all of the flower

Using the Redo History palette

Undo and Redo affect the action you've just completed, although you can undo or redo repeatedly to include more actions. The Reset button in Quick Fix and Guided Edit reverts the image back to the state it was in when it was last saved. The Undo History palette records all the actions you've performed in the current editing session and allows you to step back into the history of changes to your file. Figure C-20 shows steps in the Undo History palette. You can drag the slider up, undoing each action beneath it, or simply click the action to which you want to return. You can delete individual actions no matter where they occur in the history by right-clicking the action and then clicking Delete. To delete all actions except the one you've selected, right-click the action, then click Undo History.

FIGURE C-20: Undo History palette

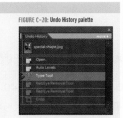

Photoshop Elements 7.0

Fixing Images Automatically in the Editor **Photoshop Elements 7.0 63**

Clues to Use boxes provide concise information that either expands on the major lesson skill or describe an independent task that in some way relates to the major lesson skill.

Assignments

The lessons feature a realistic [...]
assignments on the light purpl[...]
end of each unit increase in di[...]
Additional case studies provid[...]
interesting and relevant exerci[...]
to practice skills.
Assignments include:

- **Concepts Reviews** consis[...]
 choice, matching, and s[...]
 tion questions.

- **Skills Reviews** provide a[...]
 hands-on, step-by-step [...]

- **Independent Challenge[...]
 projects requiring critica[...]
 application of the unit s[...]
 Independent Challenge[...]
 difficulty, with the first [...]
 being the easiest. Indep[...]
 Challenges 2 and 3 bec[...]
 open-ended, requiring [...]
 ent problem solving.

- **Real Life Independent** [...]
 practical exercises to h[...]
 their everyday lives.

- **Advanced Challenge E**[...]
 the Independent Chall[...]
 optional steps for mor[...]
 students.

- **Visual Workshops** are [...]
 graded capstone proj[...]
 independent problem[...]

We[...]
lior[...]
brir[...]
tha[...]

Ad[...]
Ph[...]
Ph[...]
fra[...]
the[...]
eff[...]

Th[...]
sta[...]
m[...]

A[...]
Phly
tu-
su
te
with
ki[...]
within
the
B[...]
N[...]
Elf-
quire

vii

Instructor Resources

The Instructor Resources CD is Course Technology's way of putting the resources and information needed to teach and learn effectively into your hands. With an integrated array of teaching and learning tools that offer you and your students a broad range of technology-based instructional options, we believe this CD represents the highest quality and most cutting edge resources available to instructors today. Many of these resources are available at *www.cengage.com/coursetechnology*. The resources available with this book are:

- **Instructor's Manual**—Available as an electronic file, the Instructor's Manual includes detailed lecture topics with teaching tips for each unit.

- **Sample Syllabus**—Prepare and customize your course easily using this sample course outline.

- **PowerPoint Presentations**—Each unit has a corresponding PowerPoint presentation that you can use in lecture, distribute to your students, or customize to suit your course.

- **Figure Files**—The figures in the text are provided on the Instructor Resources CD to help you illustrate key topics or concepts. You can create traditional overhead transparencies by printing the figure files. Or you can create electronic slide shows by using the figures in a presentation program such as PowerPoint.

- **Solutions to Exercises**—Solutions to Exercises contains files students are asked to create or modify in the lessons and end-of-unit material. Also provided in this section is a document outlining the solutions for the end-of-unit Concepts Review, Skills Review, and Independent Challenges.

- **Data Files for Students**—To complete the units in this book, your students will need Data Files. You can post the Data Files on a file server for students to copy. The Data Files available on the Instructor Resources CD are also included on a CD located at the front of the textbook.

Instruct students to use the Data Files List included on the CD found at the front of the book and the Instructor Resources CD. This list gives instructions on copying and organizing files.

- **ExamView**—ExamView is a powerful testing software package that allows you to create and administer printed, computer (LAN-based), and Internet exams. ExamView includes hundreds of questions that correspond to the topics covered in this text, enabling students to generate detailed study guides that include page references for further review. The computer-based and Internet testing components allow students to take exams at their computers, and also saves you time by grading each exam automatically.

CourseCasts – Learning on the Go. Always Available...Always Relevant.

Want to keep up with the latest technology trends relevant to you? Visit our site to find a library of podcasts, CourseCasts, featuring a "CourseCast of the Week," and download them to your mp3 player at *www.coursecasts.course.com*.

Our fast-paced world is driven by technology. You know because you're an active participant—always on the go, always keeping up with technological trends, and always learning new ways to embrace technology to power your life.

Ken Baldauf, a faculty member of the Florida State University Computer Science Department, is responsible for teaching technology classes to thousands of FSU students each year. He knows what you know; he knows what you want to learn. He's also an expert in the latest technology and will sort through and aggregate the most pertinent news and information so you can spend your time enjoying technology, rather than trying to figure it out.

Visit us at *www.coursecasts.course.com* to learn on the go!

Brief Contents

Contents

PHOTOSHOP ELEMENTS | **Unit C: Fixing Images Automatically in the Editor** | **49**

PHOTOSHOP ELEMENTS | **Unit D: Adjusting Light and Color** | **75**

PHOTOSHOP ELEMENTS | **Unit E: Using Paint and Retouching Tools** | **99**

PHOTOSHOP ELEMENTS | **Unit F: Adding Layers, Artwork, and Type** | **125**

PHOTOSHOP ELEMENTS | **Unit G: Making Selections and Applying Effects** | **151**

PHOTOSHOP ELEMENTS

Unit H: Creating and Sharing Projects 177

Photo Credits

© 2008 clipart.com

Genevieve Anderson, Santa Barbara City College

Scott Bauer USDA/ARS

Jennifer Campbell

Michelle Camisa

Kim Crowley

Benedict.com

morguefile.com

Florida Keys National Marine Sanctuary

Kristine Kisky

Christina Kling Garrett

Aaron Lobliner

Susie Mullins

NASA/JPL

National Science Foundation

Bob Nichols USDA/ARS

PDPhoto.org

Jane M Sawyer/Morguefile

Stock Exchange (www.sxc.hu)

Jon Rawlinson

Kevin Rosseel

Susan Sermoneta/Flickr

Lisa Tannenbaum

Patrick Tregenza USDA/ARS

Mary R. Vogt

Karen Stevens

Alexandra Waxer

Barbara Waxer

Read This Before You Begin

This book assumes the following:

1. The software has been registered properly. If the product is not registered, students must respond to Registration and dialog boxes each time they start the software.
2. The instructor may choose to have students create one or more unique catalogs for units that use the Organizer (Units B and H), and will instruct students where to open or save files. The location is assumed in all subsequent instances.
3. Photos in the Photo Browser catalog and album names and keyword tags do not carry over to the EOU or between units.
4. Default tools in the toolbox might differ, but tool options and other settings do not carry over to the EOU or between units.
5. Students know how to create a folder using a file management utility.
6. The sender's email has been verified and other preferences selected before using the program-generated email function.
7. After introduction and reinforcement in initial units, the student will be able to respond to the dialog boxes that open when saving a file in native .psd format or as a JPEG file. Later units do not provide step-by-step guidance.
8. Palettes, windows, and dialog boxes have default settings when opened. Exceptions may be when students open these elements repeatedly in a lesson or in the unit.

Frequently Asked Questions

What are the Minimum System Requirements (Windows)?

- 2GHz or faster processor with 1GB RAM
- Microsoft Windows XP with Service Pack 2 or 3, or Windows Vista
- 1.5GB of available hard disk space
- Color monitor with 16-bit color video card
- CD-ROM
- Web features require Microsoft Internet Explorer 6, 7, or Mozilla Firefox 1.5, 2, 3

What are Data Files and where are they located?

The Data Files for this text are photographs along with some graphic images that you will use to complete the steps in the lessons and end-of-unit material. The Data Files for this text are located on a CD included at the front of this book. Insert the CD into a CD-ROM drive to access the files. Your instructor may have you copy them to a network or removable drive.

What software was used to write and test this book?

This book was written and tested using a typical installation of Microsoft Windows Vista Ultimate with Aero turned off. The browsers used are Microsoft Internet Explorer 7.0 and Mozilla Firefox 3.0.

Do I need to be connected to the Internet to complete the steps and exercises in this book?

The exercises in this book assume that your computer is connected to the Internet. If you are not connected to the Internet, see your instructor for information on how to complete the exercises.

What do I do if my screen is different from the figures shown in this book?

This book was written and tested on computers with monitors set at a resolution of 1280 × 1024. If your screen shows more or less information than the figures in the book, your monitor is probably set at a higher or lower resolution. If you don't see something on your screen, you might have to scroll down or up to see the object identified in the figures.

UNIT A
Photoshop Elements 7

Getting Started with Photoshop Elements 7

Adobe Photoshop Elements 7 is a photo-editing program used to modify digital photographs and scanned images. Its workspaces and easy-to-use tools allow you to organize, correct, enhance, share, and print photographs and other electronic images. You can also use Photoshop Elements to make custom calendars, slide shows, photo albums, and Web photo galleries. To work productively in Photoshop Elements, you need to know some basic photo-editing concepts, how to navigate in the program, how to import images, and how to get help when you need it. You have just been hired at Great Leap Digital, a business providing a wide range of digital imaging and marketing services. As an assistant in the photo lab, you'll be using Adobe Photoshop Elements to work with image files for a variety of clients. Your manager, Wen-Lin Jiang, asks you to prepare for your first project by familiarizing yourself with Photoshop Elements.

OBJECTIVES

Understand photo-editing software

Understand copyright

Start Adobe Photoshop Elements 7

View the Photoshop Elements workspaces

Import images from a digital camera

Import images from a folder

Use menus and palettes

Use Help and exit Photoshop Elements

Understanding Photo-Editing Software

A **photo-editing program** is a software program that includes tools for editing, organizing, and enhancing digital photographs and other bitmap images. A **bitmap image** is a type of file that represents an image as a series of dots, or pixels, on a grid. A **pixel** is a small, distinct square of color used to display an image on a grid, such as a computer screen; it is the smallest component of a digital image. Photoshop Elements allows you to work with images in a variety of ways to improve their appearance or make them more suitable for different uses, such as displaying on a Web site, printing on paper, and so on. You want to learn how Photoshop Elements can help you in all aspects of your work as a photo assistant.

DETAILS

You can use Photoshop Elements to accomplish the following tasks:

QUICK TIP
You can load multiple photos on a scanner bed and then automatically divide and align them when you bring them into the program.

- **Get images from a multitude of devices**

 You can transfer images and video to Photoshop Elements from cameras, card readers, hard disks, scanners, CDs, and DVDs. You can also import and play video clips, and even make a photo from a single frame of video.

- **Find and organize images in creative ways**

 Photoshop Elements can automatically search for media files stored on your computer or on storage devices, such as CD or DVD drives, and organize them by date, rating, keyword, and other groupings. A **media file** can be a photo, video, or sound clip. The program creates a searchable **catalog** of photos that includes information about all your media files, such as their location, file format, date, editing history, and so on. A Photoshop Elements catalog does not physically move or store media files. Instead, the catalog provides links to files wherever they may reside on your system and organizes them.

- **Improve images automatically or manually**

 Your goal in editing a particular image may range from making a simple fix to performing complex, precise manipulations. Photoshop Elements lets you choose from two **workspaces** for editing and enhancing your photos. In the **Organizer** workspace, you can correct common flaws automatically. The **Editor** workspace allows for more advanced editing in three modes. **Guided Edit mode** is a natural language-based interface ideal for people new to image editing; **Quick Fix mode** offers tools for making simple improvements; and **Full Edit mode** allows you to make more extensive changes using the full range of editing tools. You can also add text to any image or insert shapes and graphics. Figure A-1 shows an image file open in the Editor workspace in Full Edit mode.

- **Create multimedia and custom files**

 Photoshop Elements lets you combine your image, video, and audio files to create custom slideshows, photo albums, e-mail attachments, Web photo galleries, calendars, and greeting cards. Figure A-2 shows a Web photo gallery created in Photoshop Elements.

- **Share photos and other files**

 In addition to easily attaching a photo to a standard e-mail message, you can e-mail and upload photos to a cell phone, upload photos to a wireless handheld device or online service, or burn them onto a CD or DVD.

FIGURE A-1: Viewing an image in Full Edit mode

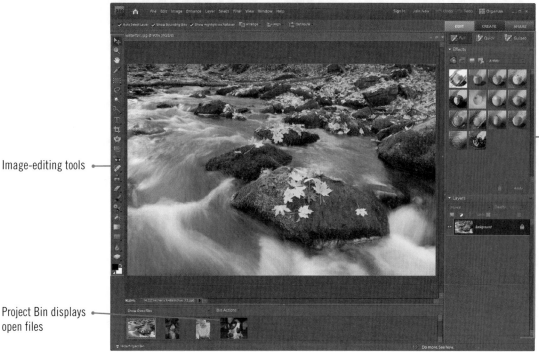

Image-editing tools

Options for modifying and organizing images

Project Bin displays open files

FIGURE A-2: Viewing an online gallery

Understanding graphics programs

The term **graphics program** covers a wide range of computer software. Simple graphics programs are either bitmap editing/paint programs or vector editing/drawing programs. A **paint program** presents a digital canvas on which you dab electronic paint to create or edit bitmap images. It's relatively easy to work with bitmap images, but they lose image quality when resized or rescaled. In contrast, **drawing programs** produce images made of individual objects, which are represented as vector images. A **vector image** can be isolated, moved, and rescaled independently without losing image quality. Drawing programs are best used for graphic illustration; examples include Adobe Illustrator and CorelDRAW.

Image-editing programs are sophisticated graphics programs that contain more powerful, flexible sets of tools. Adobe Photoshop and Adobe Fireworks provide tools for complex editing of bitmap images as well as editing capabilities for vector images. A **photo editor** is an image-editing program that specializes in improving and modifying digital photos. Photoshop Elements and Corel PaintShop Pro are popular photo editor programs.

Understanding Copyright

The creative expressions of your ideas, and especially their use and reproduction, are protected under one or more areas of law generally referred to as intellectual property law. You can think of **intellectual property** as an idea or creation from a human mind that also has the potential for commercial value. Intellectual property is similar to any other property, except that instead of being tangible, like a CD or DVD, it is intangible, like the songs on the CD or the movie on the DVD. In the United States (U.S.), intellectual property law encompasses copyright, patent, trademark, and trade secret law. When dealing with works such as photographs, the most relevant area is copyright law. Because you'll be working with photos from various sources, you want to understand the basics of copyright law.

DETAILS

Some of the basic concepts of U.S. copyright law include the following:

QUICK TIP

Each country has its own set of copyright laws, which can complicate your use of digital media.

Copyright law gives exclusive rights to the creator of a creative work to control its use, including duplication and distribution. Copyright protects "original works of authorship fixed in a tangible medium of expression." In other words, the result is something creative produced by you that someone else can experience.

The three components essential to understanding copyright are: (1.) when a work becomes protected, (2.) the types of work protected, and (3.) how long protection lasts. When the copyright expires for a work, the work no longer has protection regarding its use.

- **When a work becomes protected**—Copyright protection extends to original work *as soon* as it's created. The work must be "fixed"—able to be experienced or perceived in some fashion, such as in an electronic file stored on a memory card or on paper. Generally, the author of an original work is the owner of that intellectual property regardless of where anyone else might see the work, be it on the Web, in a magazine, or in a movie theater. Figure A-3 shows a Web site that provides information and resources on copyright law.

QUICK TIP

Registering a work with the Copyright Office or inserting the copyright symbol © is no longer required for a work to have copyright protection.

- **Types of work protected**—Copyright protects an original **work of authorship**—an independently conceived expression that includes literary works (entertainment media, catalogs, and computer code); musical works and sound recordings; dramatic works; artistic and architectural works; pictorial, graphic, and sculptural works (physical and digital); motion pictures, video games and tapes, computer and other audiovisual works; and broadcast and online transmissions. Copyright arises upon the *expression* of an idea—the idea itself is not protected, only its original expression. For example, if you take a photo of a great sunset at the beach, your photo (original creative expression) is protected as soon as you click the shutter. But, the *idea* of taking a photo of a great sunset on a beach is not protected. Everyone else around you can take their own photos, write about it on their **blog** (a publicly accessed online journal), or paint it on a 20-foot mural. Each individual expression is protected by copyright.

QUICK TIP

Obtaining written permission from an owner to use a work ensures your ability to use it without risking infringing the rights of the owner.

- **Length of protection**—Generally, for a single creator, the current length of copyright protection is the life of the author plus 70 years.

QUICK TIP

In the United States, most works created prior to 1923 are in the public domain.

- **Public domain** indicates the status of any work or creation that is no longer protected by some form of intellectual property; therefore, no one owns it or has rights to it. You can use public domain content however you wish. Many believe that using such works should be encouraged because it furthers the progress of the public and society. Figure A-4 shows a site that offers photos in the public domain.

FIGURE A-3: A copyright information Web site

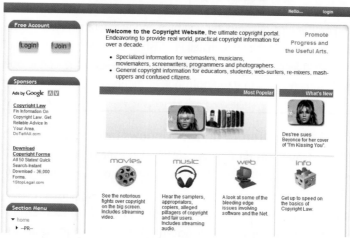

FIGURE A-4: A public domain stock photo Web site

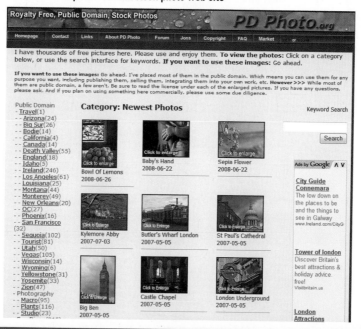

Understanding copyright infringement and fair use

Copyright infringement is the unauthorized use of one or more of the rights of a copyright holder. The penalty for infringement of a registered copyright can be tens of thousands of dollars for each infringement. Even accidental infringement can lead to penalties, though not as strict. The assumptions and burdens of proof governing copyright infringement are based on civil law, which has broader rules of evidence. Civil law does not require proof of infringement beyond a reasonable doubt, and an assumption of guilt may exist. For example, U.S. copyright law specifically prohibits removing a **watermark** (information that identifies the copyright owner) from a photograph. If you are charged with removing a watermark, the attempt itself is viewed by the court as your willful intent to violate the owner's copyright. The assumption is that you are guilty, and the burden of proof is on you to prove that you're not.

Fair use is a built-in limitation to copyright that allows users to copy all or part of a copyrighted work in support of their First Amendment and other rights. You do not need to ask permission from the copyright holder for a fair use of the work. For example, you could excerpt short passages of a protected film or song, or parody a television show, even though your use may have commercial value. Determining whether fair use applies to a work depends on the *purpose* of its use, the *nature* of the copyrighted work, the *amount* you want to copy, and the *effect* on the saleability or value of the work. Fair use is used as the defense in many copyright infringement cases, but it is always decided on a case-by-case basis—no concrete formula has been established.

Starting Adobe Photoshop Elements 7

Depending on the type of computer you own and its operating system, you can start Photoshop Elements in several ways. Usually when you install Photoshop Elements, the installation program places a Photoshop Elements shortcut icon on your desktop. You can double-click the icon to open the program from your desktop. You are ready to start Photoshop Elements and begin familiarizing yourself with its workspaces.

STEPS

1. **Click the Start button** ⊕ **on the Windows taskbar, as shown in Figure A-5**

 The Start menu opens on the desktop. The left pane of the Start menu includes shortcuts to the most frequently used programs on the computer. The items on your Start menu will differ from those shown in the figure.

 > **TROUBLE**
 > If this is the first time you are installing Photoshop Elements, you might receive prompts to register the program.

2. **Point to All Programs, then click Adobe Photoshop Elements 7**

 The Photoshop Elements Welcome Screen opens, as shown in Figure A-6. The four icons in the screen—Organize, Edit, Create, and Share—let you choose what to do next. You can also sign up for a free online membership at Photoshop.com. At Photoshop.com, you can post and instantly update online galleries, order prints of your favorite photos, download photos, and more. Once you sign up for a Photoshop.com account, the sign-in portion of the Welcome screen will display your account information.

Backing up your files

Photoshop Elements includes many organizing functions, including an easy method for backing up your files. Once you import your photos, they are as vulnerable to a computer crash as any other file on your computer. After you have imported or edited a number of photos, Photoshop Elements will prompt you to back up your catalog onto another drive or a CD or DVD. If you have moved or deleted a photo on your computer, Photoshop Elements will attempt to locate the missing file and prompt you to find it manually. After you initially perform a Full Backup, you can perform an Incremental Backup, which locates and backs up only those files not previously backed up. To back up a catalog in Organizer, click File on the menu bar, then click Back Up Catalog, to CD, DVD or Hard Disk. Photoshop.com also offers a subscription backup service. To learn more, open the Organizer, click File on the menu bar, then click Test PSE7 Service.

FIGURE A-5: Starting Photoshop Elements

Adobe Photoshop
Elements 7

Start button

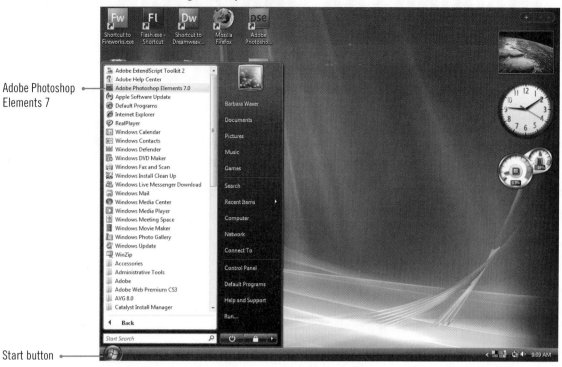

FIGURE A-6: Photoshop Elements Welcome Screen

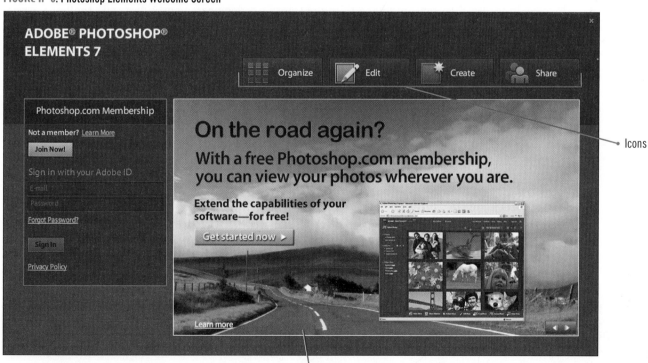

Icons

Your Welcome image might differ

Viewing the Photoshop Elements Workspaces

Photoshop Elements has two workspaces: the Organizer, where you can organize and share your files; and the Editor, where you can edit, improve, and enhance your images. The Organizer contains various views, while the Editor has different editing modes, which are described in Table A-1. ▓▓▓▓ You decide to examine both Photoshop Elements workspaces to familiarize yourself with them.

1. **Click the Organize icon ▦ Organize on the Welcome Screen**

 The Organizer opens in default Photo Browser view with the default catalog, My Catalog, open, as shown in Figure A-7. Currently, this catalog contains no photos.

2. **Maximize the program window, then take a moment to familiarize yourself with the components of this workspace**

 Many components in Photo Browser view are common to other workspaces in Photoshop Elements. The **menu bar** contains Photoshop Elements commands on the left and on the right, Undo and Redo buttons, and **workspace buttons** for switching views and switching between workspaces. The **Task Pane** contains the Organize, Fix, Create, and Share tabs, each of which has specific buttons and controls.

3. **Click the Editor button ▧ Editor▾ on the menu bar, then click Quick Fix on the Editor menu**

 After a few moments the Editor workspace opens in Quick Fix mode, as shown in Figure A-8. The workspace is empty because you have not yet opened a file. Quick Fix is perfect for performing basic touch-ups to an image. Quick Fix contains **image fixing options** for performing automatic fixes and a **toolbox** for working with images. Tool options for the selected tool appear on the **Options bar**. Thumbnails of open files appear in the **Project Bin**.

4. **Click the Full Edit button ▧ Full on the Edit tab of the Task Pane**

 Full Edit mode opens, as shown in Figure A-9. Full Edit contains powerful tools and features for editing, correcting, and fine-tuning your images. The **Palette Bin** in the Task Pane contains palettes for monitoring and altering images and can be moved, collapsed, and undocked as needed.

5. **Click the Guided Edit button ▧ Guided on the Edit tab**

 Guided Edit mode opens. Image-fixing options display in the Task Pane. When you click one of these options, instructions on how to complete the fixing option display in the Task Pane.

6. **Click the Organizer button ▦ Organizer on the menu bar**

 You return to the Organizer workspace in Photo Browser view. Once you've opened one workspace, you can use the workspace buttons on the menu bar to quickly switch between workspaces.

TABLE A-1: Components in Photoshop Elements workspaces

workspace	mode (Editor) or view (Organizer)	task pane tabs
Editor	Full Edit Quick Edit Guided Edit	Edit, Create, Share
Organizer	Photo Browser (thumbnail) Date Map	Organize, Fix, Create, Share

FIGURE A-7: Organizer workspace in Photo Browser view

Menu bar

Default catalog

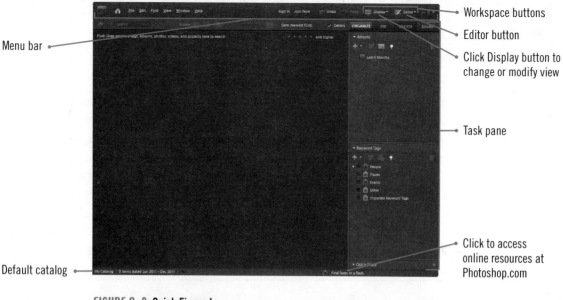

Workspace buttons

Editor button

Click Display button to change or modify view

Task pane

Click to access online resources at Photoshop.com

FIGURE A-8: Quick Fix mode

Options bar

Toolbox

Project Bin

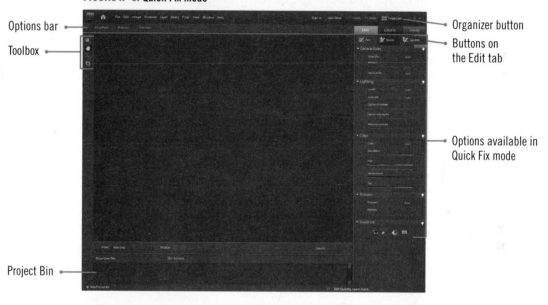

Organizer button

Buttons on the Edit tab

Options available in Quick Fix mode

FIGURE A-9: Full Edit mode

Toolbox; your size might differ

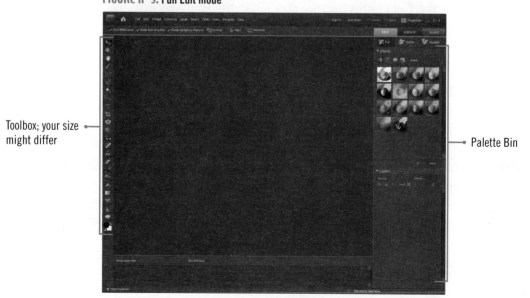

Palette Bin

Photoshop Elements 7

Importing Images from a Digital Camera

You can use different methods to transfer images from a digital camera to your computer. You can plug in your camera to your computer and then follow the instructions for transferring files. Or, you can use a card reader, CD, or a **USB** (**Universal Serial Bus**) Flash drive to upload or download files, which eliminates the need to connect the camera directly to your computer. Digital cameras (and other devices, such as MP3 players and wireless handheld devices) contain removable memory cards, the format and appearance of which vary depending on brand. A **card reader** can read multiple memory card formats and store and transfer files without draining your camera's battery. Photoshop Elements allows you to import photos directly from your camera or card reader. Merlin Harrier, Editor of the National Bird Feeding Society magazine, is dropping by with his camera so you can import two photos directly into Photo Browser.

STEPS

QUICK TIP

The Adobe Photo Downloader may open automatically when you connect your camera if it is already enabled in the system tray. To disable it, right-click the Adobe Photo Downloader icon 🔲, then click Disable.

1. **Confirm that you have one or more images stored on your camera or card reader, connect the device to your computer, and make sure your camera is turned on**

2. **Click File on the menu bar, point to Get Photos and Videos, then click From Camera or Card Reader**

 The Adobe Photoshop Elements 7 – Photo Downloader dialog box opens, as shown in Figure A-10. Here you can select import settings such as where to store the imported images, and specify a folder name, file names, and delete options.

3. **If necessary, click the Get Photos from list arrow, then click the corresponding drive or device name for your camera**

 A preview of the first photo appears in the dialog box. To preview all the photos, select which ones to import; or to choose other more advanced options, you can click the Advanced Dialog button. By default, every photo is selected. You can deselect photos by clicking the check box beneath each photo. Photoshop Elements saves files in an Adobe folder in the default location where your operating system stores image files.

QUICK TIP

You can also press [Ctrl] [G] to open the Adobe Photoshop Elements Photo Downloader.

4. **Click the Browse button, navigate to the location where you store your Data Files, then click OK**

 The Browse For Folder dialog box closes and you return to the Adobe Photoshop Elements 7 – Photo Downloader dialog box.

5. **Click the Get Photos button, click OK in the Files Successfully Copied dialog box, then click OK to view only these photos in the catalog**

 The photos are imported into the Photo Browser.

6. **Drag the Adjust size of thumbnail slider ▉ to the right, then compare your screen to Figure A-11**

 The thumbnails increase in size. Additional information about the imported photos appears beneath the photos. You'll learn more about this data in a future lesson. If you have additional photos in the catalog and want to view them, you can click the Show All button at the top of the Photo Browser.

QUICK TIP

Note that the terms "hard drive" and "hard disk" are synonymous.

7. **Press and hold [Shift], click the photos you imported from the camera, press [Delete], then click OK in the Confirm Deletion from Catalog dialog box**

 The photos are deleted from the catalog, but not from your computer or camera. The catalog only stores the photo's information, not the actual photo file. In the Confirm Deletion from Catalog dialog box, you can also choose to physically delete the image from your hard drive if you wish.

8. **Use your system's file manager to delete the imported files from your hard drive**

FIGURE A-10: Adobe Photoshop Elements 7 - Photo Downloader dialog box

Your location list might differ

Click to select camera or card reader

In Windows XP the folder is My Pictures

Click to select the location for saving files

File naming and deleting options

Click to open Advanced Dialog box

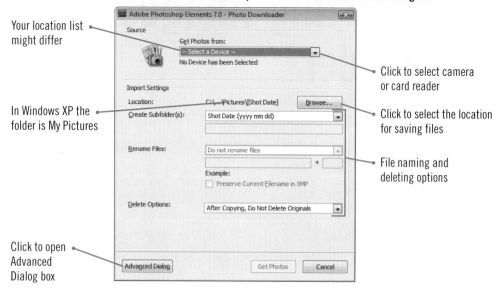

FIGURE A-11: Viewing photos imported from a camera

Adjust size of thumbnail slider

Camera or card reader; yours will differ

Imported photos; yours will differ

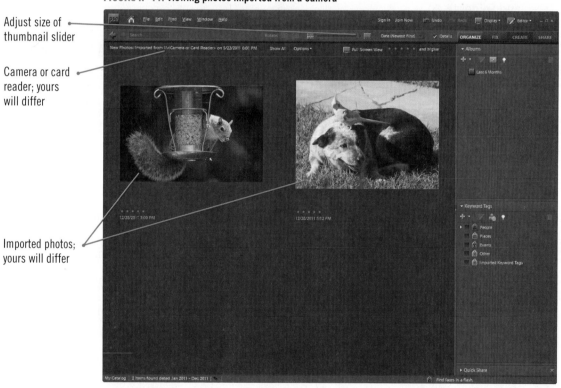

Understanding portable storage devices

The easiest way to think about portable storage is to consider the memory card that stores photos in your camera. When it's full you can take it out and put in another. Or, you can take it out and insert it into a card reader that transfers files to your computer, thus conserving your camera battery. Card readers have a specialized function: they transfer data, such as digital photos, MP3 music files, or video clips very, very quickly from the memory card to your computer. Another versatile storage device is a USB Flash drive, which plugs right into your computer. (Note that some older computers may require you to first install a driver.) Other storage options include CDs, DVDs, or an external hard drive. Remember that technology changes rapidly, so be prepared to update or change your options for long-term portable storage. A popular storage option today can leave you unable to access your files tomorrow. For example, in the past, ZIP or JAZZ drives were commonplace for storing files, and Kodak produced proprietary software for creating Kodak Photo CDs, all of which are now no longer used or supported.

Importing Images from a Folder

As you acquire images received as e-mail attachments, downloaded from the Internet, and from other sources, the number of image files on your computer can accumulate quickly. Photoshop Elements creates links to image files stored on your computer, which allows you to find them easily each time you want to view them or use them. While not everyone organizes their files perfectly, most of us have file management skills developed to the point where we know the value of creating a folder or two. Folders provide a hierarchical storage system that makes it easier to locate any file in any program. Merlin just sent you an e-mail attachment containing several replacement images for the newsletter. You've saved the images to the Great Leap Digital server and now want to add the images to the Photo Browser in the Organizer to determine their quality.

STEPS

QUICK TIP

You can also press [Ctrl][Shift] [G] to open the Get Photos from Files and Folders dialog box.

1. **Click File on the menu bar, point to Get Photos and Videos, then click From Files and Folders**

 The Get Photos from Files and Folders dialog box opens.

2. **Navigate to the location where you store your Data Files, click the Unit A folder, then double-click the Photos1 folder**

 A list of files in the folder appears, as shown in Figure A-12.

3. **Click the first file in the list, press and hold [Shift], click the last file in the list, then release the mouse button**

 All the files in the folder are selected.

4. **Click Get Photos, then click OK in the message box to view only these photos in the catalog**

 Thumbnails of the photos in this folder appear in the Organizer in Photo Browser view.

5. **If necessary, drag the Adjust size of thumbnail slider ▓ so that all six photos are visible in the Photo Browser, then compare your workspace to Figure A-13**

 You are now able to see all the images and the information for each image in the Organizer workspace.

Using other methods to bring photos into the Photo Browser

You can use a variety of methods to bring images into Photoshop Elements. You can drag and drop files into the Photo Browser view from your desktop, file management system, CD, and even other image-editing programs. To do so, arrange the windows on your desktop so that you can see both the image filename and the Photo Browser view, then simply drag the desired image into the Photo Browser (if you can't arrange your workspace to see both windows, you can also copy and paste between windows). After you drag and drop files, only those images are visible in the catalog, just as if you used one of the Get Photos and Videos commands in Photoshop Elements to obtain them. You can also import photos from some mobile phones and wireless handheld devices. Your mobile phone provider or manufacturer can verify whether your phone is compatible with Photoshop Elements, or you can visit the Adobe Web site at *www.adobe.com*. You can also drag or copy and paste an image from another program into a new or open file in the Editor workspace, instead of into the Photo Browser in the Organizer. Note that dragging an image from another program is not the same as opening the file in an Editor workspace. When you drag and drop or copy and paste a file from another program into Quick Fix mode or Full Edit mode, the image becomes part of the existing open file. If no file is open, the dragged or copied image appears as a new, untitled file.

FIGURE A-12: Get Photos from Files and Folders dialog box

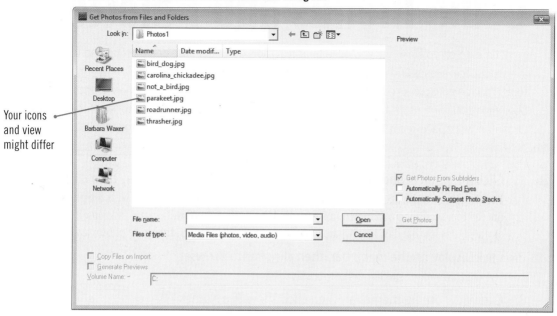

Your icons
and view
might differ

FIGURE A-13: Viewing photos imported from a folder

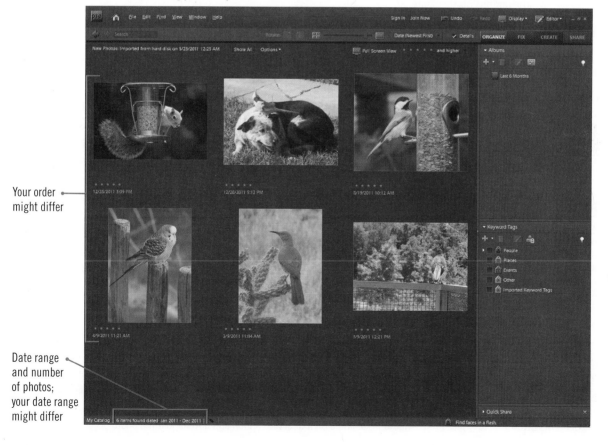

Your order
might differ

Date range
and number
of photos;
your date range
might differ

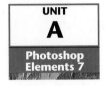

Using Menus and Palettes

Sometimes to complete a task you need to access tools other than the default tools and functions available in a workspace. Menus and palettes allow you to change views and access these additional commands and tools. You can collapse, expand, undock, or close palettes based on your work preferences. ▰▰▰▰ Before beginning your first project for Great Leap Digital, you want to become familiar with the views in the Organizer workspace, learn how to manipulate palettes, and hide and show the Task Pane.

STEPS

QUICK TIP

You can click the arrows on the calendar to view photos taken in different months.

1. **Click the squirrel photo to select it, click Display on the menu bar, then click Date View**

 The Organizer workspace switches to Date view, showing a monthly calendar with the photos appearing on the day they were taken, as shown in Figure A-14. You can click controls in the Task Pane to view a slide show of the photos for that day, or navigate to different days of the month that have photos associated with them.

2. **Click Display on the menu bar, then click Photo Browser**

 The Organizer returns to Photo Browser view.

3. **Click View on the menu bar, then click Show File Names**

 Filenames appear beneath the photos.

4. **Click the Fix tab on the Task Pane to view its contents, then repeat for the Create, Share, and Organize tabs**

 You can perform automatic fixes using the options on the Fix tab; create projects, such as a photo book or calendar, using the options on the Create tab; and make your photos available for sharing with others using the options on the Share tab.

QUICK TIP

Digital cameras embed useful information, known as **metadata**, in files. Exposure, shutter speed, date, and other storage data are contained in EXIF (Exchangeable Image File Format) data.

5. **Click the not_a_bird.jpg photo, if necessary, click Window on the menu bar, then click Properties**

 The Properties palette opens where you can view specific file information, as shown in Figure A-15. Table A-2 describes the buttons available in this palette.

6. **Click the Dock to organizer pane button ▾ at the top of the Properties palette**

 The Properties palette appears in the bottom of the Task Pane, as shown in Figure A-16. If you are not using the Task Pane, you can hide it to make more room in the Organizer or the Editor workspaces for the task at hand.

7. **Click Window on the menu bar, then click Hide Task Pane**

 Displaying the hidden Task Pane when you need to access it again is just as easy.

QUICK TIP

You can also click the Adjust Organize Bin Size arrow ▮ to close the Task Pane, or drag the arrow to resize the Task Pane.

8. **Click Window on the menu bar, then click Show Task Pane**

 The Task Pane reappears. You can also collapse a palette without closing it, or close it altogether.

9. **Click the Close button ✕ on the Properties palette**

 The Properties palette is no longer visible in the Task Pane. To collapse a palette without closing it, click the Close *Palette Name* arrow ▾.

TABLE A-2: Properties palette

button	name	what it shows
📄	**General button**	File size and location, or add a print or audio caption and notes about the photo
ⓘ	**Metadata button**	Camera settings
🏷	**Keyword Tags button**	Keywords or albums attached to files
↪	**History button**	When an image was imported, edited, shared, or used

FIGURE A-14: Organizer Date View

Click to change month

● DECEMBER 2011 ●

Click to change day

Number of photos taken on selected day

Controls for viewing slide show

Selected day

FIGURE A-15: Properties palette

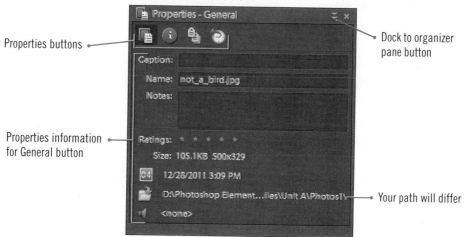

Properties buttons

Dock to organizer pane button

Properties information for General button

Your path will differ

FIGURE A-16: Properties palette docked in Task Pane

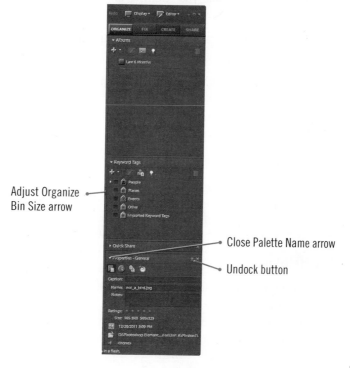

Adjust Organize Bin Size arrow

Close Palette Name arrow

Undock button

Using Help and Exiting Photoshop Elements

Photoshop Elements has an extensive Help system that supplies information quickly and easily. Help is organized so that you can find whatever you need, whether you want to look up a topic or search for specific keywords. The Help window opens in your Web browser and consists of topics arranged by category, or if you know what you're looking for, you can type a word in a search field in **Search**. You can also click the **Community Help** link to access materials such as tutorials, articles, and blogs about Photoshop Elements. ▓▓▓▓▓ You examine Photoshop Elements Help so you'll know how to get help when you need it.

STEPS

QUICK TIP
You can also press [F1] to open Help.

1. **Click Help on the menu bar, then click Photoshop Elements Help**

 The default Web browser installed on your computer opens. If the Photoshop Elements Help and Support page opens, perform Step 2. If the Contents page of the Photoshop Elements Help window opens, begin reading the information about Figure A-17 in step 2 below.

2. **Click Photoshop Elements Online Help, if necessary**

 The Contents page of the Photoshop Elements Help window opens. Figure A-17 shows the Photoshop Elements Help window in Mozilla Firefox. You can search for topics by typing a keyword in the Search text box, or by expanding topics under Using Photoshop Elements 7. Topics appear in the left pane and full descriptive text in the right pane.

3. **Click the Photoshop Elements workspace plus sign ⊞, click the About workspaces plus sign, then click the Organizer workspace**

 Specific information about the Organizer workspace topic appears in the right pane, as shown in Figure A-18.

4. **Click the This Help system only check box, click the Search text box, type metadata, then press [Enter]**

 A list of topics that include the word "metadata" appears in the search results list, as shown in Figure A-19.

5. **Close your Web browser**

 The Help window closes and you return to the Organizer workspace. You are ready to exit Photoshop Elements.

6. **In the Organizer workspace, click File on the menu bar, then click Exit**

 The Organizer workspace closes.

QUICK TIP
If both the Editor workspace and the Organizer workspace are open, you must close both workspaces to exit the program.

7. **In the Editor workspace, click the Close button on the title bar**

 Photoshop Elements closes.

Using commands on the Help menu

In addition to the main Help system, you may find the other commands on the Help menu useful. *Glossary of Terms* links to definitions of Photoshop Elements tools and functions, *Updates* and *Online Support* links to the Adobe Product Support page. (To access the Photoshop Elements knowledge base, click Photoshop Elements.) *Online Learning Resources* links to the Idea Gallery, a collection of applied uses for Photoshop Elements and Premiere Elements.

FIGURE A-17: Adobe Photoshop Elements * Using Adobe Photoshop Elements 7

Your browser might differ

Type keyword to search on here

Click to expand topic

FIGURE A-18: Viewing Help topic

Click this topic to display its contents

Topic information appears in right pane

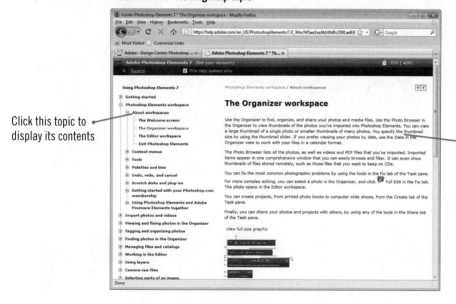

FIGURE A-19: Searching for help on a keyword

Type search expression here

Search results

Practice

▼ CONCEPTS REVIEW

Label the elements of the Organizer workspace shown in Figure A-20.

FIGURE A-20

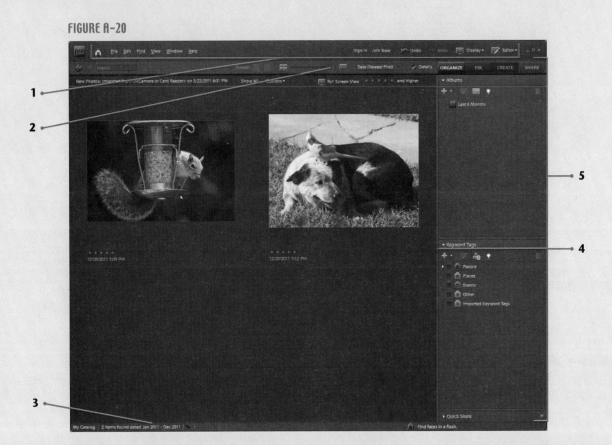

Match each term with the statement that best describes it.

6. **Properties palette**
7. **Photo Browser**
8. **Task Pane**
9. **Copyright law**
10. **Quick Fix**
11. **Catalog**
12. **Public domain**
13. **Palette Bin**

a. Areas containing tools, buttons, and functions in the Editor workspace

b. Legal classification that allows you to use published work however you wish

c. Editor workspace where you can perform common fixes

d. Organizer workspace view for organizing files

e. A category of intellectual property law that grants exclusive rights to the creator of a creative work to control its use

f. Displays information, such as history and camera settings, about your photo

g. An area of the Organizer workspace that contains the Organize, Fix, Create, and Share tabs

h. A representation of the media files, including location and file format

Select the best answer from the list of choices.

14. **Which window opens by default when you start Photoshop Elements?**
 a. Quick Fix
 b. Blank Screen
 c. Full Edit
 d. Welcome Screen

15. **Which key can you press to open Help?**
 a. [H]
 b. [F12]
 c. [F9]
 d. [F1]

16. **What is the function of the Exit command on the File menu?**
 a. To switch to a previously opened workspace
 b. To close the current workspace and any open files
 c. To close all Photoshop Elements workspaces
 d. To close all open files in all workspaces

17. **Which Organizer workspace view allows you to organize your photos chronologically?**
 a. Thumbnail view
 b. Folder Location view
 c. Date view
 d. Normal view

18. **Which of the following is *not* available in the Organizer workspace?**
 a. Access to Date View
 b. Palette Bin
 c. Access to Thumbnail view
 d. Properties palette

19. **Which of the following is *not* available in the Help system?**
 a. Preferences
 b. Glossary
 c. Keyword search
 d. Access to online resources

▼ SKILLS REVIEW

1. **Understand photo-editing software.**
 a. Describe three tasks you can accomplish using Photoshop Elements.

2. **Understand copyright.**
 a. Define the term **work of authorship** and give at least three examples of such works.
 b. Explain the difference between a work that is in the public domain and one that is copyrighted.
 c. Describe two conditions that allow you to use an image without infringing the owner's copyright.

3. **Start Adobe Photoshop Elements 7.**
 a. Start Photoshop Elements.

4. **View the Photoshop Elements workspaces.**
 a. Open the Organizer workspace.
 b. Open Quick Fix mode in the Editor workspace.
 c. Open Full Edit mode in the Editor workspace.
 d. Return to the Organizer workspace.

5. **Import images from a digital camera.**
 a. Connect a camera containing images to your computer.
 b. Open the Get Photos and Videos from Camera or Card Reader dialog box.
 c. Select the drive for your camera.
 d. Import files from the camera, then adjust the size of the thumbnails in the Photo Browser view of the Organizer workspace.
 e. Arrange your view so that all the photos are visible, if necessary.
 f. Delete the photos from the catalog that you just imported, then delete them from your hard drive using your file management system.

6. **Import images from a folder.**
 a. Open the Get Photos and Videos from Files and Folders dialog box.
 b. Navigate to the location where you store your Data Files, then import all the files in the Photos2 folder.
 c. Arrange your view so that all the photos are visible, if necessary.

7. Use menus and palettes.

 a. Select the jumbo slice photo, then switch to Date View.

 b. Switch back to Photo Browser view.

 c. Display file names for the photos, if necessary, then compare your screen to Figure A-21.

 d. View the properties for the beijing_garden.jpg photo.

 e. Undock the Properties palette, if necessary, then dock it.

 f. Hide and show the Task Pane.

 g. Collapse the Properties palette in the Task Pane.

FIGURE A-21

8. Use Help and exit Photoshop Elements.

 a. Open the Help system.

 b. Expand Viewing and fixing photos in the Organizer, then click Fixing photos in the Organizer.

 c. Click the Search link, then search for information by typing the word **catalog** in the Search text box.

 d. Display Help information on one of the topics concerning the catalog.

 e. Close the Help window.

 f. Close all open Photoshop Elements workspaces and exit the program.

▼ INDEPENDENT CHALLENGE 1

You just purchased Photoshop Elements as the image-editing software to handle advertising for your new store, Cupcake Bistro Ltd. As the owner, you are also the *de facto* subject matter expert. You are eager to get up to speed on this new program as quickly as possible so you can advertise your gourmet treats.

 a. Start Photoshop Elements, then open the Organizer workspace.

 b. Get at least five photos from your camera that match the bakery theme.

 c. Get photos from the Photos3 folder from the location where you store your Data Files, and view all the photos in the catalog.

 d. Show filenames for the photos, if necessary.

 e. Adjust the thumbnail view as desired, then compare your screen to Figure A-22.

 f. Exit Photoshop Elements.

FIGURE A-22

▼ INDEPENDENT CHALLENGE 2

Intellectual property law impacts your life every day, from the time your coffeemaker automatically grinds and brews your favorite beans, to the time you listen to the last song on your portable wireless music player. We constantly interact with someone else's protected work, although we may not always be aware of it.

 a. Think through the events of a normal day and write down two or three products or processes you come in contact with that are examples of materials protected by intellectual property law. These can include any works of authorship and something you may believe is a trademark, patent, or trade secret. Choose one of those products or processes to explore further as an example of intellectual property.

▼ INDEPENDENT CHALLENGE 2 (CONTINUED)

b. Draw a picture of your selection or obtain images that relate to it. You can obtain images from your computer, from the Internet, from a digital camera, or from scanned media. When downloading from the Internet, you should always assume the work is protected by copyright. Be sure to check the Web site's terms of use to determine if you can use the work for educational, personal, or noncommercial purposes.

c. Think of and list additional expressions of the idea. Is there any direct evidence that the work is in the public domain?

d. How could someone infringe the copyright or other rights? How would the infringement ever be noticed by the copyright holder?

e. Use your favorite word-processing program to write an argument in favor of a theoretical copyright infringer and an argument in favor of the copyright owner. Which argument do you find most compelling? Why? Save the file as **Copyright Discussion** in the location where you store your Data Files.

Advanced Challenge Exercise

Add to your Copyright Discussion document by answering any one of the following questions.

- A local photographer has told you that the slide shows you create of family events look so professional, you should consider going into business. You add perfectly timed music accompaniments, using songs from your vast music library, all of which you've purchased. You've created a Web site and want to use a couple of your slide creations in your portfolio to show to new clients. Is this okay? Why or why not?

- You use a public Web photo album service to post pictures of your dogs for friends and family to view. One of your friends just told you that a photo you took of your Saluki is featured on a hound enthusiast's Web page. This individual also sells dog-themed t-shirts, jewelry, artwork, bedding, and so on. Should you contact the person who used your photo or just feel complimented? Why or why not?

- You're helping a friend with a geology paper and found a great illustration on the Web depicting how a magma chamber feeds a volcano. The Web site is in Iceland. Can you use the image? Why or why not?

f. Add your name to your Copyright Discussion document, print it, close it, and exit the program.

▼ INDEPENDENT CHALLENGE 3

Adobe's Photoshop Elements Customer Support Web page can help answer a question, provide troubleshooting tips, and direct you to more advanced techniques. Before placing a phone call to Technical Support, you decide to go online and examine what is available.

a. Start Photoshop Elements and open any workspace.

b. Click the Help menu, then click Online Learning Resources.

c. Click an Idea Gallery that interests you, then watch a demonstration and view examples.

d. Print a page, then add your name to the printout.

Advanced Challenge Exercise

- Click Online Support on the Help menu.
- Click the Photoshop Elements product support center.
- Click the Recent documents tab, then review the TechNotes
- Print a TechNote that interests you.

e. Exit Photoshop Elements.

▼ REAL LIFE INDEPENDENT CHALLENGE

Many people post their photographs online. You want to protect your rights in this endeavor and decide to do some research to determine the best approach. Most photographers and companies who post and sell photographs online include copyright information about the images on their site. You decide to visit some existing sites and gather ideas on how to manage your own copyright policies.

a. Connect to the Internet, start your Web browser, navigate to your favorite search engine, then search for a term such as **photography sites** or **free images** to find links to Web sites that sell or allow use of digital photos online.

b. Find a site with several links to other photography sites.

c. Open at least four sites, two of which are commercial sites and two of which are offered by single photographers.

d. Locate the copyright information for each site. (*Hint*: You may need to scroll down the page or find links with words such as **terms of use**, **about me**, **contact me**, **usage**, **copyright**, and so on.) Using the following questions as a guide, print the page or pages on each site that provide information on the site's copyright policies.

 • Does the site specifically state how you can use the images? If so, state the use.
 • Do the images have obvious digital watermarks?
 • Can you download photos at different resolutions?
 • Does the site differentiate between commercial and noncommercial use?
 • If the site posts photos for members, who owns the copyright?

e. Add your name to each printout, and close your browser.

▼ VISUAL WORKSHOP

When you work in Photoshop Elements, you can customize your workspace so that you can view and access the information you need. Start Photoshop Elements, then arrange the elements in the workspace so that it matches the one shown in Figure A-23. When you are finished, press [Print Screen], paste the image into a word-processing program, add your name at the top of the document, print the document, close the word processor without saving changes, then exit Photoshop Elements. (*Hint*: Use the Folder Location command on the Display menu. Note that your drives and folders will differ.)

FIGURE A-23

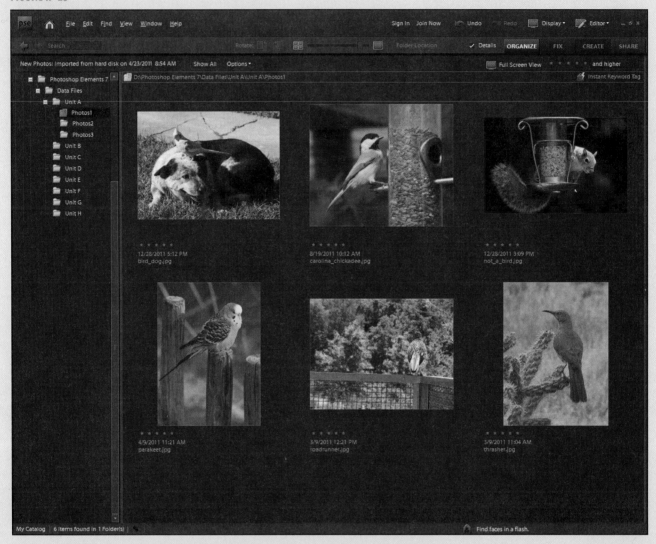

Organizing Photos

Files You Will Need:

Kids folder
Fruit folder
Squash folder
Benches folder

When you organize your photos in a physical photo album, you are limited to arranging your photos on a page, and perhaps categorizing the pages of photos using color-coded tabs or dividers. Fortunately, the Organizer workspace in Photoshop Elements provides you with an easy-to-use electronic system for organizing, storing, analyzing, rating, and labeling your photos. You can also create relationships between your files that allow you to quickly search for and sort images. You've been assigned to assist Vera Williams, a lead Web designer for Great Leap Digital, as she begins work on a Web page for a community youth program. It's your job to organize photos for an after-school safety program.

OBJECTIVES

Rate and filter photos

Assign keyword tags

Create photo stacks

Add captions to photos

Create albums and smart albums

Fix a file in Organizer

Use version sets

Search for photos

Rating and Filtering Photos

Photos in your catalog can accumulate quickly. Not every photo may be a favorite, but you may have many reasons to keep an entire set of photos. Photoshop Elements allows you to group or **rate** your photos on a scale of one star to five stars. You can then **filter** your view of the photo catalog based on your Favorites rating, so that only photos that meet a certain rating are visible. You begin your organization of the youth program photos by assigning a Favorites rating to them and then viewing just the ones that have a rating of four stars or higher.

STEPS

1. **Start Photoshop Elements, then open the Organizer workspace in Photo Browser view**
 If you have photos in the catalog already, they appear in the Photo Browser.

QUICK TIP

If prompted to back up your catalog, click Remind Me Next Time.

2. **Delete any photos in the catalog, import the photos in the Kids folder from the location where you store your Data Files, click the Don't Show Again check box to select it, click OK to confirm that you want to see only the newly imported files, then verify that the filenames are displayed**
 The photos from the Kids folder appear in Photo Browser. Five gray stars appear below each photo. These stars are used to apply a rating system to the photos in the catalog.

QUICK TIP

You can also double-click a photo to view it in Single Photo View.

3. **Click the photo bestfriends.jpg, then click the Single Photo View button ▭ on the thumbnail slider bar**
 The photo appears as a very large single thumbnail.

QUICK TIP

You can also access the Ratings menu by right-clicking an image.

4. **Click Edit on the menu bar, click Ratings, then click 5 Stars**
 The five stars beneath the photo are now yellow, as shown in Figure B-1. A photo is considered a Favorite as soon as you give it at least one star.

5. **Drag the Adjust size of thumbnail slider ▪ to the left until all images are visible in the Photo Browser**

6. **Drag the pointer ⊳ over the first three stars that appear beneath girl_playing.jpg, then click the mouse when three stars are highlighted yellow**
 This photo now has a rating of 3 stars.

7. **Using Figure B-2 as a guide, apply star ratings to the remaining photos**

8. **Drag ⊳ over the first four stars in the Specify a filter level for the Favorites ranking row at the top of the Photo Browser window, then click the mouse when four stars are highlighted**
 Only photos with a Favorites rating of four stars or higher appear in the Photo Browser, as shown in Figure B-3. To view different filter results, click additional or fewer stars.

9. **Click the fourth star in the Specify a filter level for the Favorites ranking row**
 The Favorites filter is removed and all the photos reappear in the Photo Browser.

Understanding filters for Favorites ratings

In addition to selecting the number of stars on which to filter your view of photos, you can also adjust the filter to include those photos with ratings higher or lower than your selection. Click the arrow next to the Specify a filter level for the Favorites ranking row to select which ratings are included. By default, *and higher* is selected, which means the Photo Browser will display those photos with the Favorites rating you set and any photos with a rating higher than what you selected. You can also click *and lower* to view photos with a maximum number of selected stars, or click *only* to view photos restricted to just those rated with the number of selected stars.

FIGURE B-1: Single Photo view

Edit menu

Five star rating

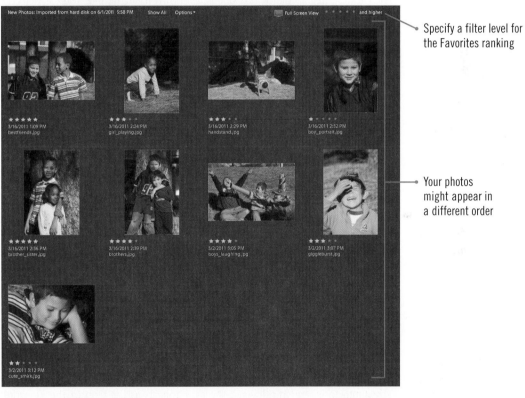

FIGURE B-2: Viewing Favorite ratings

Specify a filter level for the Favorites ranking

Your photos might appear in a different order

FIGURE B-3: Filtered Favorites ratings

Filter criteria

Favorites rating

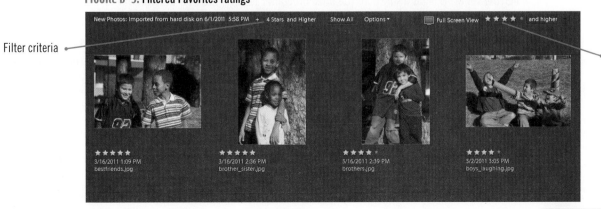

Assigning Keyword Tags

You can group your photos, other media files, and projects by attaching personalized **keyword tags** or **keyword tag categories** to them. You can choose any word or phrase as a keyword tag or category. You can assign a category—or a tag within a category—to photos. Using keyword tags eliminates the need to physically move photos into folders or rename files. A photo can have one or more keyword tags attached to it. You use the Keyword Tags palette in the Task Pane to select or create a category and then find photos based on their keyword tag. To attach a keyword tag to a photo, you simply drag and drop the keyword tag on top of the image in Photo Browser. To find files based on a specific keyword tag, you click the square next to the keyword tag in the Keyword Tags palette. To make it easy for Vera to locate photos for the community youth program Web page, you attach keyword tags to the youth photos and then view photos filtered by keyword tag.

STEPS

1. **Click the Create new keyword tag, sub-category, or category button in the Keyword Tags palette, then click New Category**
 The Create Category dialog box opens, as shown in Figure B-4. You can select a color, create a name, and choose an icon for the category.

2. **Type Kids' program in the Category Name text box, click the blue cube in the Category Icon list box, then click OK**
 The new category appears at the bottom of the Keyword Tags palette. Now you want to add the photos currently in the Photo Browser to this category.

3. **Click Edit on the menu bar, then click Select All**
 A blue border surrounds each photo, indicating that the photos are selected.

4. **Click and drag the blue cube from the Keyword Tags palette onto one of the selected photos, release the mouse button, then position the pointer over one of the cubes until the screentip Keyword Tag Attached: Kids' program appears**
 The photos have the blue cube icon attached to them, as shown in Figure B-5. Category icons appear next to the star rating.

5. **Click the New button in the Keyword Tags palette, click New Keyword Tag to open the Create Keyword Tag dialog box, type Playing in the Name text box, then click OK**
 Because the Playing keyword tag has not yet been assigned to a photo, the new keyword tag appears with a blank icon beneath the Kids' program in the Keyword Tags palette.

6. **Click a blank area in Photo Browser to deselect the photos (if necessary), press and hold [Ctrl], click girl_playing.jpg, handstand.jpg, and boys_laughing.jpg in Photo Browser, then drag the Playing icon on top of boys_laughing.jpg**
 The photo to where you dragged the icon appears as the icon in the Keyword Tags palette. Because the Playing keyword tag is a subset of the Kids' program category, the new keyword tag icon is not visible next to the photos in Thumbnail View. You can view photos based on their keyword tag.

7. **Click the blank square next to the Playing keyword tag in the Keyword Tags palette**
 A binoculars icon appears in the square, indicating the keyword tag is being used to find photos, and the three tagged photos appear in Photo Browser. See Figure B-6.

8. **Click the Playing square again in the Keyword Tags palette**
 All the photos in the Kids' program category reappear in the Photo Browser.

FIGURE B-4: Create Category dialog box

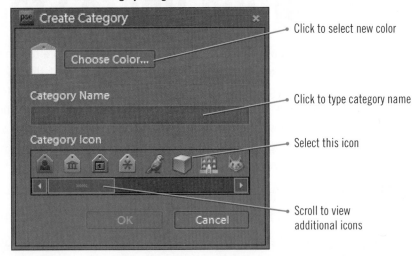

Click to select new color

Click to type category name

Select this icon

Scroll to view additional icons

FIGURE B-5: Viewing new keyword tag

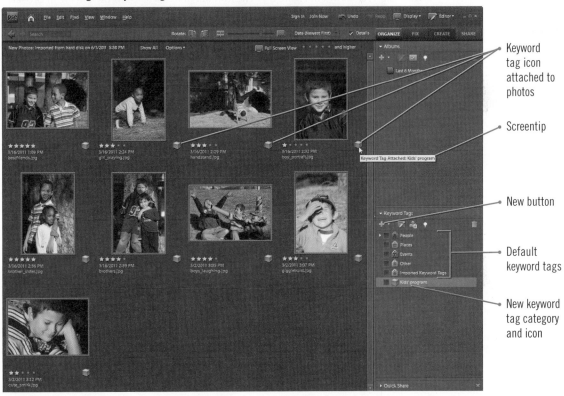

Keyword tag icon attached to photos

Screentip

New button

Default keyword tags

New keyword tag category and icon

FIGURE B-6: Viewing photos by keyword tag

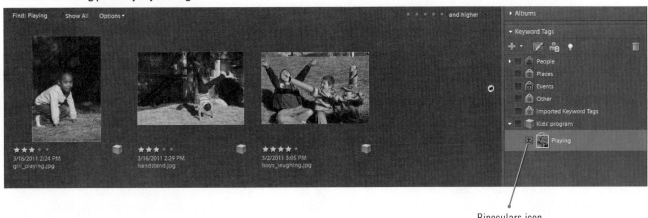

Binoculars icon

Creating Photo Stacks

A **stack** is a group of related photos that you want to store together, such as a set of shots of the same image. Unlike keyword tags, stacking alters your view of the photos; they appear grouped in Photo Browser, although you can easily unstack them. You can stack photos automatically or manually. Manual stacking allows you to stack visually unrelated photos. Automatic stacking occurs when Photoshop Elements suggests stacks based on their visual similarity, such as a series of photos taken one right after another or under different exposure settings. ████████ Vera will be working with dozens of photos. You manually stack related photos to make the collection easier to work with.

STEPS

1. **Press and hold [Ctrl], then click boy_portrait.jpg and cute_smirk.jpg**

QUICK TIP

You can also right-click selected photos, then click Stack to access the Stack menu.

2. **Click Edit on the menu bar, click Stack, then click Stack Selected Photos**

 The photos are stacked and the Stack icon 🖼 appears on top of boy_portrait.jpg, while cute_smirk.jpg is no longer visible, as shown in Figure B-7. The number of items listed in the catalog in the status bar is now eight.

3. **Click the Expand stack icon ▶ next to the stack thumbnail, then drag the Adjust size of thumbnail slider ▌ until your Photo Browser resembles Figure B-8**

 Both photos in the stack are visible. When a stack is expanded, the catalog includes all the photos in the stack in its count. When a stack is collapsed, only one photo is included in the count.

QUICK TIP

You can place stacks on Yahoo! Maps in Organizer.

4. **Click the Collapse stack icon ◀ next to the stack thumbnail**

 The stack is collapsed.

Working with stacks

You can easily modify stacks as needed. When you create a stack, by default, the newest photo in the selection is shown on top. To select a different photo as the top photo, expand the stack, select the photo you want to be on top, click Edit on the menu bar, click Stack, then click Set as Top Photo. To remove a photo from a stack, expand the stack, select the photo you want to remove, click Edit on the menu bar, click Stack, then click Remove Photo from Stack.

Removing a photo from a stack simply unstacks it; it does not remove it from the catalog or from your hard drive. To unstack all photos in a stack, select a photo in a stack, click Edit on the menu bar, click Stack, then click Unstack Photos. In contrast, if you've decided you only want to keep the top photo in the stack and want to delete the rest from the catalog or hard disk, click the Flatten Stack command and then choose the delete options you want.

FIGURE B-7: Viewing a collapsed stack

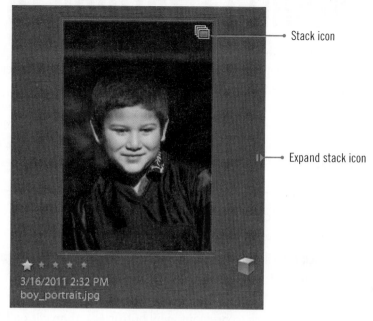

Stack icon

Expand stack icon

3/16/2011 2:32 PM
boy_portrait.jpg

FIGURE B-8: Viewing an expanded stack

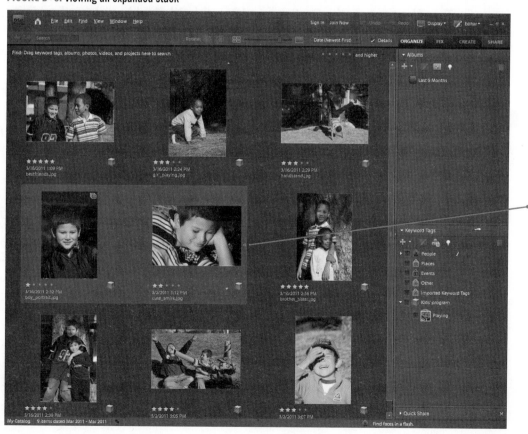

Collapse
stack icon

Adding Captions to Photos

Adding descriptive text known as **captions** to your photos helps to further identify them. Even better, you can personalize your photos with captions and you can edit them as needed. In Photoshop Elements, not only are captions visible when you view file details or the Properties palette in Photo Browser, they become a design element in projects when you build online galleries and other creations. You can add individual captions to each photo or add the same caption to multiple photos. Your captions are limited only by your imagination—they can be up to 2,000 characters long, roughly three times the length of this paragraph. ▓▓▒▒ Vera would like you to add names and other descriptive text to some of the photos.

STEPS

1. **Double-click brother_sister.jpg in Photo Browser**

 The image appears in Single Photo view.

2. **Click the Click here to add caption text box, then type Jaydon and Kayla, as shown in Figure B-9**

 The caption appears beneath the photo.

QUICK TIP

You can also press [Alt]+left arrow to return to the previous view.

3. **Click the Back to previous view button ◀, then click a blank part of the window**

 All photos are visible (except the stacked photo).

QUICK TIP

You can also press [Ctrl][Shift] [T] to open the Add Caption to Selected Items dialog box.

4. **Press and hold [Ctrl], click brothers.jpg and boys_laughing.jpg, click Edit on the menu bar, then click Add Caption to Selected Items**

 The Add Caption to Selected Items dialog box opens.

5. **Type Hermanos in the Caption text box, click OK, double-click brothers.jpg, then press [Page Down] or [Page Up] as necessary to view the other photo**

 The caption appears beneath both photos in Single Photo view. You can also use the scroll bar to view photos in Single Photo view.

6. **Click ◀, then expand the stack you created in the previous lesson, if necessary**

QUICK TIP

Some digital cameras have a built-in caption option that imports captions with the metadata.

7. **Select both photos in the stack, click Edit on the menu bar, click Add Caption to Selected Items, type Reynaldo in the Caption text box in the Add Caption to Selected Items dialog box, then click OK**

 You can edit your captions easily.

8. **Open the Properties palette, click Change Caption in the Properties palette, type Naldo in the Caption text box, click the Replace Existing Captions check box, then click OK**

9. **View the captions for the stacked photos in Single Photo view, then compare your screen to Figure B-10**

 The modified caption appears beneath the photos and in the Properties palette for both photos.

FIGURE B-9: Adding a caption

Type caption here

FIGURE B-10: Viewing a changed caption in a photo stack

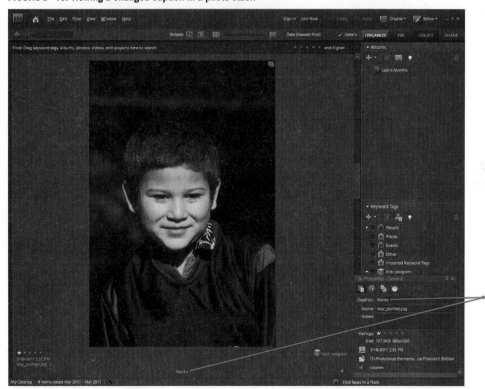

New caption

Adding audio captions

If you have a microphone attached to your computer, you can record an audio caption for any photo. You can also attach an audio file to a photo. To record a caption, prepare your microphone settings, view a photo in Single Photo view, then click the Record Audio Caption button at the bottom of Photo Browser. In the Select Audio File dialog box, click the Record button, record your caption, then click Stop. To attach an audio file, click File on the menu bar in the Select Audio File dialog box, click Browse, navigate to the audio file, then click Open. To play or navigate through the caption, use controls in the dialog box. To delete a caption, open the dialog box, click Edit on the menu, then click Clear.

Creating Albums and Smart Albums

Photoshop Elements allows you to create **albums** in which you can group photos however you wish. You can create a category and then manually select the photos to be associated with that album. For a dynamic and customized collection, you can create a **smart album**. Smart albums are based on criteria, such as filename, keyword tag, Favorites star rating, and so on. You can even create a smart album based on multiple criteria. Smart albums "remember" the criteria on which they're based, so if you create a smart album based on a keyword tag and later assign that keyword tag to other photos, Photoshop Elements automatically adds those photos to the smart album. You can also create an **album group**, which is a high-level album under which you can store other albums. ▰▰▰▰ Vera has asked you to create an album and a smart album using the Kids' Project photos so they'll be organized for a later use, such as posting them online.

STEPS

TROUBLE
You cannot use the same word or phrase for a keyword tag and an album.

1. **View all the photos in the catalog, click a blank part of the document window to deselect photos, then close the Properties palette**

2. **Click the New button ▦ ▾ in the Albums palette, then click New Album**
 The Album Details palette opens, as shown in Figure B-11.

QUICK TIP
To delete a photo from an album, right-click the album icon next to the photo, then click the Remove command for the desired album.

3. **Type Top Kid Faces in the Album Name text box, then click the Backup/Synchronize check box to deselect it, if this option is available**
 You can drag photos from the catalog to the Items preview pane.

4. **Press and hold [Ctrl], click brother_sister.jpg, brothers.jpg, and giggleburst.jpg, then drag the selected photos to the Items preview pane in the Albums Details palette**
 Thumbnails of the selected photos appear in the Items preview pane. You can add or subtract photos using the Add items selected in Photo Browser button ▦ and the Remove selected items button ▬.

5. **Click Done**
 An album icon ▦ appears beneath the photos next to the keyword tag icon.

6. **Click the Top Kid Faces icon in the Albums palette**
 The photos belonging to the album appear in Photo Browser. A binoculars icon ▦ appears next to the album icon, indicating the album being used to find photos. Photos are numbered when viewed in an album, as shown in Figure B-12. If you view all photos by both album and keyword tag, they appear with a check mark.

7. **Click the Top Kid Faces icon in the Albums palette to deselect it, click ▦ ▾ in the Albums palette, then click New Smart Album**
 The New Smart Album dialog box opens.

8. **Type Kids in Action in the Name text box, click the first criteria box list arrow, click Keyword Tags, click the Include list arrow, then click Playing**
 Your New Smart Album dialog box should look like the one shown in Figure B-13. Depending on the first criteria field you select, the specific options available from the Include list box vary. You can add multiple search criteria by clicking the Add additional criteria for this search button ▦. Icons for smart albums do not appear next to photos. You automatically add a photo to the smart album by assigning it the Playing keyword tag.

QUICK TIP
To edit an album or album group, select an album, click the Edit button ▦ in the Albums palette, make the desired changes, then click OK.

9. **Click OK, click the Show All button, drag giggleburst.jpg to the Playing keyword tag in the Keyword Tags palette, then click the Kids in Action icon in the Albums palette**
 The album updates automatically to include giggleburst.jpg, to which the keyword tag, Playing, was just added. This photo is now linked to both the Kids in Action smart album and the Top Kid Faces albums.

FIGURE B-11: Album Details palette

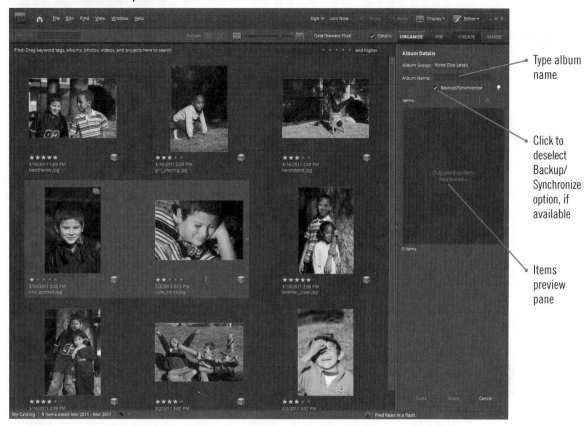

Type album name

Click to deselect Backup/ Synchronize option, if available

Items preview pane

FIGURE B-12: Viewing photos in an album

Numbered photos in album

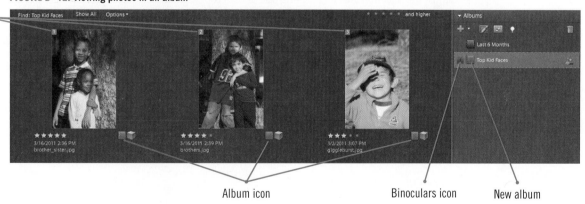

Album icon Binoculars icon New album

FIGURE B-13: New Smart Album dialog box

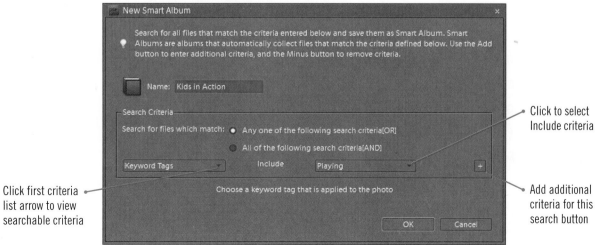

Click to select Include criteria

Click first criteria list arrow to view searchable criteria

Add additional criteria for this search button

Fixing a File in Organizer

You can use tools on the **Fix tab** of the Task Pane in Organizer to correct common or simple problems in photos. Organizer automatically saves a copy of the edited file with a distinct name, thus preserving the original. ░░░░ You will use the auto fix features in Organizer to edit a few of the images you have collected for the youth program Web site.

STEPS

1. **Double-click giggleburst.jpg, then click the Fix tab in the Task Pane**

 Fix tools, which you can use to apply automatic fixes to photos, and links to the Editor appear on the Fix tab. Table B-1 describes the function of each tool. When you click one of these Fix tools, Photoshop Elements automatically applies the associated correction to the selected photo. You cannot adjust how or how much a tool corrects an image.

QUICK TIP

Groupings of original and edited copies are known as version sets, which you'll learn about in the next lesson.

2. **Click the Auto Smart Fix button on the Fix tab**

 The Auto Smart Fix dialog box appears, displaying the progress of the correction process, and closes when the corrections are finished. The colors in the image are a bit more vibrant, as shown in Figure B-14. The new filename is giggleburst_edited-1.jpg, and the Version Set icon 🖼 appears on top of the photo.

TROUBLE

If necessary, drag the Adjust size of thumbnail slider ▮ to view all the photos in the catalog.

3. **Click the Show All button, then double-click brothers.jpg**

 Vera suggested cropping this photo. The Crop tool lets you crop, or remove, the unwanted portions of an image.

4. **Click the Crop button on the Fix tab**

 The Crop Photo dialog box opens. You initially define the area to be cropped by creating a **bounding box**, a selection area that defines the part of the image that will remain after you complete the crop. You can adjust the selection area by dragging one of the cropping handles that appear on the sides and corners of the bounding box, or by selecting a preset size from the Aspect Ratio list box.

QUICK TIP

You can also click the Apply button or press [Enter] to accept changes.

5. **Drag the handles of the bounding box until your bounding box resembles Figure B-15**

6. **Click the Commit button ✔ at the bottom of the bounding box to crop the photo**

 Now compare the original and cropped photos.

7. **Click the View list arrow in the Crop Photo dialog box, then click Before and After**

 The uncropped original and edited cropped photos appear side-by-side, as shown in Figure B-16. To reset the bounding box to its default size, click the Cancel button 🚫 or click the Undo button in the Crop Photo dialog box.

8. **Click OK**

TABLE B-1: Fix tab tools

button	fix
Auto Smart Fix	Color, contrast, lighting
Auto Color	Color balance and contrast
Auto Levels	Tonal distribution and color density
Auto Contrast	Difference between the lightest and darkest areas
Auto Sharpen	Alter color and contrast to make them more distinct
Auto Red Eye Fix	Find and eliminate red pixels in eyes
Crop	Removes pixels from an image

FIGURE B-14: Auto Smart Fix applied to photo

Fix tab

Version Set icon

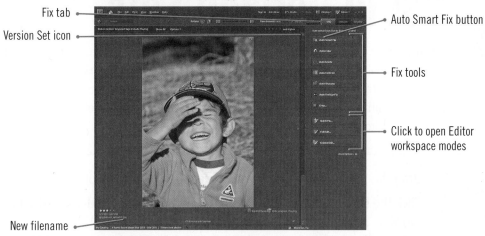

Auto Smart Fix button

Fix tools

Click to open Editor workspace modes

New filename

FIGURE B-15: Adjusting bounding box in Crop Photo dialog box

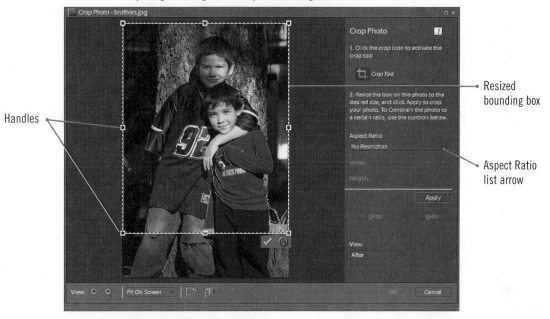

Handles

Resized bounding box

Aspect Ratio list arrow

FIGURE B-16: Viewing Before and After versions

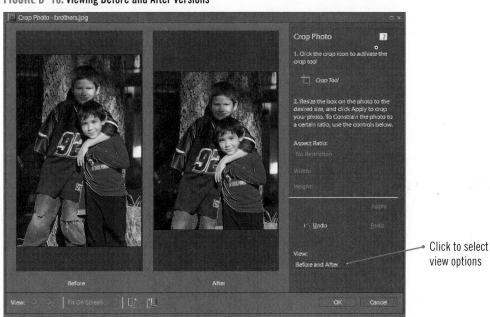

Click to select view options

Using Version Sets

When you edit a photo in Organizer, Photoshop Elements automatically creates a copy of the edited file and stacks it with the original. This linked collection is known as a **version set**. A version set operates like a stack in Photo Browser: the most recently edited file is on top of the stack. ▨▨▨ Having edited a couple of the youth program photos, you want to explore how version sets work and create other edited versions of a photo.

QUICK TIP

You can change the order of photos in a version set the same way you change the photo order in a stack.

TROUBLE

If you delete photos from a catalog, Photoshop Elements does not always reassign albums and keyword tags to those photos if you reimport them.

1. **Drag the Adjust size of thumbnail slider ▨ to display all photos**

2. **Click the Expand stack icon ▨ next to gigggleburst_edited-1.jpg, then drag ▨ until you can view both photos side-by-side**

 A Version Set icon ▨ appears in the upper-right corner of the image that is the top photo in the stack, as shown in Figure B-17. In this case, the version set contains the original gigggleburst.jpg file and the gigggleburst_edited-1.jpg file. Unlike stacks, edited versions are included in the catalog photo count.

3. **Click gigggleburst.jpg, click the Auto Levels button ▨ on the Fix tab, then adjust the thumbnail size so that the original and two versions are visible, if necessary**

 An edited copy, gigggleburst_edited-2.jpg, appears brighter in Photo Browser, as shown in Figure B-18. **Auto Levels** modifies the contrast and color in images where the colors appear incorrect or where the image has a **color cast**. A color cast occurs when one color appears dominant as a wash or tint all through the image. The most recently edited file has the highest number at the end of the filename and is on top of the version set. This fix does not offer an improvement over the first edit, so you delete it from the version set and from your computer.

4. **Verify that gigggleburst_edited-2.jpg is still selected, press [Delete] to open the Confirm Deletion from Catalog dialog box, click the Also delete selected item(s) from the hard disk check box, then click OK**

 The version is deleted from the catalog and the computer. To modify version sets, select a photo in the version set, click Edit on the menu bar, click Version Set, then select an option from the list. Table B-2 lists the options associated with version sets.

TABLE B-2: Version set options

command	use
Expand Items in Version Set	Makes all versions visible
Collapse Items in Version Set	Makes only the top photo visible
Flatten Version Set	Deletes all photos except the top photo
Convert Version Set to Individual Items	Unstacks version set to individual photos
Revert to Original	Deletes all photos except original
Remove Item(s) from Version Set	Removes selected photos and makes them individual photos
Set as Top Item	Moves selected photo to top of version set

FIGURE B-17: Viewing a version set

Version Set icon

FIGURE B-18: Comparing Auto Levels version to original

Original

Versions

Searching for Photos

After you rate, tag, categorize, stack, and modify your photos, you need to be able to find them. Photoshop Elements provides a multitude of ways to find photos and other files. You can use commands on the Find menu to search for photos quickly and efficiently. For example, you can search by date, caption or note, filename, version set, stack, history (such as when a photo was imported, printed, or emailed), media type, metadata, and even by photos that match the color and tone of a selected image. You can also search using the Timeline or Date View, displaying folders, using a keyword tag, or by locating photos you've pinned to a map. ▓▓▓▓ Vera will need to locate photos for the youth program Web pages quickly. You show her the various methods of finding the youth program photos in the catalog.

STEPS

QUICK TIP

You can also press [Ctrl][Alt][V] to find photos by All Version Sets.

1. **Click Find on the menu bar, click All Version Sets, then compare your Photo Browser to Figure B-20**

 The version sets for the original files two brothers.jpg and giggleburst.jpg appear in Photo Browser.

2. **Click the Show All button, click Find on the menu bar, then click All Stacks**

 The stacked photos appear collapsed in Photo Browser.

3. **Click the Show All button, click Find on the menu bar, then click Items not in any Album**

 The five photos not assigned to an album appear, as shown in Figure B-21.

4. **Click the Show All button, then exit Photoshop Elements**

Viewing photos in Map view

In Organizer, you can choose how you want to sort and view your photos, such as by date or keyword. You can also pin photos to a Yahoo! map to identify them by where they were taken. To open Map view, click Display on the menu bar, then click Show Map. To pin photos to a specific location, select the photos you want, zoom in to an area on the map, then drag the photos to the location. Each pin represents one or more photos.

To view a photo, click the pin. To move a pin, click the Move button ▓▓, then drag a pin to the new location. Figure B-19 shows Map view in the Organizer workspace. You can view a map as a street map, aerial satellite, or hybrid.

After your map of photos is complete, you can share it by posting it on the Web or by storing it on a CD by clicking the Share button and then following the instructions.

FIGURE B-19: Map view in Organizer

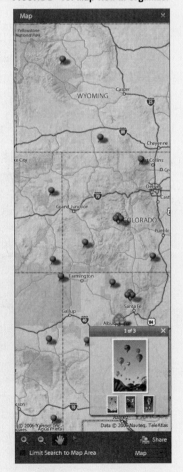

FIGURE B-20: Find results of photos based on version sets

Find menu

Find criteria

FIGURE B-21: Viewing Find results of photos not in any album

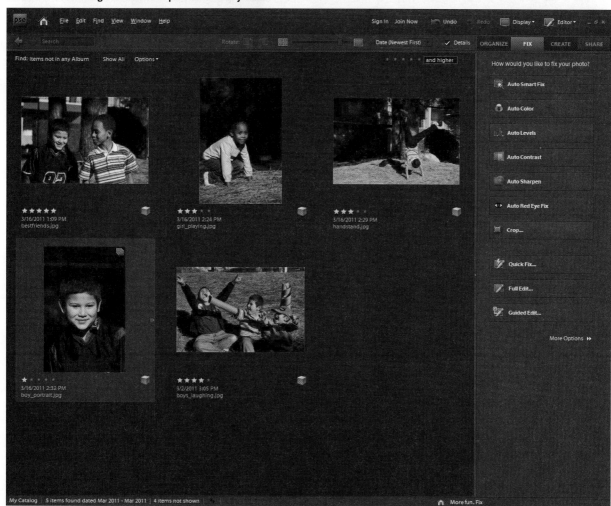

Using face tagging

Face tagging is a Photoshop Elements feature that automatically searches photos in the catalog that contain faces—not specific faces, just images that contain elements of a human face. Photoshop Elements face tagging may discern a face in a painting or other art, but most likely not your pet in a costume. Once identified, you can click a face thumbnail and tag the face with a keyword tag by dragging the photo or the tag. To use the Find Faces feature, click the Find Faces for Tagging button in the Keyword Tags palette, or click Find Faces for Tagging on the Find menu, click the faces you want to tag in the Face Tagging dialog box, then click Done.

Photoshop Elements 7

Practice

▼ CONCEPTS REVIEW

Label the elements of the Organizer workspace shown in Figure B-22.

FIGURE B-22

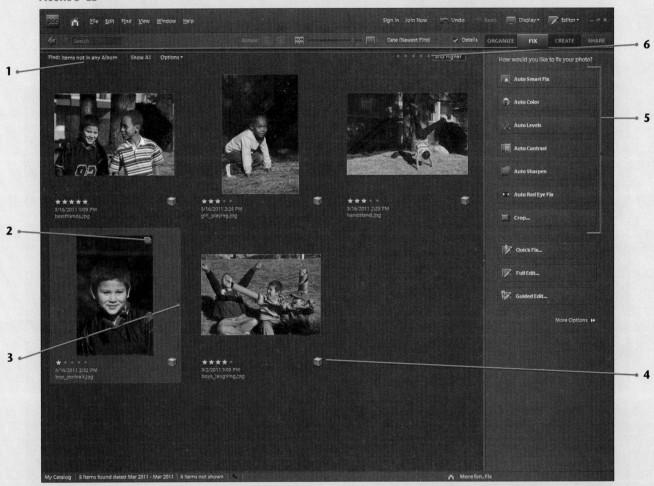

Match each term with the statement that best describes it.

7. Stack a. Contains tools for fixing common problems in photos

8. Handles b. A group of related photos stored collectively

9. Keyword tag c. Viewing photos based on certain criteria

10. Version set d. A word or phrase attached to photos

11. Fix tab e. Descriptive text used to identify and customize a photo

12. Filter f. A way to virtually store photos

13. Caption g. Used to adjust the size of the Crop tool bounding box

14. Album h. A collection of an original photo and its edited versions

Select the best answer from the list of choices.

15. **Which feature adds to the count of the catalog only when expanded?**
 a. Version sets
 b. Albums
 c. Stacks
 d. Keyword tags

16. **Which feature automatically adds photos to its collection?**
 a. Keyword tags
 b. Star ratings
 c. Stacks
 d. Albums

17. **Which of the following is true about face tagging?**
 a. The faces are automatically stacked
 b. Photoshop Elements can tag any photo that includes a face
 c. It becomes part of a version set
 d. You can identify the faces you want to search for

18. **Which of the following is *not* true about smart albums?**
 a. You can create one by setting specific criteria
 b. You cannot select a custom icon
 c. Photos can be in multiple smart albums
 d. You must manually add photos to it

19. **If a filename includes the text "-edited-3", what does that tell you about that file?**
 a. It has three stars
 b. It is the third edited version of a photo
 c. It is third in the stack
 d. It is the original

20. **Where can you add a caption to a photo?**
 a. In Single Photo view and in the Properties palette
 b. Only in Single Photo view
 c. Only in the Properties palette
 d. In any Thumbnail view and in the Properties palette

▼ SKILLS REVIEW

1. **Rate and filter photos.**
 a. Start Photoshop Elements.
 b. Import photos in the Fruit folder from the location where you store your Data Files.
 c. Keeping all photos visible in the Photo Browser, rate the photos shown below:
 - 5 stars: papayas.jpg
 - 4 stars: seedless_grapes.jpg
 - 3 stars: oranges.jpg, plums.jpg
 - 2 stars: red_grapes.jpg, longans.jpg
 - 1 star: blackberries.jpg
 d. Filter the photos so that only photos with two stars are visible.
 e. Show all photos.

2. **Assign keyword tags.**
 a. Click the New button in the Keyword Tags palette, create a new category named **USDA**, select the sun icon as the Category icon, then create the keyword tag.
 b. Select all photos, then attach the USDA keyword tag to the photos.
 c. Create a new keyword tag named **Grapes** in the USDA keyword tag category.
 d. Attach the keyword tag to the two photos with "grapes" in the filename.
 e. Show photos with the Grapes keyword tag, then show photos with the USDA keyword tag.
 f. Create a new keyword subcategory named **Yellows and Oranges** in the USDA keyword tag category, then attach this keyword tag to oranges.jpg, longans.jpg, and papayas.jpg.
 g. Show photos with the Yellows and Oranges keyword tag.
 h. Show photos with the USDA keyword tag.

3. **Create photo stacks.**
 a. Stack the grape photos, making seedless-grapes.jpg the top photo on the stack.
 b. Expand and then collapse the stack.

4. Add captions to photos.

 a. Show longans.jpg in Single Photo view, then add the caption **Longan – cousin to the Lychee**.

 b. Show all photos, then add the caption **Fight free radicals** to the photos in the grapes stack. (*Hint*: Use a command on the Edit menu.)

 c. Modify the captions to read **Helps fight free radicals**.

5. Create albums and smart albums.

 a. Create a new album group named **Fruit**.

 b. Create a new album in the Fruit album group named **Cut Fruit**.

 c. Add oranges.jpg and papayas.jpg to the Cut Fruit album and deselect Backup/Synchronize.

 d. Create a new smart album named **Grapes** where the filename contains the word "grape."

6. Fix a file in Organizer.

 a. Show all photos, then close the Properties palette.

 b. Show longans.jpg in Single Photo view, then apply the Auto Levels fix.

 c. Show papayas.jpg in Single Photo view, then crop the photo so that none of the top violet material appears.

 d. View the before and after versions of the image.

7. Use version sets.

 a. Show papayas.jpg in Single Photo view.

 b. Crop the photo so that just the sliced papayas are visible.

 c. Delete papayas_edited-2.jpg from the catalog and your computer.

8. Search for photos.

 a. Show all fruit photos.

 b. Use a command on the Find menu to find photos by caption or note using the word **fight**. (*Hint*: Select the Match any part of any word in the Captions and Notes option in the Find by Caption or Note dialog box.)

 c. Show all fruit photos.

 d. Use a command on the Find menu to find photos not in any album.

 e. Show the Organize tab, show all fruit photos, expand stacks and version sets, then compare your screen to Figure B-23.

 f. Exit Photoshop Elements.

FIGURE B-23

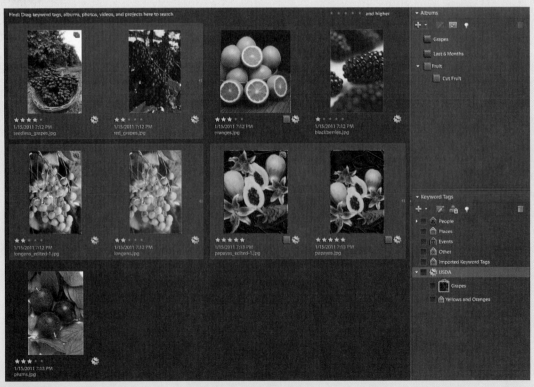

▼ INDEPENDENT CHALLENGE 1

A friend of yours is going to sell pumpkins and gourds at the local outdoor market in the fall. You're helping collect and organize various photos for his brochure.

a. Start Photoshop Elements, then open the Organizer workspace.

b. Import photos in the Squash folder from the location where you store your Data Files.

c. Create a new keyword tag category named **Squash-Gourds-Pumpkins** with the orange sphere icon, then attach the keyword tag to all photos.

d. Rate the photos as follows:
 - 5 stars: assorted_squash.jpg
 - 3 stars: pumpkin_stein.jpg, gourds.jpg, hidden_pumpkin.jpg
 - 2 stars: carvedsmile_pumpkin.jpg, striped.jpg

e. Create a new keyword tag subcategory named **Multiples** and attach it to all the photos showing more than one gourd or squash.

f. Create a new keyword tag in the Squash-Gourds-Pumpkins category named **Carved** and attach it to the two carved pumpkins photos.

g. Find photos with the Carved keyword tag, find photos with the word "pumpkin" in their filenames, then display all photos.

h. Apply the Auto Contrast fix to striped.jpg.

i. Find photos with the Squash-Gourds-Pumpkins keyword tag.

j. Expand the version set, then compare your screen to Figure B-24.

k. Exit Photoshop Elements.

FIGURE B-24

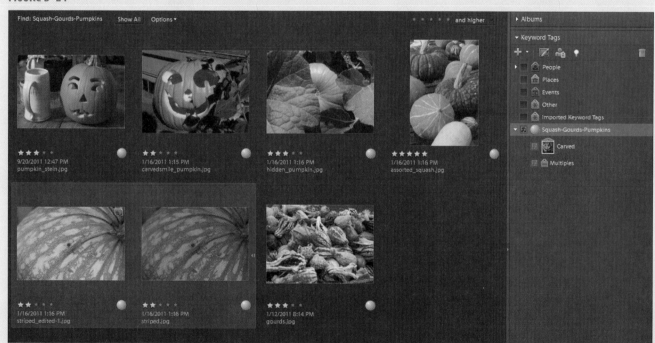

▼ INDEPENDENT CHALLENGE 2

Your company just announced plans to build a new outdoor seating area for breaks and lunchtime. Employees are encouraged to participate in the design, so you volunteered to research benches. You begin by compiling, editing, and organizing some photos.

 a. Start Photoshop Elements, then open the Organizer workspace.

 b. Import photos in the Benches folder from the location where you store your Data Files.

 c. Rate the photos as desired.

 d. Create a keyword tag category named **Benches** with the bird icon and attach it to each photo.

 e. Create a keyword tag under Benches named **Wooden** and attach it to custom_wooden.jpg, classic_funky.jpg, and modern.jpg.

 f. Create two edited versions of classic_funky.jpg by cropping off the bottom of the image in the first one and by cropping off the left side and grass in the second.

 g. Stack contemporary.jpg and slab.jpg, then make slab.jpg the top photo in the stack. (*Hint*: Use a command on the Stack menu on the Edit menu.)

 h. Find photos with the Benches keyword tag, then create a smart album using that search criteria named **Outdoor Break Area**. (*Hint*: Use a command when you click the New button in the Albums palette.)

 i. Find the photos by smart album, expand the stack and version set, then compare your screen with the sample shown in Figure B-25.

FIGURE B-25

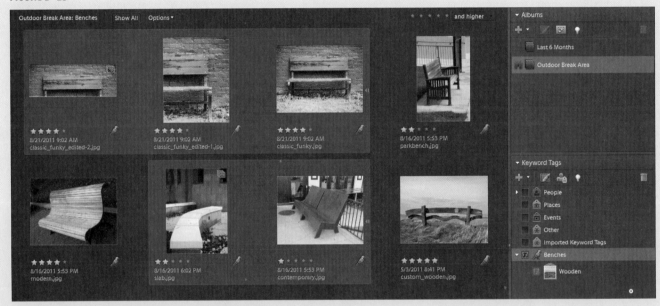

Advanced Challenge Exercise

 ■ Create two edited versions of custom_wooden.jpg by applying the Auto Levels tool and the Auto Smart Fix tool.

 ■ Add the caption of your choice to multiple photos, then find photos by caption.

 j. Exit Photoshop Elements.

▼ INDEPENDENT CHALLENGE 3

You want to renovate your home office and decide to ask a friend for ideas. She suggests building a wall out of glass blocks. You are not familiar with glass block. To get used to being around glass, you organize photos of glass walls to use as a screensaver.

a. Start Photoshop Elements, then open the Organizer workspace.

b. Import photos in the GlassBrick folder from the location where you store your Data Files. You can also use additional images of your own. You can take your own photos or obtain images from your computer, scanned media, or from the Internet. When downloading from the Internet, you should always assume the work is protected by copyright. Be sure to check the Web site's terms of use to determine if you can use the work for educational, personal, or noncommercial purposes.

c. Rate the photos as desired, then find photos with only one, specific star rating.

d. Create a keyword tag category named **Glass Block** with the icon of your choice and attach it to each photo.

e. Create at least one additional keyword tag of your choice and attach it to relevant photos.

f. Create an album group named **Glass**.

g. Create an album named **Block** in the album group and attach it to relevant photos.

h. Add a caption to multiple photos, then modify two or more captions.

i. Stack photos as desired.

Advanced Challenge Exercise

- Apply a fix to a photo, then apply a different fix to the edited version.
- Unstack photos from a version set.

j. Exit Photoshop Elements.

▼ REAL LIFE INDEPENDENT CHALLENGE

It is easy to feel overwhelmed by the number of digital photos in your Organizer catalog. With a little practice, arranging and organizing photos in Photoshop Elements will become second nature. You can hone theses skills by working with a small collection of your photos.

a. Start Photoshop Elements and open the Organizer workspace.

b. Import at least six photos. You can take your own photos or obtain images from your computer, scanned media, or from the Internet. When downloading from the Internet, you should always assume the work is protected by copyright. Be sure to check the Web site's terms of use to determine if you can use the work for educational, personal, or noncommercial purposes.

c. Rate photos as desired.

d. Create a keyword tag category and a keyword tag subcategory or keyword tag and attach it to the photos.

e. Create a smart album for two or more photos.

f. Stack photos as desired.

g. Add captions as desired.

h. Expand and collapse stacks.

i. Exit Photoshop Elements.

▼ VISUAL WORKSHOP

Organizing photos helps you maximize flexibility and efficiency when working with your photos. The drag-and-drop functionality in Organizer makes this quick and easy. Start Photoshop Elements, then create the keyword tags and albums shown in Figure B-26. When you are finished, press [Print Screen], paste the image into a word-processing program, add your name at the top of the document, print the document, close the word processor without saving changes, then exit Photoshop Elements. (*Hint*: Remove the keyword tags and albums you've already attached to these photos.)

FIGURE B-26

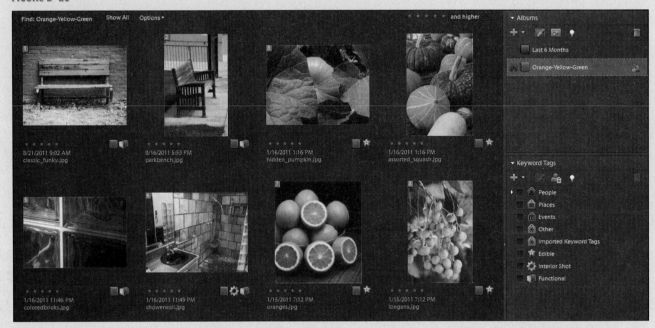

Fixing Images Automatically in the Editor

Photoshop Elements includes a variety of tools you can use to improve your images. In the Editor workspace, both Guided Edit and Quick Fix modes allow you to make automatic image fixes. For example, you can fix general aspects of a photo or view and correct a little detail you want to fix, such as red eye. But these automatic corrections may not always improve the image in the way you'd hoped. Fortunately, after applying an auto fix you can also adjust the settings manually using other modes in the Editor workspace. Great Leap Digital is preparing a proposal to install relaxing wall art for the Straight to the Point Acupuncture Clinic. Your manager, Wen-Lin, has posted some images on the Great Leap Digital server and asks you to fix them quickly so she can use them in her proposal.

OBJECTIVES

Use Guided Edit tools

Fix a photo in Quick Fix

Use view tools

Fix red eye

Get an image from a video frame

Understand resolution

Crop, undo, and redo

Save a file in a different format

Print a photo

Using Guided Edit Tools

Guided Edit is the most structured of the Editor workspace modes. Here you can perform a variety of image fixes with step-by-step instruction to guide you. Many options allow you to tweak the results. Best of all, you can always click the **Reset button** to start over. One of the photos Wen-Lin wants to use in the waiting room may have too deep a shadow to be fully appreciated. You use Guided Edit exposure tools to lighten the shadows.

STEPS

1. **Start Photoshop Elements, then click the Edit icon**
 The Editor workspace opens in Full Edit mode. In the Editor, you open and close files as you work with them.

> **QUICK TIP**
> You can also open a file by pressing [Ctrl] [O].

2. **Click File on the menu bar, click Open, then navigate to the location where you store your Data Files**
 The Open dialog box opens and the list of available files appears in the file list, as shown in Figure C-1. Opening a file in the Editor gives you access to the full range of Photoshop Elements tools and features.

3. **Click PSE C-1.jpg, then click Open**
 The photo opens in the Full Edit **document window**, which is the space in the Editor where the active image displays. You want to preserve the original photo before fixing it in the Editor, so it is good practice to first make a duplicate of the file before editing it.

> **QUICK TIP**
> By default, Photoshop Elements adds the image to the Organizer catalog.

4. **Click File on the menu bar, click Save As to open the Save As dialog box, type thrasher-cactus in the File name text box, click Save, then click OK in the JPEG Options dialog box**
 The file is saved with a new name.

5. **Click the Guided Edit button on the Edit tab of the Task Pane**
 Guided Edit opens, where you can select several common fixes in the Task Pane. See Figure C-2.

6. **Under Color Correction in the Task Pane, click Enhance Colors**
 The Enhance Colors options appear in the Task Pane.

> **QUICK TIP**
> To undo the edit, click the Reset button.

7. **Click the Auto button, compare your screen to Figure C-3, then click Done**
 The colors in the photo are significantly enhanced, and the Guided Edit options reappear in the Task Pane.

> **QUICK TIP**
> You can also close a file by pressing [Ctrl] [W].

8. **Click File on the menu bar, click Close, then click Yes in the Editor — Photoshop Elements 7 dialog box to save the changes to the photo**
 The file closes.

Setting preferences

Photoshop Elements preferences allow you to change many of the default program settings to suit the way you like to work. For example, you can select the e-mail client to use when you e-mail photos, or you can adjust the contrast of the gray-colored background of the Photoshop Elements interface. The preferences you can change vary depending on whether you are working in the Editor or in the Organizer. When working in the Editor, you can change settings related to the appearance of type, transparency, and other on-screen elements; how units of measure are displayed; how Photoshop Elements manages computer resources such as memory and RAM; where files are saved by default; and more. To change a preference, click Edit on the menu bar, point to Preferences, then click a topic in the list. For example, to change the number of recently opened files that appear on the File menu, click Saving Files, then type a number in the Recent file list contains text box.

FIGURE C-1: Open dialog box

Your icons might differ

Your details might differ

Click to open selected file

FIGURE C-2: Viewing Guided Edit mode

Guided Edit button

Guided Edit options

FIGURE C-3: Enhance Colors Guided Edit applied to image

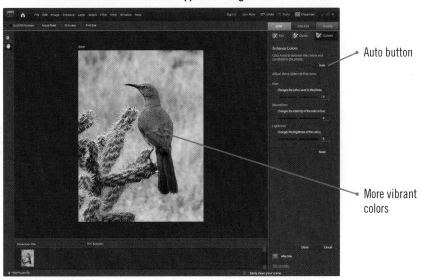

Auto button

More vibrant colors

Photoshop Elements 7

Fixing a Photo in Quick Fix

The options in Quick Fix give you more control over how you can refine your images. Quick Fix has auto fix options, and it also allows you to adjust the settings. Being able to modify automatic adjustments has obvious advantages. Sometimes you may want to tweak the settings a bit or experiment with them so you can become adept at quickly improving recurring flaws. ██████ Wen-Lin has selected a photo of a Japanese garden to be used in one of the examination rooms in the clinic. She asks you to edit the photo to minimize the effects of the shadows in it.

STEPS

1. **Click the Quick Fix button** 🔳Quick **on the Edit tab**

2. **Open the file PSE C-2.jpg from the location where you store your Data Files, then save it as japanese_garden using default JPEG settings**

 The photo opens in the Quick Fix document window, as shown in Figure C-4. In Quick Fix, you can adjust settings before or after applying an automatic improvement and compare the changes to the original image.

3. **Click the View list arrow at the bottom of the document window, then click Before & After — Horizontal**

 Before and after views of the photo appear side-by-side. The two images are identical at this point because you haven't made any changes yet. You begin fixing the shadows in the image using Smart Fix.

4. **In the General Fixes palette, click the Smart Fix Auto button**

 The auto Smart Fix settings are applied to the image on the right, the After image. Smart Fix addresses the most common problems associated with photos; you can adjust the amount of Smart Fix applied to the image.

5. **Drag the Amount slider ▮ to the third hash mark, then compare your screen to Figure C-5**

 Additional adjustments are made to the image, but you must manually accept (commit) or reject (cancel) the changes. This setting overcorrects the brightness, so you cancel the fix.

6. **Click the Cancel button 🔳 in the General Fixes palette, then click the Reset button in the document window**

 The settings first revert to the auto settings level and then back to the original image. Clicking the Reset button removes any fixes you've applied to the image. Instead of tweaking Smart Fix settings, you decide to just lighten the shadows.

7. **In the Lighting palette, drag the Lighten Shadows slider ▮ to the first hash mark, then click the Commit button ✔**

 The shadows are lightened.

8. **Click the View list arrow, click After Only, then compare your screen to Figure C-6**

9. **Click File on the menu bar, then click Save to save the changes to the file**

FIGURE C-4: Viewing Quick Fix mode

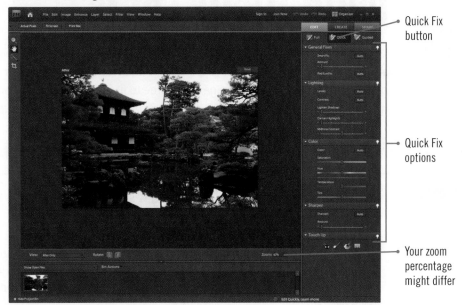

Quick Fix button

Quick Fix options

Your zoom percentage might differ

FIGURE C-5: Viewing before and after changes

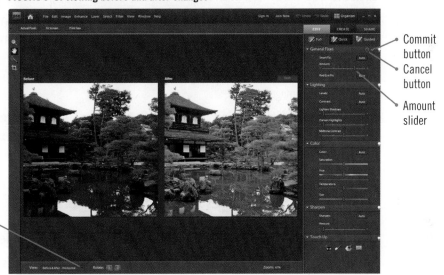

Commit button

Cancel button

Amount slider

Click to change view

FIGURE C-6: Viewing lighten shadows fix

Fixing Images Automatically in the Editor

Using View Tools

When working in the Editor, you may often need to adjust your view of an image. You can use the **Zoom Tool** to zoom in or out of the image. You can use the **Hand Tool** to move a particular part of a large or magnified image into view if the image is too large to fit completely in the workspace. Neither tool affects the pixels in your image; they simply allow you to manipulate your view in the document window. You can also adjust the magnification of an image by using buttons on the Options bar. You want to examine the garden image more closely for picture quality.

STEPS

QUICK TIP
You can also press [Ctrl] [0] (zero) to fit the image on screen.

1. **Verify that the file japanese_garden.jpg is still open in Quick Fix, then click the Fit Screen button on the Options bar**

 Depending on your monitor size, the image fills the document window, as shown in Figure C-7. Other view options include Actual Pixels, which shows the image in its actual size as viewed on the Web, and Print Size, which is an approximation by Photoshop Elements of your actual print size. The size and resolution of your monitor affect what you see on screen. The Options bar is tool-specific; the buttons change based on which tool is selected.

2. **Click the Zoom Tool in the toolbox, if it is not already selected**

QUICK TIP
You can set the Zoom pointer by clicking the Zoom In or Zoom Out buttons on the Options bar.

3. **Position the Zoom In pointer in the middle of the pagoda, which is the building in the picture, then click the image until 200% appears in the Zoom text box at the bottom of the document window**

 The pagoda fills the document window. The plus sign in indicates that you are zooming in, or enlarging your view of the image.

4. **Press and hold [Alt], position the Zoom Out pointer anywhere in the image, then click the image until approximately 67% appears in the Zoom text box**

 The view is reduced. The minus sign in indicates that you are zooming out, or reducing your view of the image.

5. **Click the middle of the pond until 300% appears in the Zoom text box**

 The view is enlarged.

QUICK TIP
You can access at any time by pressing [Spacebar].

6. **Click the Hand Tool in the toolbox, then position in the top-left corner of the window**

7. **Drag to the bottom-right until the top of the pagoda appears in the window**

 You can drag as often as necessary to view the desired portion of the image, as shown in Figure C-8.

8. **Click File on the menu bar, then click Close**

 The file closes. Because you simply viewed different areas of the image without making any changes to it, there are no changes to save.

Fixing Images Automatically in the Editor

FIGURE C-7: **Viewing the image to fit on the screen**

Fit Screen button

FIGURE C-8: **Using the Hand Tool**

Drag to pan over the image

Magnifying your zoom options

You can adjust the magnification of any area in the document window. To change magnification to a specific percentage, type a number in the Zoom text box. You can set magnification between 0% and 3200%. To zoom in or out while another tool is already selected, press [Ctrl][Spacebar], then click the image to zoom in; you can switch to zoom out 🔍 by pressing [Alt][Spacebar], but only when 🔍 is active. You can double-click the Zoom Tool in the toolbox to return to 100% magnification, or double-click the Hand Tool in the toolbox to fit the image on the screen. To magnify just a portion of the image you're working on, click the Zoom Tool, then click and drag to draw a marquee around a part of the image in the window, as shown in Figure C-9.

FIGURE C-9: **Creating a zoom marquee**

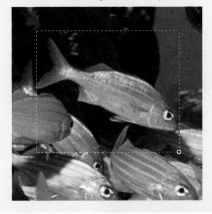

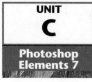
Fixing Red Eye

One common flaw of flash photography is red eye, an unnatural reddish glow in your subject's eyes. In a previous unit you saw how red eye can be corrected automatically when an image is imported into Photoshop Elements. You can also use the Red Eye Removal Tool to remove the glow and achieve a natural-looking eye. Wen-Lin wants to feature different patient stories in the waiting room, but one of the photos is flawed by red eye. You use the automatic and manual options of the Red Eye Removal Tool to correct the image.

STEPS

1. **Open the file PSE C-3.jpg from the location where you store your Data Files, then save it as focus_story.jpg using default JPEG settings**

 The photo, a picture of a young girl, appears in the document window. Notice the eyes have a red glow, which is the result of the camera flash hitting the subject's retina. The retina has an outer layer of blood vessels which are, of course, red. Because a camera flash occurs faster than our pupils can contract in response, the flash can travel through the opening of the eye all the way to the retina. The red glow is the reflection of the flash off the red surface of the retina.

2. **Click the Full Edit button** ▨ Full **on the Edit tab, maximize the document window if necessary, click the Zoom Tool** 🔍 **in the toolbox, then click** ⊕ **in the image until the girl's eyes fill the document window**

3. **Click the Red Eye Removal Tool** 👁 **in the toolbox, then compare your screen to Figure C-10**

 Options for the Red Eye Removal Tool include **Pupil Size**, which is the ratio between the pupil and the iris, and **Darken Amount**, which is how much "removal" is applied. If you simply use a tool that applies color, such as the Brush Tool to paint over the red, you make all the pixels the same color, which creates a flat and unrealistic effect. Using 👁 replaces the red using a range of black, gray, and brown colors, creating a realistic effect.

4. **Click the Auto button on the Options bar**

 Red eye is removed using default settings. Now compare default removal with manual removal.

5. **Click Edit on the menu bar, then click Undo Red Eye Removal Tool**

 The image reverts to its previous state, with red eye.

6. **Position** + **over the girl's right eye, click once, then repeat for the left eye**

7. **Click** 🔍 **in the toolbox, then click the Fit Screen button on the Options bar**

 The girl's eyes appear natural in the photo, as shown in Figure C-11.

8. **Save and close the file focus_story.jpg**

FIGURE C-10: Red Eye Removal Tool options

Pupil Size
text box

Darken Amount
text box

Auto button

Pupil

Iris

Red Eye
Removal Tool

Your default color
might vary

FIGURE C-11: Red eye removed

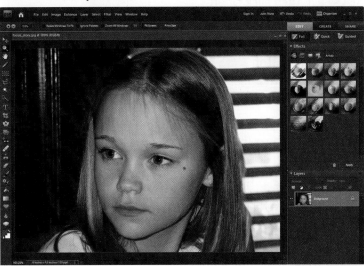

Removing the glow in animal eyes

Many animals, especially nocturnal animals such as cats, have a reflective membrane directly beneath their retinas. As a result, in addition to a red glow, animal eyes can appear green or white in a photograph. To remove the green or white glow from the eyes of your animal subjects, you can use the Brush Tool and change the blending mode. **Blending mode** uses an original color in the image and the Foreground paint color to create a new color. Photoshop Elements has several blending modes from which to choose, and Mode is one of the options for the Brush Tool. Click the Brush Tool in the toolbox, click the Mode list arrow on the Options bar, scroll down, then click Color. When you click the green or white glow of the eye, the pupil turns natural shades of gray and black, as shown in Figure C-12. (*Note:* Be sure to change the blending mode back to Normal when you're done modifying the image.)

FIGURE C-12: Removing animal eye glow

Photoshop Elements 7

Getting an Image from a Video Frame

You can grab individual video frames from your favorite videos and then edit them as still images. Photoshop Elements supports many common video formats for Windows, including AVI (Audio Video Interleaved), WMV (Windows Media Video), and MPEG (Moving Pictures Experts Group). MPEG video files on the Web have the .mpg and .mpeg extensions. ███████ Wen-Lin has proposed a butterfly theme for one of the clinic's exam rooms. She asks you to capture a frame from a video clip she has provided.

STEPS

1. **In Full Edit, click File on the menu bar, point to Import, then click Frame From Video**
 The Frame From Video dialog box opens. You can open and play a video to capture individual frames.

2. **Click the Browse button, navigate to the location where you store your Data Files, click PSE C-4.avi, then click Open**
 The first frame of the clip appears in the preview window of the Frame From Video dialog box, and the playback control buttons are active, as shown in Figure C-13.

3. **Click the Play button ▶ to view the clip, then when it stops, click the Go to beginning of the clip button ◄◄**
 The preview window displays the first frame of the video again.

4. **Drag the frame slider ▲ to the right until the time frame reads 00:06 and the slider and the butterfly appear in the locations shown in Figure C-14**
 This frame is located six seconds into the clip, and the butterfly appears with a fully spread wingspan.

5. **Click Grab Frame at the bottom of the dialog box, then click Done**
 The Frame From Video dialog box closes and the frame you grabbed is open as a new file in the document window, as shown in Figure C-15. The filename contains the number "01," indicating that this is the first frame grabbed from the video.

6. **Press [Ctrl] [0] to fit the image to screen**

7. **Save the file with the name butterfly_frame to the location where you store your Data Files**
 The file is saved as a .psd file, the native Photoshop Elements file type. You'll learn more about file types in a later lesson.

Understanding interlacing and deinterlacing

Digital video cameras record by intermixing two pictures of alternating horizontal lines, known as **fields**, into one frame. The fields are identified as even or odd lines in a process known as **interlacing**. When you capture a still frame from a video, you may see these horizontal lines in your image, especially if you captured a moving image. Photoshop Elements provides two video filters you can use to correct video images: De-Interlace and NTSC Colors. The De-Interlace command smoothes out an image by removing some odd or even lines. The NTSC Colors command limits colors for reproduction on a television. You can access these Video filter commands in either Full Edit or Quick Fix by clicking Filter on the menu bar and then pointing to Video.

FIGURE C-13: Frame From Video dialog box

Video clip open to the first frame

Frame slider

Playback control buttons

Play button

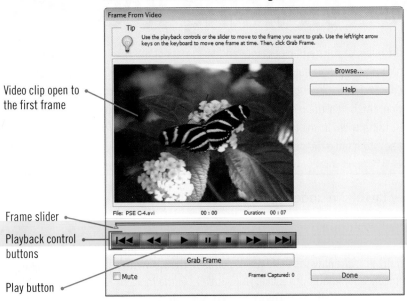

FIGURE C-14: Locating the frame to grab

Grab Frame button

Current time frame

Drag frame slider to this location

Done button

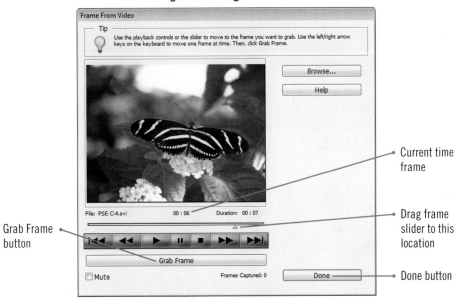

FIGURE C-15: Viewing photo grabbed from a video clip

"01" in filename indicates this is the first frame grabbed from this video

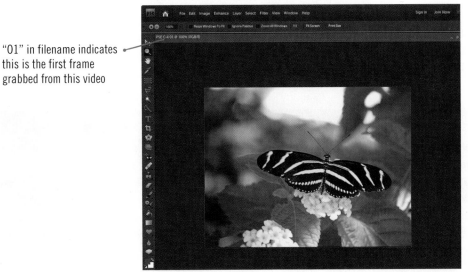

Understanding Resolution

Resolution refers to the degree of clarity and sharpness of a displayed or printed image. Although the term "resolution" has meaning in both the on-screen and print worlds, image resolution and print resolution refer to two different ways of measuring clarity and sharpness. However, resolution has one consistent rule: the higher the resolution, the better the picture. Wen-Lin wants to print some of the wall art images so that she can suggest using them in the clinic's brochure. You decide to learn more about resolution so you can understand how best to handle the photos.

DETAILS

Some key factors to understanding resolution include:

- **Image Resolution**

 For an image displayed on a computer screen, the unit of measurement is in **PPI** (pixels per inch). The higher the PPI, meaning the more pixels per inch, the clearer the image will be. Figures C-16 and C-17 show the difference resolution can make. In Figure C-16, the image is 300 PPI; the detail is sharp, and the tone transitions (the brightness of color) are very smooth. Compare that to Figure C-17, where at 72 PPI, the image is blurry and its edges appear jagged.

 If you viewed both images on a computer screen, depending on the zoom, they would both look good. But when you enlarge the lower resolution image to the size of the higher resolution image, you have a problem because of the smaller number of pixels being spread over a greater area. The lower resolution picture also looks fuzzy when you print it, because the onscreen resolution is too low for printing detailed tone transitions.

 > **QUICK TIP**
 >
 > Screen images require considerably less resolution than print images, something you may have noticed if you've ever tried to print a low-resolution photo from the Web.

- **Screen Resolution**

 The standard resolution setting for Web images is 72 PPI, which is directly related to the display capability of most computer monitors. Computer monitors also have resolution settings that refer to the number of pixels contained across the horizontal and vertical axes; that is, how densely packed the pixels are onscreen per inch.

 For example, a monitor set at a resolution of 1024 × 768 can display 1,024 pixels on each of 768 lines, totaling around 786,400 pixels. You can easily notice this when you change the resolution of your computer monitor: the lower the resolution, the larger the image appears, but it displays less detail than it would at a larger resolution.

 > **QUICK TIP**
 >
 > PPI is the correct measurement to use when referring to the resolution of a bitmap image, while DPI measures the printer's resolution when outputting an image.

- **Print Resolution**

 When you print an image, you refer to the printout's resolution in terms of **DPI** (dots per inch); literally the number of individual dots produced on the paper. The resolution capacity of a printer is determined by the highest DPI at which it can print. The higher a printer's DPI, the greater its capacity to capture the data in a high-resolution image.

 DPI is used when referencing the piece of equipment doing the printing, not the image being printed, although some Web designers, photographers, and scanner manuals use the terms DPI and PPI interchangeably.

Understanding resolution and print quality

When shopping for a digital camera, among the many decisions you have to make is choosing how many **megapixels** (millions of pixels) you want available in the camera. The more megapixels it has, the higher the camera's resolution. When it comes to printing on paper, what constitutes ideal resolution depends on what you're printing, your purpose, and, of course, the quality and DPI capacity of your printer. For a bitmap image, casual and home photographers can obtain good-quality prints at resolutions as low as 180 PPI, while commercial printing starts at 300 PPI.

Often, the best idea is to test the same photo on your printer, using different PPI values and (if your printer is capable) different DPI settings. When you get to the point where you can't see a difference between two resolutions (such as 240 PPI and 300 PPI), you've found the ideal resolution for your printer.

FIGURE C-16: Image saved at 300 PPI and printed

Image quality
is good
at higher
resolution

FIGURE C-17: Image saved at 72 PPI and printed

Image quality
degrades when
enlarged
at lower
resolution

Coping with aspect ratio and high definition

By default, many digital cameras shoot at a ratio of 4:3 (although some shoot at 3:2), which means you'll need to crop these images when you print in common snapshot sizes, such as 4" x 6". Having to sacrifice part of an image area is not unique to digital photography. You have already dealt with aspect ratio conflicts whenever you've seen the following message on your television screen before the start of a movie: *"This film has been modified from its original version. It has been formatted to fit your screen."* Up until the early 1950s, movies were made with an aspect ratio of 1.33:1; that is, the image on film was one and one-third times as wide as it was tall. When television came along, it adopted a standard aspect ratio of 4:3, or 1.33:1, which perfectly matched the movies made up until

that time. However, most movies since the 1950s have been shot in some form of widescreen format (the current standard aspect ratio is 16:9). When widescreen movies are shown on television, the sides must be cropped for the image to fit on the screen. The solution is to show the movie in letterbox format, which preserves the entire original film image. HDTV (high-definition television) also uses a ratio of 16:9.

The main reason images look so much better in high definition over traditional television is because HDTV uses smaller, square pixels (traditional television uses larger rectangular pixels). Therefore, more pixels fit on the screen—many times more than traditional television—which means that the images display at a higher resolution.

Photoshop Elements 7

Cropping, Undoing, and Redoing

There may be times when you want to keep just a portion of a photo. The **Crop Tool** lets you crop, or remove, the unwanted portions of an image that surround your subject. If you need to undo or redo one or more sequential actions, you can use the **Undo** and **Redo** commands. Wen-Lin wants a photo of a butterfly to hang behind the reception desk at the clinic, so you decide to remove some of the background area of this image to emphasize the butterfly and better suit her design concept.

STEPS

QUICK TIP

Zoom in on the image as needed.

1. **Verify that the file butterfly_frame.psd is open, then click the Crop Tool ▣ in the toolbox**

 Options for the Crop Tool appear on the Options bar. You can select a preset crop size by selecting an option from the Aspect Ratio list box, specify dimensions in the Width and Height text boxes, or adjust the resolution. **Aspect ratio** is the ratio of a photo's width to height.

QUICK TIP

You can rotate a bounding box by positioning the mouse just outside a corner of the bounding box, then dragging the rotate pointer ↱ left or right.

2. **Position ⌗ over the butterfly's left wing so it is even with the antenna, then click and drag a bounding box around the butterfly, as shown in Figure C-18**

 The **bounding box** defines the part of the image that will remain after you complete the crop. The darkened area of the image outside the bounding box indicates the area that will be cropped. You can adjust the selection area by dragging one of the **cropping handles** that appear on the sides and corners of the bounding box, or by entering values in the Width and Height text boxes on the Options bar.

3. **Drag the lower-middle handle down to include the entire pink flower, as shown in Figure C-19**

QUICK TIP

You can also press [Enter] to complete a crop.

4. **Click the Commit button ✓**

 The crop is complete. To cancel a crop, press [Esc] or click the Cancel button ⬡. Photoshop Elements requires that you click either Commit or Cancel before you make further changes.

5. **Click the Undo button ↶ Undo on the menu bar**

 The image reverts to its precropped state. You decide to keep your original crop.

QUICK TIP

You can also redo an action by pressing [Ctrl] [Y].

6. **Click the Redo button ↷ Redo on the menu bar**

 The image regains its cropped appearance. Now save the file.

7. **Open the Save As dialog box, then deselect the Save in Version Set with Original check box**

 Because you have already saved this image once in the current editing session, this option is active and will automatically add "edited-1" to the filename. By deselecting this option box, you can give the file a unique name.

8. **Save the file as butterfly_cropped.psd**

FIGURE C-18: Creating a crop bounding box

Drag handles to resize bounding box

Crop tool

Shaded area will be removed

FIGURE C-19: Adjusting the crop bounding box

Drag handle to include all of the flower

Using the Redo History palette

Undo and Redo affect the action you've just completed, although you can undo or redo repeatedly to include more actions. The Reset button in Quick Fix and Guided Edit reverts the image back to the state it was in when it was last saved. The Undo History palette records all the actions you've performed in the current editing session and allows you to step back into the history of changes to your file. Figure C-20 shows steps in the Undo History palette. You can drag the slider up, undoing each action beneath it, or simply click the action to which you want to return. You can delete individual actions no matter where they occur in the history by right-clicking the action and then clicking Delete. To delete all actions except the one you've selected, right-click the action, then click Undo History.

FIGURE C-20: Undo History palette

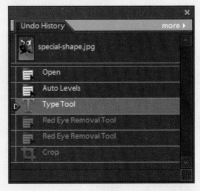

Saving a File in a Different Format

You can open a file from any Photoshop Elements workspace and save your files in many different file formats, as shown in Table C-1. The native file format in Photoshop Elements is **PSD (Photoshop Document)**, a high-quality graphics format that is the same native format as Adobe Photoshop. This native file format allows you to use all of Photoshop Elements' tools and features the next time you work on the image. For example, you can apply filters, styles, and effects to a PSD file and then edit them whenever you like. The main advantage to working with a PSD file is that it retains all the quality in the original image. You can then edit the file however you like and save it in another file format depending on your final use. 　　　 Wen-Lin is pleased with the edited butterfly image, and wants you to save it as a JPEG file so she can e-mail a copy to the clinic's director later.

STEPS

1. **Verify that the file butterfly_cropped.psd is open**
 You want to save this file as a JPEG file.

2. **Click File on the menu bar, then click Save As**
 The Save As dialog box opens.

3. **Click the Format list arrow, then compare your dialog box to Figure C-21**
 The list of available file formats is displayed.

QUICK TIP

Note that when you select a file format, only those files in that format that are currently saved in the specified location are visible in the Save As dialog box.

4. **Click JPEG (*.JPG, *.JPEG, *.JPE), then click Save**
 The **JPEG (Joint Photographic Experts Group)** file type is one of the most versatile and commonly used formats for printing photos, and is also used extensively for optimizing images for the Web. Repeated editing of a JPEG image does have its shortcomings, however. If you make changes to a JPEG file over multiple work sessions, the quality of the image degrades each time you save it, which is why it is always good practice to make a copy of your original and save it in the PSD file format.

5. **In the JPEG Options dialog box, type 10 in the Quality text box, then click OK**
 By reducing the quality setting, the file size is reduced, which makes it easier to send as an e-mail attachment or use in a Web page.

Understanding file formats

Chances are you've selected JPEG as the file format in your camera. JPEGs are used extensively in Web pages because JPEG images have a high tolerance for lossy compression. **Lossy compression** is a file compression technique that sacrifices some precise detail (quality) in the original picture in exchange for high-level compression. Higher quality image formats, such as PSD or TIF, also provide lossless compression, which results in much larger files. As you increase compression, such as selecting a smaller image size in your digital camera, file size decreases, but so does image quality. To avoid any compression, set your camera to save in Camera Raw format, if available, which contains minimal internally processed and uncompressed image data. In order to prepare a Camera Raw file for an end purpose, you'll need to process it manually.

FIGURE C-21: Viewing file formats in the Save As dialog box

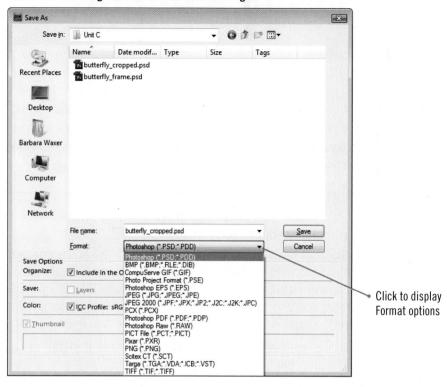

Click to display
Format options

TABLE C-1: Save As file formats in Photoshop Elements

file format	extension
Bitmap	.BMP
CompuServe GIF	.GIF
Photoshop EPS	.EPS
Photoshop PSD	.PSD, .PDD
JPEG	.JPG, .JPEG, .JPE
JPEG 2000	.JPF, .JPX, .JP2, .J2C, .J2K, .JPC
PC Paintbrush	.PCX
Photo Project Format	.PSE
Photoshop PDF	.PDF
Photoshop RAW	.RAW
PICT	.PCT, .PICT
Portable Network Graphics	.PNG
Scitex CT	.SCT
Pixar	.PXR
Targa	.TGA, .VDA, .ICB, .VST
Tagged Image Format	.TIF, .TIFF

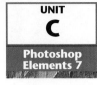

UNIT

C

Photoshop
Elements 7

Printing a Photo

You can print images from both the Organizer and the Editor. The Print dialog box differs slightly between the two workspaces. Printing in the Editor allows for more complex options, such as scaling or repositioning the image. If you want to print multiple pages, such as a contact sheet (a sheet of thumbnails) or a picture package (such as the same photo printed in different sizes), you use the Organizer Print dialog box. The clinic has just set up a lunch meeting with Wen-Lin. You print the cropped butterfly image you have been working on so she can give them a copy. You examine the Print features in the Editor and in the Organizer, and print the image as a 4 x 6 photo.

STEPS

1. **Verify that the file butterfly_cropped.jpg is open, click File on the menu bar, click Print, then compare your dialog box to Figure C-22**

 The Print dialog box opens. You can select various print options that customize the job, such as adjust size, position (centering), add caption or filename labels, and so on. Note that you can fit the image to the print area of any selected paper size by clicking the Scale to Fit Media check box in the Scaled Print Size section, and then scaling the size by typing a percentage or by typing numerical values. See Table C-2 for a description of the settings in the Print dialog box.

 > **TROUBLE**
 > Depending on your printer, you may be prompted to click OK in additional dialog boxes, such as printing to a non-Postscript printer.

2. **Click the Print Size list arrow, click 4" × 6", click Print, then click Print in your system's Print dialog box to print it**

3. **Click the Organizer button 🔲 Organizer on the menu bar, then click butterfly_cropped.jpg in the Photo Browser to select it**

 The images that you recently worked on appear in the catalog, as shown in Figure C-23. Notice that butterfly_cropped.jpg has an Edit in Progress lock bar across it, indicating that it is open in the Editor and locked from any editing in the Organizer. Fortunately, printing does not involve editing functions.

4. **Click File on the menu bar, then click Print**

 The Print Photos dialog box opens in Photo Browser, as shown in Figure C-24. In this dialog box, you can select the printer to use, set printer preferences, change the type and quantity of prints, and set the print size. Depending on the options you set, you may see additional options for choosing how many photos to print per page, whether to crop the photo to fit the page, and whether to add labels to the printout. You can select the printer, paper size, orientation, and source by clicking Page Setup.

 > **QUICK TIP**
 > You can only edit an open file in one workspace at a time.

5. **Click Cancel, then exit the Organizer**

6. **Close the file butterfly_cropped.jpg, then exit the Editor**

TABLE C-2: Print dialog box settings

setting	what it does
Image Preview area	Shows how the selected image will look when printed
Print Multiple Photos button	Opens Print Photos dialog box in Organizer
Print Size list arrow	Specifies the print layout
Crop to Fit Print Proportions check box	Scales and crops the image as needed
Position settings	Specifies where the image should print
Scaled Print Size settings	Rescales the printed image
Show Bounding Box check box	Displays a resizable bounding box around the image preview
Output settings	Selects label options to print in a photo
Color Management	Displays color management for photos, including printer preferences

FIGURE C-22: Print dialog box in the Editor

Your printer
will differ

Click to select
print size

Click to open
Print Photos
dialog box in
Organizer

Output options

Color Management
options

Scaling and
positioning
options

Print button

FIGURE C-23: Viewing a file in the Organizer that is open in the Editor

Edit in Progress
lock icon

Your photos
and order
might differ

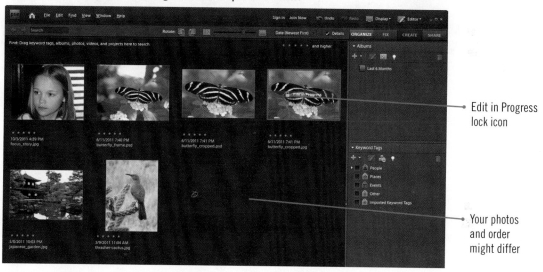

FIGURE C-24: Print Photos dialog box (Organizer)

Click to select
contact sheet
or picture
package

Click for
label, border,
and color
options

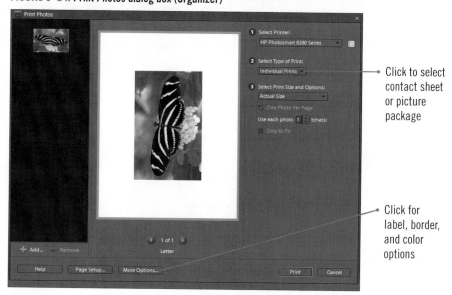

Photoshop Elements 7

Practice

▼ CONCEPTS REVIEW

Label the elements of the Editor workspace shown in Figure C-25.

FIGURE C-25

Match each term with the corresponding statement.

9. Image resolution	a. Deletes the previously performed action
10. Undo	b. Stops an action from occurring
11. PSD	c. The number of pixels in an image
12. Hand Tool	d. Enlarges or decreases a visible portion of an image
13. Cancel button	e. Native Photoshop Elements file format
14. Zoom Tool	f. Moves an image across the document window

Select the best answer from the list of choices.

15. **Which file format best preserves Photoshop Elements features?**
 a. JPEG
 b. PSD
 c. AVI
 d. TIF

16. **Which option is associated with the Red Eye Removal Tool?**
 a. Commit
 b. Resolution
 c. Darken Amount
 d. Reset

17. **Which feature would you use to delete multiple edits you've made in Quick Fix?**
 a. Reset
 b. Redo
 c. Undo
 d. Cancel

18. **What happens when you click an image when the Zoom Tool pointer contains a minus sign?**
 a. The view is reduced.
 b. The Save As dialog box opens.
 c. The view is enlarged.
 d. You can drag to view another part of the image.

19. **What happens after you grab a video frame and click Done?**
 a. You can grab another frame.
 b. The frame is automatically saved as a new file.
 c. The frame is removed from the clip.
 d. The frame is opened as a new file in Full Edit.

20. **Which unit of measurement is associated with print resolution?**
 a. AVI
 b. DPI
 c. PPI
 d. JPG

▼ SKILLS REVIEW

1. **Use Guided Edit tools.**
 a. Start Photoshop Elements, then open Guided Edit in the Editor workspace.
 b. Open the file PSE C-5.jpg from the location where you store your Data Files, then save it as **carolina_chickadee.jpg** with default JPEG settings.
 c. Under Color Correction in the Task Pane, click Remove a Color a Cast.
 d. Click the ColorCast Eyedropper pointer in the white feathers directly beneath the bird's eye.
 e. Save and close the file carolina_chickadee.jpg.

2. **Fix a photo in Quick Fix.**
 a. Open the file PSE C-6.jpg from the location where you store your Data Files, then save it as **balloons1.jpg** with default JPEG settings.
 b. Open Quick Fix in the Editor, then set the view to Before and After — Vertical.
 c. Under Color in the Task Pane, apply an automatic fix, then reset the image.
 d. Under Lighting, apply a Levels automatic fix.
 e. Drag the Hue slider (under Color) to the left just before the blue color, then cancel the fix.
 f. Under Color, drag the Temperature slider approximately two slider lengths to the left, then accept the fix.
 g. Compare your screen to Figure C-26, then change the view to After Only.
 h. Save the file balloons1.jpg.

FIGURE C-26

3. **Use view tools.**

 a. View the image in actual pixel size and then fit to the screen.

 b. Use the Zoom Tool to zoom in to the middle balloon, then use the Hand Tool to drag right the red, white, and blue balloon into view.

 c. Open Full Edit, then close the file balloons1.jpg.

4. **Fix red eye.**

 a. Open the file PSE C-7.jpg from the location where you store your Data Files, then save it as **radioflyer.jpg** with default JPEG settings.

 b. Use the Zoom Tool to zoom in until you can see both eyes on the girl, then select the Red Eye Removal Tool.

 c. Use the Red Eye Removal Tool to remove red eye automatically in both eyes.

 d. Save and close the file radioflyer.jpg.

5. **Get an image from a video frame.**

 a. Import the file PSE C-8.avi from the location where you store your Data Files using the Frame From Video command.

 b. Play the clip, then return to the first frame.

 c. Locate a frame toward the end of second 2, as shown in Figure C-27. (*Hint*: Use the location of the frame slider as a guide.)

 d. Grab that frame, then close the Frame From Video dialog box.

 e. Save the file as **cat_frame.psd**.

6. **Understand resolution.**

 a. Describe how resolution can affect the appearance of a printed image.

 b. Describe the difference between screen and print resolution.

7. **Crop, undo, and redo.**

 a. Make sure that the file cat_frame.psd is open.

 b. Select the Crop Tool.

 c. Drag a crop bounding box to include the left half of the image (just the cat).

 d. Change the resolution to **150**. (*Hint*: Use the Options bar.)

 e. Complete the crop.

 f. Undo the crop, then redo the crop.

 g. Save the file as **cat_cropped.psd**.

8. **Save a file in a different file format.**

 a. Make sure that the file cat_cropped.psd is open.

 b. Use a command on the File menu to save the image as a JPEG file with default settings.

9. **Print a photo.**

 a. Make sure that the file cat_cropped.jpg is open.

 b. Open the Print dialog box, set the Print Size to **3.5" x 5"**, then print the photo.

 c. Close the file cat_cropped.jpg, then exit Photoshop Elements.

FIGURE C-27

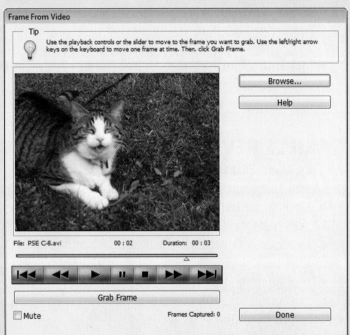

▼ INDEPENDENT CHALLENGE 1

A fellow teacher is developing an online treasure hunt game for very young explorers. He wants it to be challenging, so he thought he'd test a first draft on you. The assumption is that the children will breeze right through anything the adults find tricky. The mission is to find hidden messages in a photograph, and then edit the photo to verify that it's been read. In the draft, you crop a photo to match a sample.

 a. Start Photoshop Elements, then open Guided Edit in the Editor.

 b. Open the file PSE C-9.psd from the location where you store your Data Files.

 c. Use the Zoom Tool and the Hand Tool to locate the balloon's name. (*Hint*: Look in a flag.)

 d. Use the Hand Tool to locate where the photo was taken. (*Hint*: Look around the grass.)

 e. Save the photo as **international_balloon.jpg** with a JPEG quality setting of **8**.

 f. If desired, print a copy of the image at **2.1" x 2.8"**, write your name, the balloon's name, and the location at the top, then close the file international_balloon.jpg and exit Photoshop Elements.

▼ INDEPENDENT CHALLENGE 2

You work at SeaDee Transmission, a company that transfers photos from video onto DVDs or as downloadable media files. One of your clients is selling his favorite 78-page stamp collection. He's photographed each page to keep as a memory. Upon opening the first photo, you immediately notice that the images need some improvement.

FIGURE C-28

 a. Start Photoshop Elements, then open Quick Fix in the Editor.

 b. Open file PSE C-10.jpg from the location where you store your Data Files, then save it as **stamps_pg1.psd**.

 c. View the image in a before and after view.

 d. Under General Fixes, apply Auto SmartFix, then cancel the change.

 e. Drag the Amount slider to the second hash mark, then accept the change.

 f. Under Lighting, drag the Lighten Shadows slider halfway to the first hash mark.

 g. Crop the image just outside the white border, then compare your image to Figure C-28.

 h. Save the file stamps_pg1.psd.

Advanced Challenge Exercise

 ■ Crop out everything except the first four stamps of the third row.

 ■ Save the file as **thirdrowACE.jpg**.

 i. Exit Photoshop Elements.

▼ INDEPENDENT CHALLENGE 3

Your graphic design firm has just signed a new client, an experimental techno band called Super Nova and the Celestial Fragments. After listening to them practice for a while, you decide it's best to leave them to rehearse. You investigate possible images to use for the band t-shirts. You start out by finding a space-related video.

 a. Start Photoshop Elements, then open Full Edit in the Editor.

 b. Import the file PSE C-11.mpeg as Frame From Video from the location where you store your Data Files.

 c. Grab four frames of your choice.

 d. Save the four files as **supernova1.psd**, **supernova2.psd**, and so on.

 e. Compare your images to the samples shown in Figure C-29.

Advanced Challenge Exercise

 ■ Crop three of the images as you see fit.

 ■ Apply the Quick Fix or Guided Edit fix of your choice to each file.

 ■ Save the edited files as **supernova1ACE. jpg**, **supernova2ACE.jpg**, and **supernova3ACE. jpg**.

 ■ Print one or more of the images.

 f. Exit Photoshop Elements.

FIGURE C-29

▼ REAL LIFE INDEPENDENT CHALLENGE

It can be disappointing to take a great photo of your favorite people or animals only to discover that red eye or a spooky glow dominates the image. Fortunately, you can easily transform the images by removing red eye or the glow.

a. Start Photoshop Elements and open Full Edit in the Editor.

b. Import at least two photos where the subjects' eyes are glowing. You can take your own photos or obtain images from your computer, scanned media, or from the Internet. When downloading from the Internet, you should always assume the work is protected by copyright. Be sure to check the Web site's terms of use to determine if you can use the work for educational, personal, or noncommercial purposes.

c. Use the Red Eye Removal Tool to automatically remove red eye. Note if the automatic fix doesn't do the job.

d. If necessary undo your changes, then use the Red Eye Removal Tool to manually remove red eye. Experiment with the Pupil Size and Darken Amount settings to become familiar with how they work.

e. Save your files as **redeyefix1.jpg**, **redeyefix2.jpg**, and so on.

f. Crop the images as desired.

g. Exit Photoshop Elements.

▼ VISUAL WORKSHOP

Open the file PSE C-12.jpg from the location where you store your Data Files, then save it as **palm.psd**. Apply crop and Quick Fixes to approximate the appearance of the image shown in Figure C-30. When you are finished, press [Print Screen] and paste the image into a word-processing program, add your name to the document, print the page, then close the word processor without saving changes. Close the file palm.psd, then exit Photoshop Elements. (*Hint*: Crop the image using a 5 x 7 aspect ratio, and apply Auto Smart Fix, Lighten Shadows, and a cool Temperature.)

FIGURE C-30

Adjusting Light and Color

As you work with images in Photoshop Elements, you often want to edit them so that they convey a particular impact. Color, brightness, and lighting affect the overall look and feel of an image. Of course, your planned use dictates how you choose to fine-tune each image. You may even want to remove the color in an image. Seeds of Enthusiasm, a network of organic farmers, ranchers, and community food banks, is planning their annual meeting and awards dinner. Great Leap Digital has been asked to finalize artwork for the event. Specifically, each table is to display a photograph unique to that table's sponsor. Also, a display featuring information on prizes and awards to be presented during the dinner will be set up. Wen-Lin would like you to begin customizing the images for posters, placards, and other event items.

OBJECTIVES

Understand tonal range

Adjust brightness, contrast, and levels

Adjust shadows and highlights

Adjust hue and saturation

Apply a photo filter

Convert an image to black and white

Straighten an image

Work with a Camera RAW image

Understanding Tonal Range

A photograph contains 256 discrete brightness levels, the values of which range from absolute black (0) to absolute white (255). This range between the lightest and darkest parts of an image is known as an image's **tonal range**. An image with a wide tonal range has a good mixture of dark, light, and midtone areas. An image with a narrow tonal range will lack very light or dark areas, or be weighted in light and/or dark areas. In Photoshop Elements, you can adjust a photograph's tonal range to maximize areas of shadow and highlight. You can view a graphical representation of the tonal range of an image or selection using the Histogram palette. You can adjust the tonal range using the Levels dialog box and other commands on the Adjust Lighting submenu located on the Enhance menu. Before moving on to editing more complex photos, you want to learn about tonal range.

DETAILS

Understanding tonal range involves the following:

- **Histograms**

 A **histogram** graphically displays the brightness levels contained in an image by graphing them in a vertical line format. The bar of a histogram is actually composed of individual lines, one for each value in the tonal range. The length of the bar tells you how much of the tonal range the image has. The height of an individual line tells you how many pixels are in a given tone relative to the image.

 When making changes to an image, viewing a histogram can give you a better understanding of the tonal values so that you can make better decisions about what to adjust. Figure D-1 shows the histogram for a photograph of gumballs. To open the Histogram palette, click Window on the menu bar, then click Histogram.

 You can adjust the tonal range using the Levels dialog box. Figure D-2 shows the histogram in the Levels dialog box. Common adjustments to balance tones include dragging the Shadows or Highlights sliders in the Levels dialog box. You can also manually set the black, gray, and white points in an image using the eyedropper buttons in the dialog box.

- **How Photoshop Elements supports color**

 For computers, color is expressed in the **RGB (Red, Green, Blue)** color model. You'll learn more about color and color models in the next unit. Photoshop Elements supports 8 bits per channel. A **bit** is the smallest unit of computerized data. In computer graphics, the **bit depth** of an image refers to the number of bits used to store information about each pixel. A **channel** is the way Photoshop Elements portrays an image's color range. A bit can store up to 32 colors, so for photos you work on in Photoshop Elements, 8-bit color equals 256 colors per channel, which is the total *amount* of color in an image—not the total *number* of colors in an image. The higher the bit depth is, the greater the number of possible colors.

 Figure D-3 shows the histogram for the gumballs image broken out by color. You can see that red dominates the dark and light areas, while green and blue are spread out throughout the tonal range. To view the colors channel, click the Channel list arrow, then click Colors.

FIGURE D-1: Viewing a histogram for an image

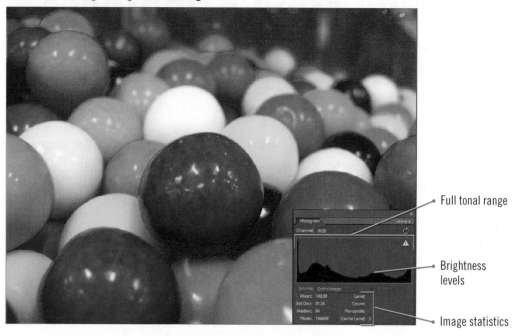

Full tonal range

Brightness levels

Image statistics

FIGURE D-2: Adjustment options in the Levels dialog box

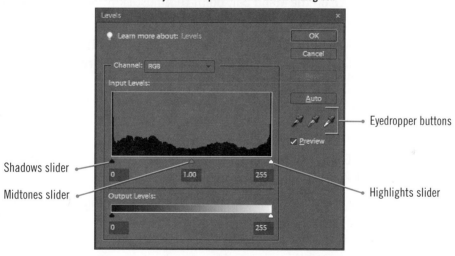

Eyedropper buttons

Shadows slider

Midtones slider

Highlights slider

FIGURE D-3: Viewing color channels in a histogram

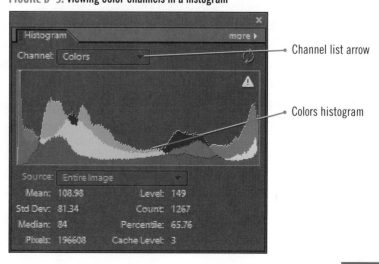

Channel list arrow

Colors histogram

Adjusting Brightness, Contrast, and Levels

If a photo looks too dark or the colors just aren't very vibrant, your first step could be to adjust the photo's virtual exposure. You can do this in different ways by adjusting the Brightness/Contrast and Levels. **Brightness** adjusts the relative lightness or darkness of an image. **Contrast** adjusts the relative differences in intensity between the darkest and brightest parts of an image. The higher the contrast, the greater the distinction will be between black and white colors. ▓▓▓▓▓ The first photo Wen-Lin has you work on is of pomegranates, which will be on display at one of the sponsor's tables. You will make adjustments to the photo's brightness and contrast.

STEPS

1. **Start Photoshop Elements, then click the Edit icon** ▰ Edit
 Editor opens in Full Edit.

2. **Open the file PSE D-1.jpg from the location where you store your Data Files, then save it as pomegranate_bandc.jpg, accepting default JPEG options**
 A picture of a pomegranate displays in the document window.

3. **Click Enhance on the menu bar, point to Adjust Lighting, then click Brightness/Contrast**
 The Brightness/Contrast dialog box opens.

4. **Drag the Brightness slider ▰ to the left until the Brightness text box reads –10, drag the Contrast slider to the right until the Contrast text box reads +35, compare your screen to Figure D-4, then click OK**
 Notice that as you move the sliders in the dialog box, the photo in the document window changes to reflect the adjustments. With these current settings, the colors in the image appear richer. You compare these results with another lighting adjustment tool, Levels.

5. **Reopen PSE D-1.jpg, then save it as pomegranate_levels.jpg, accepting default JPEG options**
 Thumbnails of both photos appear in the Project Bin.

6. **Click Enhance on the menu bar, point to Adjust Lighting, then click Levels**
 The image's histogram appears in the Levels dialog box. Levels improve an image's dynamic tonal range by defining the image's lightest and darkest pixels. You can adjust the input levels for shadows, midtones, or highlights to refine detail.

7. **Click the Auto button, compare your screen to Figure D-5, then click OK**
 Automatic Levels adjustments are applied to the image.

8. **Click the Restore Down button in the pomegranate_levels.jpg document window, then arrange the two photographs in the document window, as shown in Figure D-6**
 You can easily compare the changes made with different tools. In many cases, the quality difference is subjective; note the color and brightness differences in the two photos.

9. **Save and close the files pomegranate_bandc.jpg and pomegranate_levels.jpg**

FIGURE D-4: Brightness/Contrast dialog box

Enhance menu

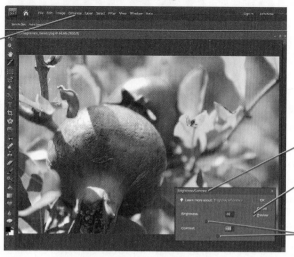

Brightness/Contrast dialog box

To view photo without corrections, deselect this option

Drag sliders to make adjustments

FIGURE D-5: Levels dialog box

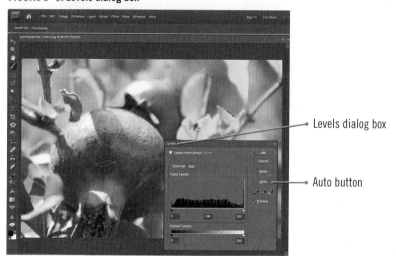

Levels dialog box

Auto button

FIGURE D-6: Comparing different adjustments

Thumbnails in the Project Bin

Adjusting Shadows and Highlights

Shadows are the darkest areas of an image and **highlights** are the lightest areas of an image. When adjusting these settings, your goal should be to make the shadows in an image less dark and the highlights less bright. For example, you can brighten an underexposed part of a photo and not affect a well-balanced background or foreground, or vice versa. Adjusting shadows and highlights is useful if the image has too much contrast, is poorly lit, or is backlit. One of the prizes at the awards dinner is a balloon ride, and Wen-Lin wants you to improve the photo by adjusting the shadows and highlights.

STEPS

QUICK TIP
Maximize the document window, if desired.

1. **Open the file PSE D-2.psd from the location where you store your Data Files, then save it as balloonride.psd**
 The hot air balloon photo appears in Full Edit.

2. **Click Enhance on the menu bar, point to Adjust Lighting, then click Shadows/Highlights**
 The Shadows/Highlights dialog box opens, as shown in Figure D-8. In this dialog box, you can correct shadows and highlights and increase the contrast in midtones. The effect of the default setting, Lighten Shadows 25%, is applied to the image.

3. **Drag the Lighten Shadows slider ▆ to the right until the Lighten Shadows text box reads 45**
 Increasing the amount of shadows reveals more detail in the shadowed portion of the image.

QUICK TIP
You can also type a value in the text box instead of dragging the slider.

4. **Drag the Darken Highlights slider ▆ to the right until the Darken Highlights text box reads 14**
 Increasing the Darken Highlights percentage reveals more detail in the highlights.

5. **Drag the Midtone Contrast slider ▆ to the right until the Midtone Contrast text box reads +15, then compare your screen to Figure D-9**
 Increased detail in the midtones is revealed. **Midtones** are the areas in between the highlights and shadows.

6. **Click OK, then save the file**

7. **Right-click the photo thumbnail in the Project Bin, then click Show Filenames**
 The filename appears beneath the thumbnail, as shown in Figure D-10. Viewing filenames are helpful when you have multiple files open or just want to see the filename.

Adjusting skin tone

Even if the colors, shadows, and brightness are balanced in an image, it can still not look as natural as you'd like. This is particularly true when the photo is of a person. To achieve natural-looking skin tone, you can use the options in the Adjust Color for Skin Tone dialog box, shown in Figure D-7. To open this dialog box, click Enhance on the menu bar, point to Adjust Color, then click Adjust Color for Skin Tone. You can select a sample area of skin and then refine the adjustment using sliders for facial color and ambient (existing) light. Be aware, though, that all the colors in the image are adjusted as well.

FIGURE D-7: Adjust Color for Skin Tone dialog box

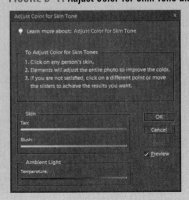

FIGURE D-8: Shadows/Highlights dialog box

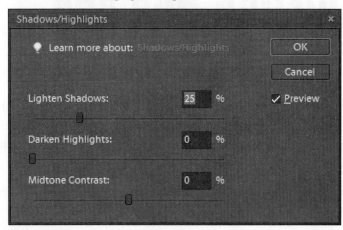

FIGURE D-9: Viewing the results of Shadows/Highlights adjustments

FIGURE D-10: Viewing a filename in the Project Bin

Filename

Adjusting Hue and Saturation

Hue defines what we experience as color. Literally, hue is determined by a specific wavelength of light. For example, we can easily describe the hue of a carrot as orange, or the hue of a tomato as red. **Saturation** determines how strong a hue, or color, appears. ▓▓▓▓ You are almost finished working on the balloon ride photo, but want to fine-tune the hue and saturation to really make the colors pop.

STEPS

1. **Verify that the file balloonride.psd is open**

2. **Click Enhance on the menu bar, point to Adjust Color, then click Adjust Hue/Saturation**
 In the Hue/Saturation dialog box, shown in Figure D-12, you can adjust hue (color), saturation (density), and lightness by dragging a slider or entering a new value in a text box. You can choose whether to edit one hue at a time (such as reds or yellows) by clicking the Edit list arrow and choosing a hue; the default setting, Master, affects all hues in the image. Select the Colorize check box to convert the image to a single hue, which you determine by dragging the Hue slider.

3. **Drag the Saturation slider ▊ to the right until the Saturation text box reads +16**
 The colors become more intense.

4. **Drag the Lightness slider ▊ to the left until the Lightness text box reads -20**
 The image now looks too dark, and the contrast is flat. See Figure D-13.

5. **Drag the Lightness slider ▊ to the right until the Lightness text box reads 0**

6. **Click OK, then save the file**

7. **Click File on the menu bar, point to Open Recently Edited File, then click PSE D-2.psd**
 The original photo of the balloon ride opens in the document window and the color difference between the original image and the one you edited in this lesson is readily apparent.

8. **Double-click the balloonride.psd thumbnail in the Project Bin, compare your screen to Figure D-14, then close both files**

Understanding hue

Sir Isaac Newton is quoted as saying "Color exists only in the brain." In the study of light physics, hue is the color transmitted through or reflected from an object. The human eye, along with high-end image acquisition devices such as scanners and digital cameras, can process millions of colors. When you turn a color wheel, you inevitably wind up at the color where you started. In Photoshop Elements, when you drag the Hue slider to either end, you also end up with the same color; in between is the full color spectrum. Simply by adjusting hue and saturation settings, you can dramatically alter the color in an image, as shown in Figure D-11.

FIGURE D-11: Color variations using hue and saturation

FIGURE D-12: Hue/Saturation dialog box

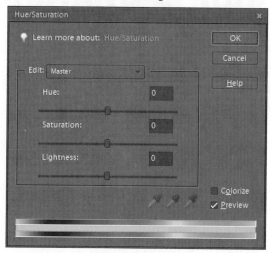

FIGURE D-13: Lightness setting applied to image

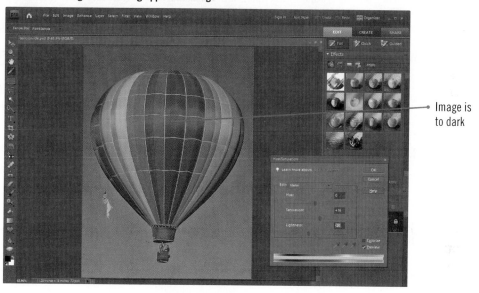

Image is to dark

FIGURE D-14: Hue and Saturation settings applied to image

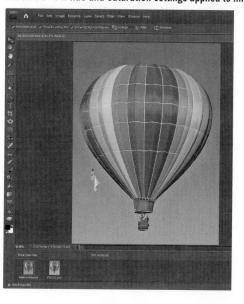

Applying a Photo Filter

Light can be characterized as **warm** or **cool**. Warming an image adds yellow, orange, or red; cooling an image adds blue, green, or purple. In Photoshop Elements, you can achieve these and many other effects by applying a **photo filter**. In traditional photography, a filter you attach to a camera lens absorbs certain wavelengths as light passes through the lens, which alters the color content (blue for cooling, red for warming). A **filter** in Photoshop Elements alters the appearance of an image by adding an effect to it, such as color, dimension, texture, and so on. ▓▓▓▓ You and Wen-Lin notice that the color in one of the Wild Bird Feed Organics photos is completely off. She asks you to cool the image and suggests you use a filter to do so.

STEPS

1. **Open the file PSE D-3.jpg from the location where you store your Data Files, then save it as snowy_bird.psd**

 A photo of a bird opens in the document window.

2. **Click Filter on the menu bar, point to Adjustments, then click Photo Filter**

 The Photo Filter dialog box opens and the default filter, Warming Filter (85), is applied to the preview image, as shown in Figure D-15. You can adjust the amount of filter applied by changing the value in the Density text box, and you can avoid darkening the image by selecting the Preserve Luminosity check box.

3. **Click the Preview check box to deselect it, notice the color change in the image, then click the Preview check box again to select it**

 The color in the image reverts to its original color and then returns to the default filter color. In addition to preset filters, you can select the color of the filter by clicking the Color square and clicking a different color in the Select filter color dialog box.

4. **Drag the Density slider ▓ to the right to 45%, as shown in Figure D-16**

 The image has a slight orange hue, evocative of sunset or of sun shining from behind a cloud.

5. **Click the Filter list arrow, then click Cooling Filter (80)**

 The image has a decidedly blue hue that looks unnatural.

6. **Drag ▓ to 30%, then compare your workspace to Figure D-17**

 The amount of saturation is reduced and the image appears to have been shot on a very bright, sunny day.

7. **Click OK**

 The Photo Filter dialog box closes.

8. **Save and close the file snowy_bird.psd**

FIGURE D-15: Photo Filter dialog box

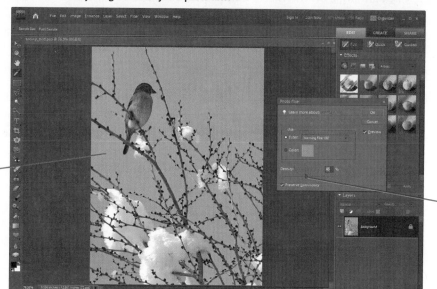

Click to select filter presets

Click to select filter color

Drag to determine how much filter to apply

FIGURE D-16: Adjusting the density of a photo filter

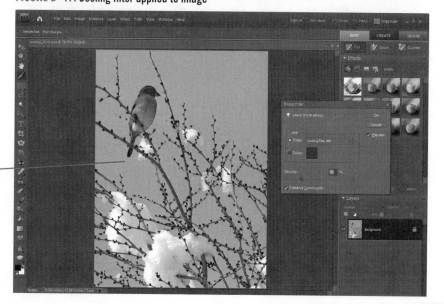

Image has distinct orange hue

Density slider

FIGURE D-17: Cooling filter applied to image

Colors are realistic

Converting an Image to Black and White

While many digital cameras have a black-and-white setting you can select before you shoot, you can also convert an existing color image to a black-and-white image. Using tools in Photoshop Elements, you can create a striking image with strong contrast. The Medicinal Herb Guild wants to stand out from the rest of the sponsor crowd by using a black-and-white image in their poster. They provide you with a color photo, so you experiment with different ways you can convert the image to black and white.

STEPS

1. **Open the file PSE D-4.jpg from the location where you store your Data Files, save it as agave.psd, then maximize the document window**

 A close up of an agave plant opens. One way to change this image to black and white is to use the Remove Color command.

QUICK TIP
You can quickly remove color by pressing [Shift] [Ctrl] [U].

2. **Click Enhance on the menu bar, point to Adjust Color, then click Remove Color**

 The colors in the image are converted to gray hues, as shown in Figure D-18, but the lack of contrast makes the image appear flat. Using the Remove Color command is the same as opening the Hue/Saturation dialog box and then dragging the Saturation slider all the way to the left (to –100).

3. **Click the Undo button on the menu bar**

QUICK TIP
You can also press [Alt][Ctrl] [B] to open the Convert to Black and White dialog box.

4. **Click Enhance on the menu bar, then click Convert to Black and White**

 The Convert to Black and White dialog box opens, as shown in Figure D-19. Here you can preview and select from various conversion options and adjust specific settings. It may seem odd to see Red, Green, and Blue adjustment sliders for Adjustment Intensity. Even though the image is now in black and white, the values in each RGB channel still affect the image's appearance. You can examine this effect by previewing the conversion styles.

5. **Click each style in the Select a style list box, previewing the effect in the After photo preview area in the dialog box, then drag the Red, Green, and Blue sliders ▉ to the left and right**

 Notice that each style causes the Adjustment Intensity sliders to shift to new settings, and individual adjustments can have a dramatic effect on the image.

QUICK TIP
It is not unusual to need to adjust a black and white image.

6. **Click the Reset button, click the Scenic Landscape style, then drag the Contrast slider ▉ to the middle of the bar**

 The contrast between the black and white tones is increased.

7. **Click OK**

 The Convert to Black and White dialog box closes and the Scenic Landscape settings are applied to the image, as shown in Figure D-20.

8. **Save and close the file agave.psd**

FIGURE D-18: Effects of Remove Color command

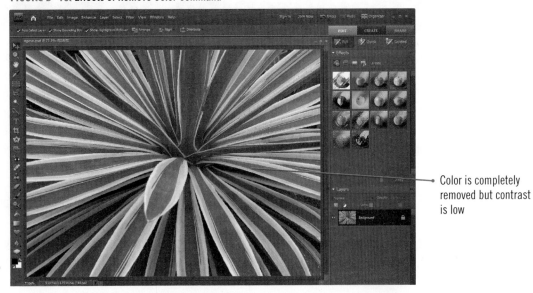

Color is completely removed but contrast is low

FIGURE D-19: Convert to Black and White dialog box

Reset button

Undo and Redo buttons

Click to select style

Drag sliders to adjust intensity

FIGURE D-20: Viewing style applied to converted image

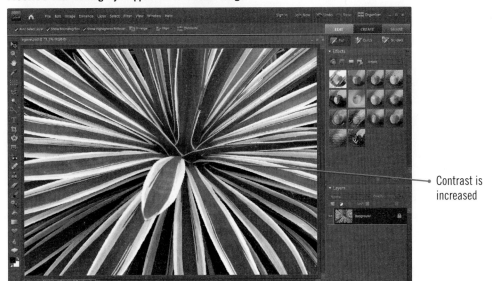

Contrast is increased

Straightening an Image

Sometimes the subject matter in a photo is out of alignment; perhaps the photographer wasn't holding the camera level, or the person or object was on an uneven surface. The Straighten Tool is effective for straightening a crooked image. You draw a line across the image's tilted horizon and the canvas rotates to realign it to a straight line. Your next sponsor for the awards dinner is Cobblers for Toddlers, a coalition of parenting groups that encourages healthy eating for young children. The image for their poster is slightly tilted, so the first thing you want to do is straighten it.

STEPS

1. **Open the file PSE D-5.jpg from the location where you store your Data Files, save it as pumpkin_boy.psd, then fit the image on screen**

2. **Click the Straighten Tool ▧ in the toolbox, click the Canvas Options list arrow, then compare your screen to Figure D-21**

 Options for the Straighten Tool determine how straightening affects the canvas. **Grow or Shrink Canvas to Fit** resizes the canvas to fit the straightened image, including blank areas; **Trim Background** crops the image to eliminate blank areas; and **Original Size** straightens the image using the canvas size as the boundary, resulting in blank areas and cropped pixels.

3. **Click Trim Background**

4. **Position the Straighten Tool pointer ┄┼┄ beneath the leftmost pumpkin on the top row, then drag to the bottom of the rightmost pumpkin in the top row, as shown in Figure D-22**

 The image rotates counterclockwise a few degrees, straightening the image, as shown in Figure D-23.

5 **Save and close the file pumpkin_boy.psd**

Straightening an image automatically

While the Straighten Tool gives you precision in straightening images, you can also use the automatic image-straightening tool to straighten scanned images you import in Photoshop Elements. Click Image on the menu bar, point to Rotate, then click Straighten Image. The image contains pixels in the blank background, just as if you selected the Original Size option for the Straighten Tool. To trim the background, click Image on the menu bar, point to Rotate, then click Straighten and Crop Image.

FIGURE D-21: Options for the Straighten Tool

Canvas cropping options

Straighten Tool

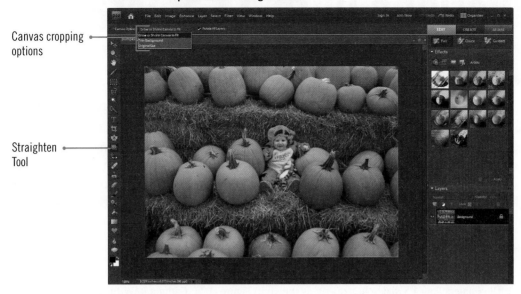

FIGURE D-22: Creating a horizon line

Start dragging here

Slanted line follows current horizon

Stop dragging here

FIGURE D-23: Straightened image

Working with a Camera RAW Image

Every digital camera allows you to save photos in common graphics formats. Some cameras also allow you to save photos in a completely unprocessed and uncompressed format, known as **Camera RAW**. RAW is not an acronym—it literally refers to the original image pixels created by the camera's sensor when the camera takes a picture. Photoshop Elements supports the Camera RAW format for many different cameras, allowing you to work in a "digital dark room" to adjust your images. Seeds of Enthusiasm will be giving away packets of wildflower seeds at the event. You've been given a photo in Camera RAW format that needs some improvement before it can be used for the giveaway.

STEPS

1. **Open the file PSE D-6.CR2 from the location where you store your Data Files**

 The Camera Raw 4.5 dialog box opens, as shown in Figure D-24. Camera RAW file extensions vary depending on the camera. In this instance, the .CR2 extension is specific to certain Canon cameras. You can adjust many options in the dialog box; see Table D-1.

2. **Click the White Balance list arrow, then click Daylight**

 White balance adjusts the colors in an image to how they would appear under specific lighting conditions. When adjusted for daylight shooting conditions, the colors appear warmer and more balanced.

3. **Drag the Blacks slider ⬦ to the right to a setting of 18**

 The **Blacks** setting increases the shadows in an image. You can view these areas by pressing [Alt] and then clicking ⬦.

4. **Drag the Contrast slider ⬦ to the right to a setting of +37, then drag the Vibrance slider ⬦ to the right to a setting of +11**

 The **Vibrance** setting increases saturation in lower-saturated pixels.

5. **Compare your dialog box to Figure D-25, then click Open Image**

 The Camera RAW dialog box closes and the adjusted image opens in Full Edit. With these adjustments, the flower looks sunnier and brighter than it did in the original Camera RAW image. The changes are made to the Camera RAW file, but they are still editable. In Full Edit, you can save it in another file format so that you can apply the full range of Editor features to the image without altering the original.

6. **Save the file as wildflower.jpg, accepting default JPEG settings**

7. **Close the file wildflower.jpg, then exit Photoshop Elements**

Understanding digital cameras and Camera RAW formats

Every time you take a digital photo, the camera's image sensor captures raw data of the image. What happens next depends on the file format you've selected in the camera. When you take pictures in common file formats, the software built into your camera applies settings that automatically adjust the photo for color, white balance, exposure, sharpening, and so on. The software accomplishes this before it transfers the image to the memory card, and many cameras allow you to adjust these settings manually. When you shoot in Camera RAW format, the image bypasses the camera's software completely. Camera manufacturers have their own proprietary formats of Camera RAW and the file extensions vary, sometimes even among cameras by the same manufacturer. Image-editing programs such as Photoshop Elements convert RAW files so you can edit them. To eliminate compatibility issues, Adobe has proposed that camera makers adopt their universal RAW format, known as DNG (Digital Negative Specification). You can save in the DNG format by clicking the Save Image button in the Camera RAW dialog box.

FIGURE D-24: Camera Raw 4.5 dialog box

Camera Raw controls

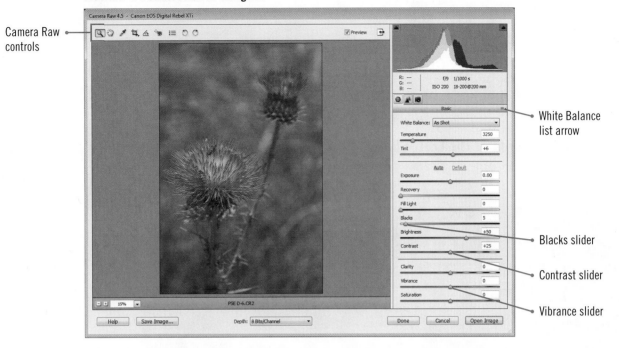

White Balance list arrow

Blacks slider

Contrast slider

Vibrance slider

FIGURE D-25: Adjusted Camera RAW image

Adjusted image

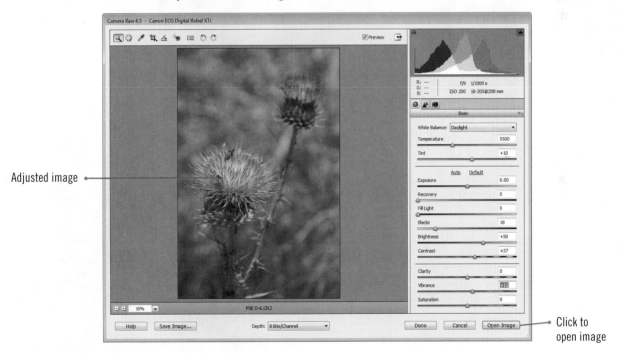

Click to open image

TABLE D-1: Camera RAW adjustment options

option	description	option	description
White Balance	sets color display under specific conditions	Blacks	increases black areas
Temperature	sets colors warmer or cooler	Brightness	adjusts overall brightness
Tint	sets color variations	Contrast	adjusts dark and light midtones
Exposure	sets amount of lightness or darkness	Clarity	sharpens edges in image
Recovery	recovers details from bright areas	Vibrance	modulates amount of saturation
Fill Light	recovers details from dark areas	Saturation	adjusts intensity of specific hues

Practice

▼ CONCEPTS REVIEW

Label the elements of the Editor workspace shown in Figure D-26.

FIGURE D-26

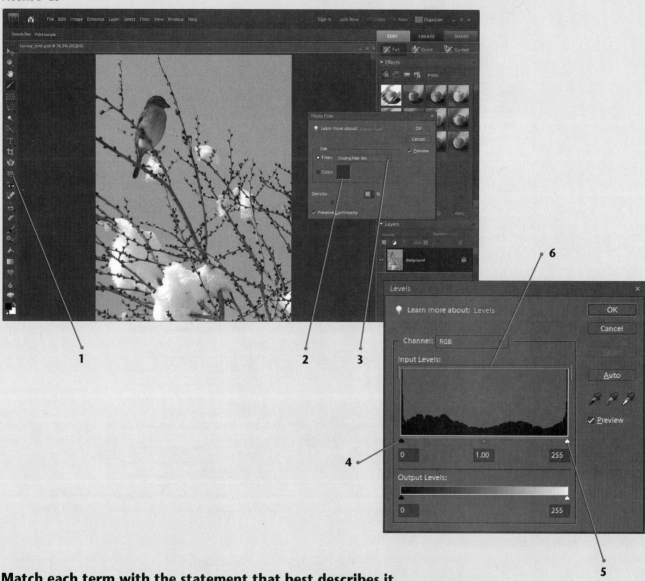

Match each term with the statement that best describes it.

7. **Camera RAW**	**a.** Default color model for computer monitors
8. **Photo Filter**	**b.** A specific wavelength of light; color
9. **Hue**	**c.** Warms or cools an image
10. **Highlights**	**d.** The lightest area in an image
11. **RGB**	**e.** Graphic display of an image's tonal range
12. **Histogram**	**f.** An unprocessed and uncompressed photographic image

Select the best answer from the list of choices.

13. **Which of the following do you adjust to increase the distinction between black and white colors?**
 a. Brightness
 b. Recovery
 c. Contrast
 d. Saturation

14. **Which filter would you apply to add blue to an image?**
 a. Density
 b. Warming
 c. Darken Amount
 d. Cooling

15. **Which option is not associated with adjusting Shadows and Highlights?**
 a. Midtones
 b. Contrast
 c. Shadows
 d. Highlights

16. **What happens to blank areas when you straighten an image with the Trim Background canvas option selected?**
 a. Blank areas are deleted from the image.
 b. There are no blank areas.
 c. Blank areas remain in the image.
 d. Blank areas are filled in by stretched pixels.

17. **Which adjustment reveals more detail in the shadows of a image?**
 a. Midtone contrast
 b. Lighten Shadows
 c. Highlights
 d. Darken Highlights

18. **Which of the following is not a way to remove color from an image?**
 a. Making saturation setting 0
 b. Making the lightness setting 0
 c. Selecting a conversion style
 d. Applying the Remove Color command

▼ SKILLS REVIEW

1. **Understand tonal range.**
 a. Describe how a histogram displays tonal range.
 b. Describe how a channel stores color.

2. **Adjust Brightness, Contrast, and Levels.**
 a. Start Photoshop Elements, open the file PSE D-7.jpg from the location where you store your Data Files, then save it as **poppies_bandc.jpg** with **10** as the JPEG Quality setting.
 b. Open the Brightness/Contrast dialog box, then set the Brightness to **14** and the Contrast to **8**.
 c. Reopen PSE D-7.jpg, then save it as **poppies_levels.jpg** with **10** as the JPEG Quality setting.
 d. Open the Levels dialog box, apply Auto levels, then reset the image.
 e. Enter **10** in the Adjust shadow input level text box, enter **200** in the Adjust highlight input level text box, then accept changes and close the dialog box. (*Hint*: Use the text boxes beneath the histogram.)
 f. Compare both images, then save and close both files.

3. **Adjust Shadows and Highlights.**
 a. Open the file PSE D-8.jpg from the location where you store your Data Files, then save it as **adobe_gate.psd**.
 b. Open the Shadows/Highlights dialog box.
 c. Set the Lighten Shadows setting to **15**, the Darken Highlights setting to **5**, then accept changes and close the dialog box.
 d. Save the file adobe_gate.psd.

4. **Adjust Hue and Saturation.**
 a. Open the Hue/Saturation dialog box.
 b. Set the Hue to **–6**, the Saturation to **+17**, then accept changes and close the dialog box.
 c. Save and close the file adobe_gate.psd.

5. Apply a photo filter.

 a. Open the file PSE D-9.jpg from the location where you store your Data Files, then save it as **cliff-dweller.psd**.

 b. Open the Photo Filter dialog box. (*Hint*: Use the Adjustments command on the Filter menu.)

 c. Set the density to **84%**.

 d. Deselect and then reselect the Preview check box, noticing the changes to the image.

 e. Apply **Cooling Filter (82)**.

 f. Set the density to **42%**.

 g. Accept changes and close the dialog box.

 h. Save and close the file cliff-dweller.psd.

6. Convert an image to black and white.

 a. Open the file PSE D-10.jpg from the location where you store your Data Files, then save it as **wordplay.psd**.

 b. Open the Hue/Saturation dialog box, drag the Saturation slider all the way to the left, then cancel your changes and close the dialog box.

 c. Open the Convert to Black and White dialog box.

 d. Click Style options to view the effects, then click Newspaper.

 e. Drag the Blue slider so that it is even with the Green slider.

 f. Accept the changes, then close the dialog box.

 g. Save the file, compare your image to Figure D-27, then close the file wordplay.psd.

FIGURE D-27

7. Straighten an image.

 a. Reopen the file adobe_gate.psd from the location where you store your Data Files.

 b. Select the Straighten Tool with the Trim Background option.

 c. Drag a line that follows the top row of bolts on the gate door.

 d. Save the file, compare your image to Figure D-28, then close the file adobe_gate.psd.

8. Work with a Camera RAW image.

 a. Open the file PSE D-11.mrw from the location where you store your Data Files.

 b. Adjust the White Balance to **Cloudy** and apply **Auto** settings.

 c. Change the following settings: Blacks: **21**; Clarity: **13**; Vibrance: **18**; Saturation: **7**.

 d. Open the image.

 e. Save the file as **fritillary.psd**.

 f. Close the file fritillary.psd, then exit Photoshop Elements.

FIGURE D-28

▼ INDEPENDENT CHALLENGE 1

You're taking a class examining cultural identity as expressed through public architecture. The next class topic is about the use of abstract art in public buildings. Your presentation is due soon and you need to improve a photo before you use it in your presentation.

a. Start Photoshop Elements, then open Full Edit.

b. Open the file PSE D-12.jpg from the location where you store your Data Files, then save it as **angelfire.psd**.

c. Open the Shadows/Highlights dialog box and adjust settings as follows: Lighten Shadows: **20**, Darken Highlights: **8**, Midtone Contrast: **+6**.

d. Open the Hue/Saturation dialog box and set Hue to **4** and Saturation to **12**.

e. Open the Brightness/Contrast dialog box and set Brightness to **29** and Contrast to **6**.

f. Save the file angelfire.psd, then compare your image to Figure D-29.

FIGURE D-29

Advanced Challenge Exercise

■ Open the file PSE D-12.jpg, then apply the Auto SmartFix command to it. (*Hint*: Use a command on the Enhance menu.)

■ Compare the angelfire.psd photo to PSE D-12.jpg.

■ Which do you like better? Why?

■ Use your favorite word-processing program to answer the questions in the previous bullet. Save the document as **angelfireACE**, then print it. Be sure to include your name in the document.

■ Close PSE D-12.jpg without saving changes.

g. Close the file angelfire.psd, then exit Photoshop Elements.

▼ INDEPENDENT CHALLENGE 2

You've been invited to supply the artwork for the opening of Baristi, a new espresso bar. For one wall, the owners have asked for variations on a common theme. They'd like the photos to reflect the upscale coffee offerings, so you get to work. You'll save several versions of the same image.

a. Start Photoshop Elements, then open Full Edit.

b. Open file PSE D-13.jpg from the location where you store your Data Files, then save it as **lambo1.jpg** with a JPEG Quality setting of **10**.

c. Repeat Step b twice, saving the files as **lambo2.jpg** and **lambo3.jpg**, respectively.

d. Display the lambo1.jpg file, open the Hue/Saturation dialog box, then change the interior color to bright green. (*Hint*: Adjust the Hue and Saturation settings.)

e. Save the file lambo1.jpg, then open the file lambo2.jpg.

f. Change the interior color to bright pink.

g. Save the file lambo2.jpg, then display the file lambo3.jpg.

h. Convert the photo to black and white using the style of your choice and adjusting intensity as desired.

Advanced Challenge Exercise

■ Apply the Warming Filter (LBA) Photo Filter with a density of 93% to the lambo3.jpg file.

■ Save the file as **lambo3ACE.jpg**.

i. Compare your images to the samples shown in Figure D-30, then save and close all photos.

j. Exit Photoshop Elements.

FIGURE D-30

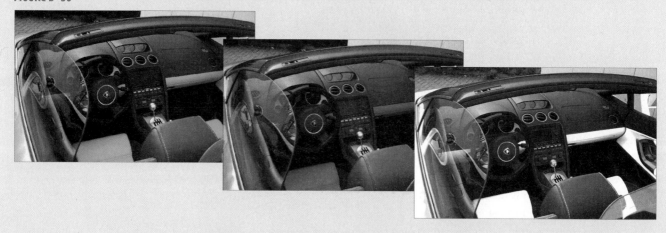

▼ INDEPENDENT CHALLENGE 3

You're in charge of investor relations for MenuTek, a company specializing in menu-printing software for restaurants. The current beta version is behind schedule, and some of the investors are getting worried. To reassure them, you prepare a sample menu that highlights all the new features. First, you need to find suitable photos to use in the sample menu.

a. Select a type of restaurant cuisine, such as Italian, Japanese, or Indian.

b. Connect to the Internet, then download three photos that represent your chosen cuisine. You can take your own photos or obtain images from your computer, scanned media, or from the Internet. When downloading from the Internet, you should always assume the work is protected by copyright. Be sure to check the Web site's terms of use to determine if you can use the work for educational, personal, or noncommercial purposes.

c. Start Photoshop Elements and open Full Edit.

d. Use the image improvement techniques of your choice from this unit to improve the appearance of the photos, and crop or rotate the images as desired.

e. Assign the photos filenames **restaurant1**, **restaurant2**, and so on, then save them as .psd files.

f. Examine the samples shown in Figure D-31.

g. Close all open files, then exit Photoshop Elements.

FIGURE D-31

▼ REAL LIFE INDEPENDENT CHALLENGE

Shooting in Camera RAW format is becoming increasingly popular, even among casual photographers. One obstacle to its widespread use is that camera manufacturers use proprietary versions of Camera RAW format so that only the manufacturer's software can be used to read the file. Despite this effort, image-editing programs such as Photoshop Elements can open the files. As a photography enthusiast, you need to stay informed of the issues surrounding Camera RAW.

a. Find friends or classmates whose different cameras support Camera RAW. What are the file extensions?

b. Use your favorite search engine to search the Web for articles about Camera RAW format. (*Hint*: Start with online computer magazines and digital camera enthusiast Web sites.)

c. Print three articles that address the following points. Be sure to write your name at the top of each printout.

- Why is a standardized file format advantageous for consumers?
- Have camera makers adopted a universal format? Which one? Is it widespread?
- What is the current state of a standardized Camera RAW format?

▼ VISUAL WORKSHOP

Open the file PSE D-14.jpg from the location where you store your Data Files, then save it as **beach_smiles.jpg**. Use skills you learned in this unit to modify the image to match the figure. (*Hint*: Be sure to straighten the image, set auto Levels, and darken Highlights.) Compare your image to Figure D-32. When you are finished, press [Print Screen] and paste the image into a word-processing program, add your name to the document, and print the page. Close the word processor without saving changes, then exit Photoshop Elements.

FIGURE D-32

Using Paint and Retouching Tools

Photoshop Elements has several tools that allow you to select, apply, or remove color in a bitmapped image by altering the pixels. Other Photoshop Elements tools work like traditional art tools, such as paints, pastels, charcoal, and brushes, and can be used to apply color to embellish a photo, drawing, clip art, or any type of graphic image. You can also select a specific color from a color palette or select any color in an image. These tools are available in Full Edit. The Montrose Pediatric Dentistry Clinic has hired Great Leap Digital to provide themed artwork for each dental office. The goal is to have the artwork keep the attention of younger patients, while encouraging good dental practices. Wen-Lin has assigned you to work on this project. The theme for the artwork is Dino Tots Detectives. You'll be working on dinosaur-themed artwork for young patients that the staff can display throughout the clinic. You will also be repairing some photographs.

OBJECTIVES

Understand color modes

Sample a color

Fill with color and pattern

Paint with the Brush Tool

Modify Brush Tool options

Erase pixels

Clone pixels

Fix imperfections

Correct camera distortion

Understanding Color Modes

The relationship between light and color is crucial to understanding how to manipulate color in Photoshop Elements. This understanding can help you to identify the color needs of an image based upon its final use, whether the image will be viewed on a monitor or cell phone, or as a printed photo. Before working with color, you review key color concepts.

Understanding color involves the following:

- **The relationship between light and color**

 When we talk of color, we also—by implication—talk about light. For those living in this solar system, our primary source of natural light is the sun. The light that reaches the earth from the sun and other stars is known as the **electromagnetic spectrum**, which includes the full range of wavelengths from radio and microwave to X-ray and gamma ray. As human beings, our eyes have rather limited photosensitive receptor cells; cells that are sensitive to light. The narrow band of visible light that we can perceive is known as **white light**.

- **The colors we see**

 White light can be bent to separate the colors that form it. For example, when you shine a light through a prism, it separates white light into its component colors. The most common experience we have seeing separated white light is when we see a rainbow, like the one shown in Figure E-1. When combined, raindrops act like prisms, bending, or refracting, the light into the familiar color arc of the rainbow: red, orange, yellow, green, blue, indigo, and violet. Each color has a specific wavelength. Red, which has a longer wavelength, is always on the outside of the arc; violet, which has the shortest wavelength, is always on the inside of the arc.

- **RGB color**

 RGB is the default color model used for computer monitors, television screens, and any other medium that emits the light itself. Red, green, and blue are the additive primary colors of light. **Additive primary colors** combine to produce other colors, as shown in Figure E-2. The range of RGB colors is 0 to 255, which represents all possible levels of red, green, or blue. Adding 100% of all three colors (255 red, 255 green, and 255 blue) produces white. A value of 0 red, 0 green, and 0 blue, which is the absence of light, produces black.

- **CMYK color**

 CMYK (Cyan, Magenta, Yellow, Black) are secondary colors used mainly for print media in what is known as four-color process printing. CMYK is based on reflected and absorbed light. You can think of CMYK as mixing pigment, whereas RGB mixes light. When the sun shines white light on a surface, some of the light spectrum is absorbed by the surface and the rest of the light is reflected to your eye. The color we perceive in printed materials is based on **subtractive secondary colors**; colors created by subtracting cyan, magenta, yellow, and black from white, as shown in Figure E-3. For example, when you combine CMYK colors in equal amounts, you produce black; the absence of color is white. The percentages between them form the color spectrum.

FIGURE E-1: Viewing colors in a rainbow

FIGURE E-2: RGB color mode – additive primary colors

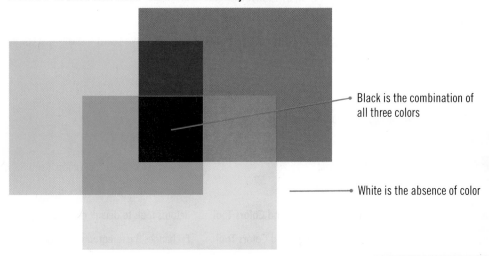

White is the combination of all three colors

Black is the absence of color

FIGURE E-3: CMYK color mode - subtractive secondary colors

Black is the combination of all three colors

White is the absence of color

Sampling a Color

You can set a color as the foreground or background color in an image either by **sampling** it (selecting an existing color in the image) or choosing one from the **Color Picker**, a Photoshop Elements component you can use to select colors. You use the **foreground color** when you paint, type, or add a border or stroke, to an image. You use the **background color** when you erase pixels or move a selection to reveal the background color. You will work with background color in a later unit. ![logo] Vera gives you a photo that contains a color she wants to use in other Dino Tots Detective artwork. You will sample the color using the Set foreground color Tool.

STEPS

1. **Start Photoshop Elements, open Full Edit, then open the file PSE E-1.jpg from the location where you store your Data Files**

 A picture of a dinosaur opens in the document window.

2. **Click the Default Foreground and Background Colors Tool ▇ at the bottom of the toolbox**

 The foreground color is reset to black and the background color is reset to white. The foreground (top) and background (bottom) color boxes overlap each other. Table E-1 describes the four elements of the foreground and background Tool group.

3. **Click the Set foreground color Tool ■ at the bottom of the toolbox**

 The Select foreground color dialog box opens, as shown in Figure E-4. You can choose a color by clicking a colored area in the image, or by dragging the color slider to the desired color and then selecting a particular shade by clicking in the color field. In addition to RGB color values, you can view and set values for other color models: **HSB** (**hue**, **saturation**, **brightness**), which expresses color by percentage, and **hexadecimal**, an alphanumeric system for defining color on the Web. When this dialog box is open, the pointer changes depending on where you point. The pointer changes to 🖋 when you position it in the image, and to ○ when you position it in the color field.

> **QUICK TIP**
>
> To set the background color, click the Set background color Tool ☐.

4. **Move the Select foreground color dialog box so it does not obstruct your view of the image, position 🖋 on the tip of the dinosaur's tongue, as shown in Figure E-5, then click the mouse**

 The color values for the color you sampled appear in the Select foreground color dialog box, the shade of red is circled in white in the color field, and the color slider moves to the red range. You can also compare the current foreground color to the previous one.

> **QUICK TIP**
>
> You can also set foreground and background colors using the Eyedropper Tool 🖊 in the toolbox or the Color Swatches palette, available from the Window menu.

5. **Write down the RGB color values shown in the figure (R: 199, G: 54, and B: 57) for reference, then click OK to close the Select foreground color dialog box**

 The dialog box closes, and in the toolbox, the foreground color box changes from default black to the sampled red color, as shown in Figure E-6.

6. **Close the file PSE E-1.jpg**

 Saving this file is not necessary because you only used it to sample a color; you did not make any changes to the file itself.

TABLE E-1: Foreground and Background Color Tools

tool	name	description
▇	Set foreground color Tool	Sets color for Brush Tool group, Paint Bucket Tool, and Gradient Tool
☐	Set background color Tool	Sets color for Eraser Tool group
▣	Default Foreground and Background Colors Tool	Returns tools to default colors
⬄	Switch Foreground and Background Colors Tool	Exchanges the foreground and background colors

FIGURE E-4: Select foreground color dialog box

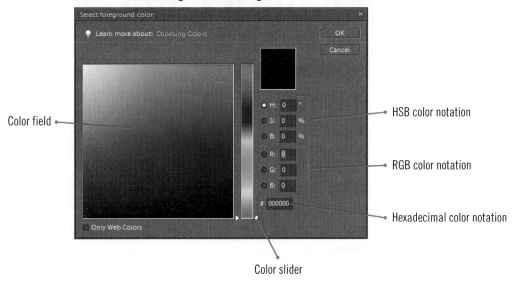

Color field

HSB color notation

RGB color notation

Hexadecimal color notation

Color slider

FIGURE E-5: Sampling a color

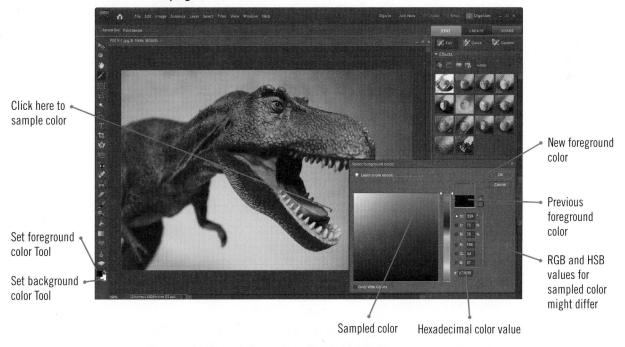

Click here to sample color

Set foreground color Tool

Set background color Tool

New foreground color

Previous foreground color

RGB and HSB values for sampled color might differ

Sampled color

Hexadecimal color value

FIGURE E-6: Viewing the new foreground color in the toolbox

Foreground color is sampled color

Using Paint and Retouching Tools

Filling with Color and Pattern

You can use the **Paint Bucket Tool** to fill an area of an image with the color currently selected as the foreground color, or with a pattern. The area can be a defined space, the entire image area, or a space already filled with color. The Patterns palette contains a wide variety of patterns, which are organized into categories, such as Artist Surfaces and Rock Patterns. Having sampled a color for your Dino Tots Detectives project, you're ready to apply it to a drawing you've created for the project.

STEPS

1. Open the file PSE E-2.jpg from the location where you store your Data Files, then save it as happyteeth.psd

 A drawing of a stegosaurus opens in the document window. You want to fill it with color.

2. Verify that the foreground color in the toolbox is the same as the color you selected in the previous lesson; or if necessary, click the Set foreground color Tool ■ in the toolbox, then enter the RGB values you noted in the previous lesson

QUICK TIP
Deselect the Pattern check box on the Options bar if it is selected.

3. Click the Paint Bucket Tool ⬛ in the toolbox, then type 35 in the Tolerance text box on the Options bar

 Tolerance determines the number of pixels to be included around a particular selected pixel. You can think of tolerance as the radius of the selection area. The higher the tolerance, the more color that is included.

4. Position ⬛ over the stegosaurus's body, then click the mouse in the body and legs

 The areas bounded by the stegosaurus's body and legs are filled with the red foreground color, as shown in Figure E-7. You can increase the zoom percentage or press [Caps Lock] to change the pointer to a precision pointer for improved accuracy.

5. Click the Pattern check box to select it on the Options bar, then click the Pattern list arrow on the Options bar

 The Pattern picker opens, as shown in Figure E-8. You can select from several pattern sets in the Pattern picker, and even make custom patterns.

6. Click the Pattern picker list arrow ⬛, click Artist Surfaces, then point to each pattern and read its name

7. Click the Oil Pastel Light pattern (the second pattern in the third row), click the Opacity list arrow on the Options bar, drag the slider ⬛ until 33% appears in the Opacity list box, then click the dinosaur's body and legs

 The pattern is applied to the body, giving it a more dinosaurian-skin appearance. The **Opacity** amount determines the transparency (0%) or opaqueness (100%) of pixels.

8. Click the Pattern list arrow on the Options bar, click the Wax Crayon on Sketch Pad pattern (the fifth pattern in the third row), then click each armor plate

 The plates fill with the pattern, as shown in Figure E-9.

9. Save the file happyteeth.psd

FIGURE E-7: Areas filled using the Paint Bucket tool

Tolerance text box

Paint Bucket Tool

Color painted in image

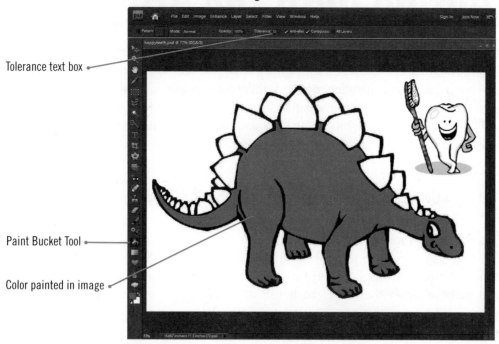

FIGURE E-8: Pattern picker

Pattern list arrow

Click check box to select it

The patterns in your Pattern picker might differ

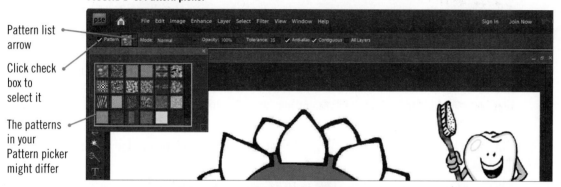

FIGURE E-9: Image filled with color and patterns

Plates filled with Wax Crayon on Sketch Pad pattern

Body filled with foreground color and Oil Pastel Light pattern

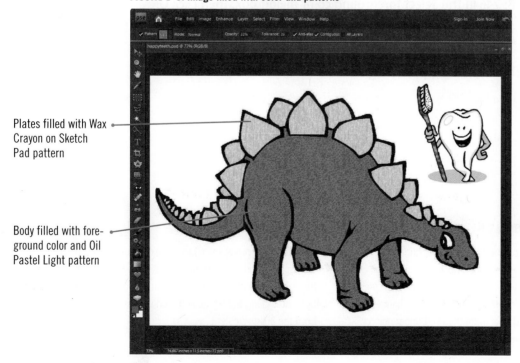

Painting with the Brush Tool

You can use various tools in the Brush Tool group to paint pixels in Photoshop Elements. You can paint in a blank canvas (such as a new file), a photograph, or line art, such as clip art. The **Brush Tool** offers a variety of brush styles and options for creating a distinctive appearance. Some styles function like stencils; when you drag the brush pointer, a pattern repeats, such as a blade of grass or a patterned brush stroke. The dental staff wants you to draw some elements on the dinosaur picture. You use the Brush Tool to do so.

STEPS

1. Verify that the file happyteeth.psd is open and that the foreground color in the toolbox is the same as the color you selected in the previous lesson

2. Click the Brush Tool in the toolbox

 Some tools, such as the Brush Tool, have multiple tools associated with them in the toolbox. A small arrow in the bottom-right corner of the tool icon indicates that other tools are available in that tool group. To select additional tools, you click and hold the tool, then click the tool you want from the list that opens.

3. On the Options bar, click the Show selected brush presets list arrow, verify that Default Brushes is displayed in the Brushes list box, as shown in Figure E-10, point to several preset options in the palette to read the description, then click Soft Round 17 pixels

 A thumbnail of the new brush selection appears in the Show selected brush presets list box.

4. Click and drag ◯ to approximate the designs shown in Figure E-11 on the top plate and beneath the tooth

 The brush paints the red foreground color in the image. As long as you click and hold the mouse button, the Brush Tool will not add additional color when you go over areas you've already painted. However, when you release the mouse button and then repaint over an area, the color deepens, just as if you were adding another coat of paint.

5. Click and hold the Brush Tool in the toolbox, then click the Color Replacement Tool

6. Click Set foreground color Tool in the toolbox, enter the RGB values R: 129, G: 231, B: 246 in the Select foreground color dialog box, then click OK

7. Carefully click and drag ◯ over the inner lines, arms, and floor of the tooth image

 The pink pixels change to light blue, as shown in Figure E-12.

8. Save the file happyteeth.psd

Using Brush Tool shortcuts

Painting with a brush style can be a challenge. Fortunately, a few handy shortcuts are available. To paint a horizontal or vertical straight line, click the starting point in the image, and then press and hold [Shift] while you drag the pointer. Need to change the foreground color? Press [Alt] to activate the eyedropper pointer, then resample a color. To quickly reduce the current brush size, press the left-bracket key ([) to decrease brush size in 10-pixel increments. To quickly increase brush size in 10-pixel increments, press the right-bracket key (]). You can change brush styles while painting by right-clicking the image and then selecting a new brush style from the Brushes palette.

FIGURE E-10: Brush Tool presets

Show selected brush presets list arrow

Brushes category

Brushes palette

Brush Tool

Soft Round 17 pixels brush style

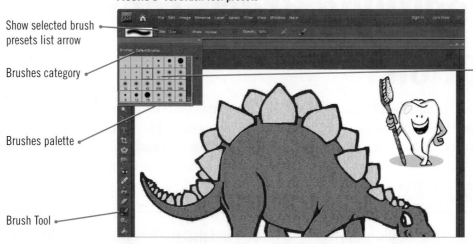

FIGURE E-11: Painting an image

Paint these areas

Brush Tool pointer

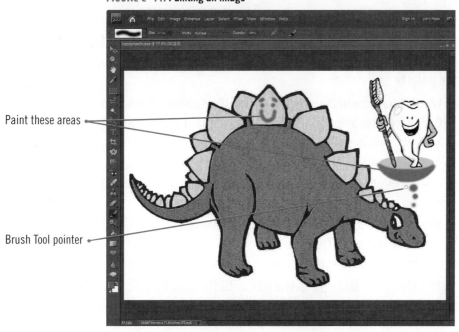

FIGURE E-12: Color changed using the Color Replacement Tool

Replaced pixels are light blue

Color Replacement Tool

New foreground color

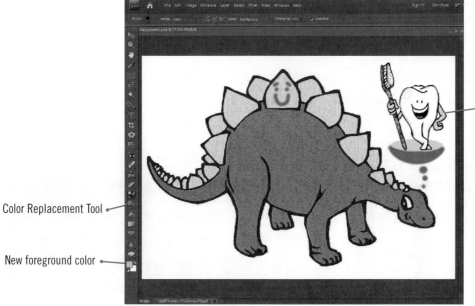

Modifying Brush Tool Options

Photoshop Elements lets you apply the dexterity of an artist's talent into your own artwork; you do this by modifying Brush Tool options. In addition to controlling color and patterns, you can access a variety of brush styles. You can select brush strokes that repeat a pattern and customize the components that make up the brush stroke itself. You want to add some grass beneath the stegosaurus's feet, and decide to experiment with a brush stroke to create a unique look. First, you need to reset the foreground color.

STEPS

1. **Verify that the file happyteeth.psd is open and that the foreground color in the toolbox is the light blue you selected in the previous lesson**

2. **Click and hold the Color Replacement Tool , then click the Brush Tool in the toolbox**

3. **Click the Show selected brush presets list arrow on the Options bar, click Default Brushes in the Brushes list, if necessary, then scroll down to and click Dune Grass (numbered 112) in the palette**

4. **Click the Set background color Tool in the toolbox, then enter the RGB values R: 92, G: 110, B: 75 in the Select background color dialog box, then click OK**

 The background color is set to an olive green.

 TROUBLE
 Don't worry about drawing a straight line.

5. **Drag / across the bottom edge of the canvas**

 A row of differently hued dune grass appears, as shown in Figure E-13. Some brush styles use multiple colors in them; Dune Grass uses both the foreground and background colors.

 QUICK TIP
 The Set to enable airbrush capabilities button on the Options bar mimics traditional airbrush techniques by appearing to spray a fine mist.

6. **Click the Show options for setting brush dynamics button on the Options bar, then compare your screen to Figure E-14**

 The Brush dynamics palette contains controls that alter the brush stroke's appearance.

7. **Drag the Hue Jitter slider to the left until the text box displays 65%, then drag the Scatter slider to the right until the Scatter text box displays 20%**

 Changing the **Hue Jitter** setting can add dimension or realism to the overall effect. This setting alters the stroke color by adding a random amount of background to the brush stroke; the higher the Hue Jitter setting, the more background color. **Scatter** affects the distribution of the brush marks. See Table E-2 for a description of the brush dynamic controls.

8. **Double-click the Size text box on the Options bar, type 55, then drag / around each leg of the dinosaur**

 The grass appears smaller and more widely spaced, as shown in Figure E-15.

9. **Save and close the file happyteeth.psd**

TABLE E-2: Brush dynamics palette options

option	description	option	description
Fade	The number of brush marks before the color fades out	Spacing	The distance between individual brush marks
Hue Jitter	The rate at which the stroke uses the background and foreground colors	Hardness	The size of the brush's center
		Angle	The slant of an elliptical brush
Scatter	The area included in brush mark distribution	Roundness	The roundness of a brush tip

FIGURE E-13: Painting with a modified brush stroke

Brush preset is
Dune Grass

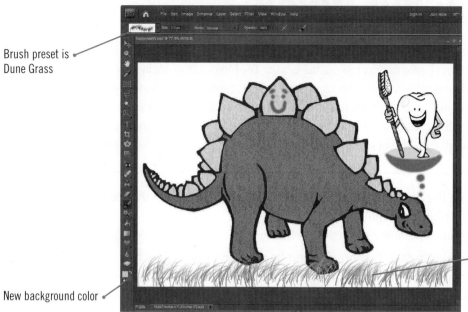

Default Dune Grass
brush stroke

New background color

FIGURE E-14: Brush dynamics window

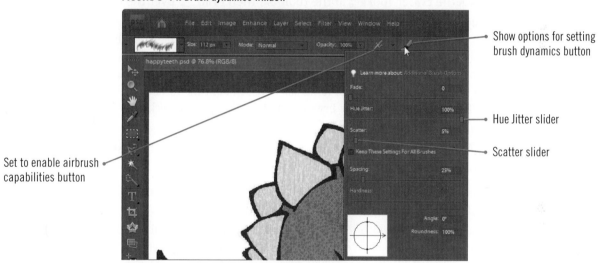

Show options for setting
brush dynamics button

Hue Jitter slider

Scatter slider

Set to enable airbrush
capabilities button

FIGURE E-15: Painting with modified brush settings

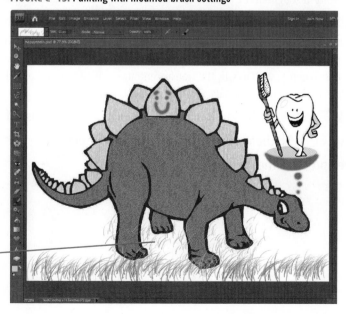

Modified grass

Erasing Pixels

When you erase a pencil mark from paper, you eliminate the graphite to reveal the original paper beneath. In Photoshop Elements, you can use the **Eraser Tool** to delete pixels in your image and replace them with pixels colored in the specified background color. You can select any brush style for the Eraser Tool to define the shape and size of the erasing path. Everyone at the clinic is very excited about this project. One of the dentists created a drawing she'd like you to use for the art display. You decide to use the Eraser Tool to simplify the image yet preserve the client's concept.

STEPS

1. Open the file PSE E-3.jpg from the location where you store your Data Files, then save it as brushing-thought.psd

 A picture of a dinosaur with a thought bubble opens in the document window.

2. Click the Default Foreground and Background Colors Tool, click the Tool arrow icon at the left on the Options bar, click Reset All Tools, then click OK in the message box

 The tool options on the Options bar are reset to the default settings, while current toolbox selections do not reset.

3. Click the Eraser Tool in the toolbox, then drag ◯ over the two thought bubbles that appear above the toothbrush, as shown in Figure E-16

 The Eraser Tool removes the two thought bubbles and paints in the current background color, white, which matches the file's background color. Like the Brush Tool, the Eraser Tool contains other tools in its tool group. The **Background Eraser Tool** removes the current background color in an image while preserving all the other colors within the brush's diameter. You can click the Mode list arrow to select a Brush, Pencil, or Block eraser tip. The **Magic Eraser Tool** erases the color you click in the image, revealing transparency, which indicates the absence of any pixels in the image.

4. Click the Zoom Tool in the toolbox, then click the toothbrush until it fills the document window

5. Click and hold in the toolbox, click the Magic Eraser Tool, double-click the Tolerance text box on the Options bar, then type 40

 The pointer changes to ✂. The tolerance setting of both the Background Eraser Tool and the Magic Eraser Tool determines how much color will be affected by each tool. By increasing the tolerance, the Magic Eraser Tool will select a larger range of blue pixels. Deselecting the Contiguous check box allows all pixels of the same color throughout the image to be selected, not just the ones next to each other.

 QUICK TIP

 Press [Caps Lock] to change the pointer to a dash crosshair, which gives you greater control when you click any tool.

6. Position ✂ over the first vertical column of maroon pixels at the left, then click the mouse

 The maroon area becomes checkerboard, indicating transparency, as shown in Figure E-17. **Transparency** means that there are no pixels in an area, not even a background color. Because only certain file types support transparency, such as GIF, the transparent area will appear as the background color, in this case white, in JPEG, PSD, and other formats when the image is printed.

7. Click ✂ in the remaining maroon columns to remove most of the pixels

8. Press [Ctrl] [0], then compare your screen to Figure E-18

9. Save and close the file brushing-thought.psd

FIGURE E-16: Erasing pixels with the Eraser Tool

Click to select
brush tip

Eraser Tool

Drag to erase pixels

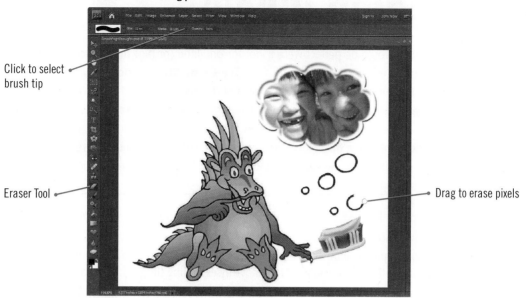

FIGURE E-17: Viewing erased pixels

Tolerance text box

Contiguous check box

Magic Eraser Tool

Maroon pixels are erased

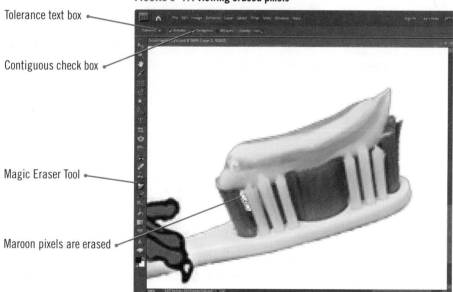

FIGURE E-18: Pixels removed from image

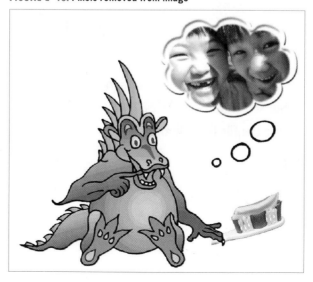

Cloning Pixels

Some photos would be perfect were it not for one little (or big) thing, such as a distracting object in the background or a flaw on the subject's face. The **Clone Stamp Tool** allows you to remove those flaws by replacing them with pixels from another area of the image. Cloning is a two-step process. First, you sample the area you want to clone, and then you paint, or stamp, over the area you want to cover with the original area you sampled. The clinic shares building space with a sculptor, who has several pieces installed onsite. You want to use the colors in the outdoor sculpture garden to inspire your Dino Tots Detectives art. You've taken a photo of the sculpture and now want to delete distractions in the background.

STEPS

1. **Open the file** PSE E-4.jpg **from the location where you store your Data Files, then save it as** blue-dino.psd

 A photograph of a dinosaur sculpture opens in the document window. In the top right corner of the image is a blue walkway that you want to remove by extending the greenery to cover it.

> **TROUBLE**
>
> Adjust your zoom as needed.

2. **Reset default foreground and background colors, reset all tools, then zoom in so you can see the bushes on the right**

> **QUICK TIP**
>
> When you drag after sampling, the sample pointer + trails the Clone Stamp pointer ⊕ and continues to sample pixels from the image.

3. **Click the** Clone Stamp Tool **in the toolbox, then click the** Aligned check box **on the Options bar to deselect it**

 See Figure E-19. Clone Stamp Tool options on the Options bar include brush type and size; Opacity, which determines the transparency (0%) or opaqueness (100%) of pixels; and **Aligned**, which determines how the sampled pixels are painted each time you click, but not drag, the mouse. You always paint with the selected area the first time you click the mouse. When the Aligned check box is selected, with each successive mouse click, you continue to paint the pixels surrounding the initially sampled area. When the Aligned check box is not selected, you paint with the initial sampled area again and again with each successive mouse click. You can paint the surrounding pixels only as long as you hold down the mouse button.

4. **Click the** Show selected brush presets list arrow **on the Options bar, click** Soft Round 65 pixels, **press and hold [Alt], position** ⊕ **in the middle of the bushes, then click the mouse**

 The area in the bushes is sampled, and you are ready to stamp the walkway.

5. **Position** ◯ **over the top branches, then click and drag over the walkway a few times until you remove all traces of it, taking care not to clone over too much of the building**

 The sampled leaves cover the walkway in a repeating but not particularly realistic pattern, as shown in Figure E-20. Cloning is not a precise art; your results will only approximate the figures. When cloning large areas, it may be best to first clone a large set of pixels and then refine the area with smaller samples.

6. **Double-click the** Set the brush size text box **on the Options bar, type** 35, **position** ⊕ **in the bright leaves in the middle of the bush, press and hold [Alt], then click the mouse**

> **QUICK TIP**
>
> The Pattern Stamp Tool is in the same tool group as the Clone Stamp tool; it paints with a preset pattern instead of sampled pixels.

7. **Sample different areas of leaves from the original bushes, clone and stamp in small increments over the walkway area until the effect looks realistic, press [Ctrl] [0], then compare your screen to Figure E-21**

8. **Save and close the file** blue-dino.psd

FIGURE E-19: **Options for the Clone Stamp Tool**

Opacity text box

Aligned check box

Clone Stamp Tool

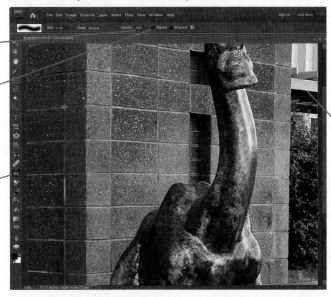

Area to be replaced
with cloned pixels

FIGURE E-20: **Cloning pixels**

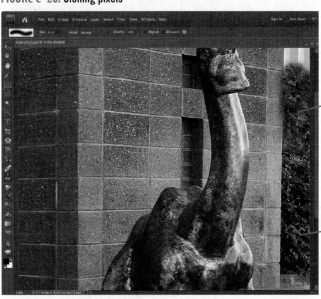

Cloned pixels; yours
will differ slightly

Source pixels

FIGURE E-21: **Viewing cloned area**

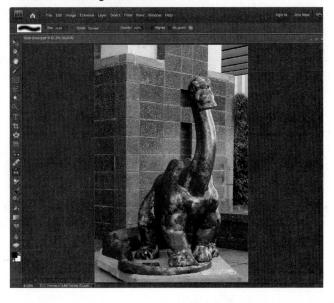

Fixing Imperfections

Repairing or improving an image that has texture can be challenging. The **Healing Brush Tool** and **Spot Healing Brush Tool** ease the effort considerably, especially when you want a fix to appear seamless, by blending in pixels with the surrounding area. The Spot Healing Brush Tool is best at sampling and fixing small areas (under 300 pixels) in one motion, while the Healing Brush Tool gives you finer control over a larger area by sampling pixels from one area and blending pixels in the target area. The clinic would like to add some animal photos to the mix. They've provided a great photo, but it needs some minor improvement. You use the Spot Healing Brush and Healing Brush Tools to repair some crucial spots.

STEPS

1. Open the file PSE E-5.jpg from the location where you store your Data Files, then save it as big_smile.psd

 A picture of a dog opens in the document window. First you want to remove some dirt patches from his nose.

2. Reset default foreground and background colors, reset all tools, then zoom in so you can see both small patches of dirt near the dog's nose

3. Click the Spot Healing Brush Tool in the toolbox

 The Spot Healing Brush Tool covers an area by estimating the color of the area being healed, and then uses that information to create a textured color blend patch. The Type options specify which pixels to use in creating the patch of pixels: Proximity Match uses pixels all around the selection, whereas Create Texture uses pixels just in the selection.

> **TROUBLE**
>
> You may need to practice a few times to become adept at using the tool.

4. Position ◯ over the spots, as shown in Figure E-22, then click the mouse to cover the spots

 The dirt smudges are covered by pixels of fur, which match the surrounding area.

5. Zoom out so the entire image is visible in the document window

 Next you are going to repair the background in the bottom right side of the image.

> **QUICK TIP**
>
> For this task, a soft brush tip is more effective than a hard brush tip.

6. Click and hold in the toolbox, click the Healing Brush Tool , click the Click to open the Brush picker list arrow on the Options bar, drag the Diameter slider to 66, then drag the Hardness slider to 27%, as shown in Figure E-23

 The Healing Brush tool operates in a two-step process similar to the Clone Stamp Tool. First, you sample an area and then blend the sampled pixels with the ones you want to repair. You can set brush options in the Brush picker as well as the Mode, Source (sampled or pattern), Aligned (whether to paint with the original sample or trail the mouse pointer), and All Layers options.

> **QUICK TIP**
>
> Experiment with both tools to discover which is more effective in healing an image.

7. Press and hold [Alt], click ⊕ on the fuzzy brown area above the white circle, then click and drag ◯ a few times over the white circles to cover them

 The white circles are replaced with sampled and blended pixels that match the surrounding brown area, as shown in Figure E-24.

8. Save and close the file big_smile.psd

FIGURE E-22: Working with the Spot Healing Brush Tool

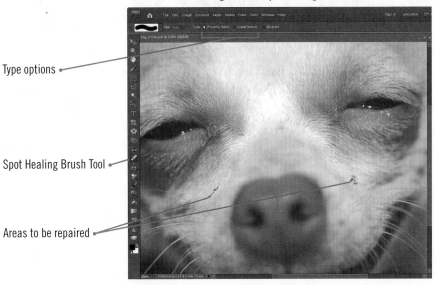

Type options

Spot Healing Brush Tool

Areas to be repaired

FIGURE E-23: Working with the Healing Brush Tool

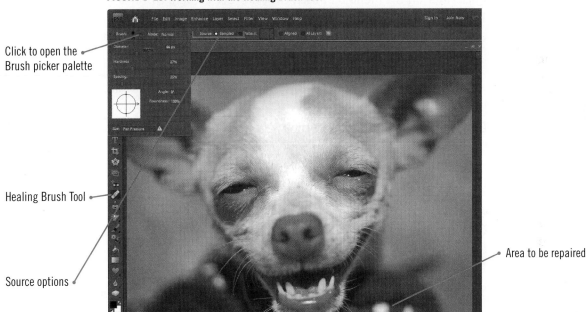

Click to open the
Brush picker palette

Healing Brush Tool

Source options

Area to be repaired

FIGURE E-24: Image repaired using the Healing Brush Tool

Repaired pixels; yours
will differ slightly

Correcting Camera Distortion

When you shoot a tall building or attach a wide-angle lens to a camera, you can achieve a wide range of results, some of which are unintended. **Barreling**, also known as **fish-eye** distortion, can make straight-line edges appear slightly convex, or curved outward, on all sides, or can bulge facial features on a close-up. **Pincushion** distortion is when the image appears to curve in slightly and the edges appear to collapse. You can adjust for distortions by applying the Correct Camera Distortion filter. ▓▓▓▓ The clinic wants to feature a dentist every month as the Lead Dino Tots Detective. The photo they've provided has barreling distortion in it. You correct the effect to create a more flattering image.

STEPS

1. **Open the file PSE E-6.jpg from the location where you store your Data Files, then save it as dr-katie-grant.psd**

 A photograph of the dentist opens in the document window. The image is clearly distorted—the woman's forehead and center of her face have too much curvature and appear as if you were viewing her through a door peephole.

2. **Click Filter on the menu bar, then click Correct Camera Distortion**

 The Correct Camera Distortion dialog box opens, as shown in Figure E-26. In this dialog box, you can use controls to reduce pincushion and barrel distortion, adjust the amount of **vignette**, which are the dark or faded corners in an image, and **perspective**, which is the viewer's apparent position in an image where closer objects appear larger than large objects farther in the distance. You can also fill the image to the canvas using the Edge Extension Scale slider, and use other options. The grid lines that appear on top of the image are used for aligning the image. You fix the image by reducing the amount of barrel distortion.

3. **Double-click the Remove Distortion text box, then type 54**

 The barrel distortion is removed. The areas of the image that were modified to remove the distortion now appear with a checkerboard pattern in the preview window.

4. **Under Edge Extension, drag the Scale slider ▉ to 145**

 The image fills the window, as shown in Figure E-27.

5. **Click OK to close the Correct Camera Distortion dialog box, then compare your screen to Figure E-28**

 The image is corrected and appears balanced.

6. **Save and close the file dr-katie-grant.psd, then exit Photoshop Elements**

Transforming images

Transforming alters an item by modifying its physical qualities. You can change an object's 2D (two-dimensional) orientation by making transformations such as rotating, skewing, and flipping. You can use some transformations to create or add to the illusion of three dimensions. To access rotate and flip commands, click Image on the menu bar, then point to Rotate; to resize the canvas, image, or object, click Resize. For an all-in-one set of free transformation tools that rotate, scale, skew, distort, or change the perspective, click Image on the menu bar, point to Transform, and then click Free Transform. Other commands under Transform are Perspective; Skew, which slants an image horizontally or vertically, and gives the illusion that the viewer's angle to the image has shifted; and Distort, which makes the entire image appear to be stretched between two end points. The other dramatic transformation tool is the Liquify filter. To access the Liquify filter, click Filter on the menu bar, point to Distort, and then

click Liquify. The Liquify filter consists of nine powerful tools that you can use to push, pull, twist, reflect, pucker, and inflate pixels in your image. An example of the Warp tool in the Liquify filter is shown in Figure E-25.

FIGURE E-25: Before and after using the Liquify filter

FIGURE E-26: **Correct Camera Distortion dialog box**

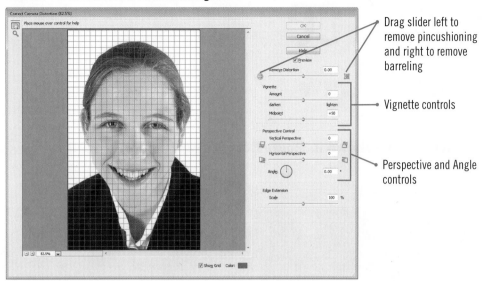

Drag slider left to remove pincushioning and right to remove barreling

Vignette controls

Perspective and Angle controls

FIGURE E-27: **Correcting barrel distortion**

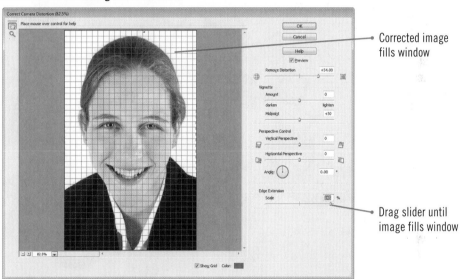

Corrected image fills window

Drag slider until image fills window

FIGURE E-28: **Distortion removed from image**

Practice

▼ CONCEPTS REVIEW

Label the elements shown in Figure E-29.

FIGURE E-29

Match each term with the statement that best describes it.

8. Barreling
9. Paint Bucket Tool
10. Magic Eraser Tool
11. White light
12. Clone Stamp Tool

a. Fills an area with the foreground color
b. Erases the color to reveal transparency
c. Wavelengths that are visible to humans
d. Stamps pixels sampled from another area
e. A distortion that makes an object appear to be bulging out

Select the best answer from the list of choices.

13. **What happens when you decrease the tolerance of a tool?**
 a. You paint with a hard edge
 b. You increase the range of pixels affected by the tool
 c. You paint with both foreground and background colors
 d. You decrease the range of pixels affected by the tool

14. **Which of the following tools requires a two-step process?**
 a. Healing Brush Tool and Spot Healing Brush Tool
 b. Brush Tool and Eraser Tool
 c. Healing Brush Tool and Clone Stamp Tool
 d. Magic Eraser Tool and Clone Stamp Tool

15. **Which of the following is associated with transparency?**
 a. Opacity setting of 0%
 b. Eraser Tool
 c. Paint Bucket Tool
 d. Barreling

16. **Which term best describes pin cushioning?**
 a. Curved inward
 b. Erased pixels
 c. Curved outward
 d. Incorrectly stamped pixels

17. **Which of the following is associated with mixing pigment?**
 a. CMYK color
 b. Hue Jitter
 c. Highlights
 d. RGB color

18. **What happens when the Brush Tool is selected and you repeatedly click the image?**
 a. You darken pixels in the background color
 b. You erase more pixels
 c. You paint with a different brush
 d. You darken pixels in the foreground color

▼ SKILLS REVIEW

1. **Understand color modes**
 a. Describe one way we can see the colors in white light.
 b. Describe the difference between additive and subtractive colors.

2. **Sample a color.**
 a. Start Photoshop Elements, open Full Edit, then open the file PSE E-7.jpg from the location where you store your Data Files.
 b. Reset default foreground and background colors.
 c. Activate the Set foreground color Tool, sample the dark green part of the top green pepper, then write down those values. (*Hint*: The RGB values should be close to R: 2, G: 54, B: 6.)
 d. Close the file PSE E-7.jpg.

3. **Fill with color and a pattern.**
 a. Open the file PSE E-8.jpg from the location where you store your Data Files, then save it as **green-chiles.psd**.
 b. Select the Paint Bucket Tool, change the Opacity to **85%**, then fill the chiles. (*Hint*: Do not fill the stems.)
 c. Open the Pattern picker, select the Texture Fill category, then choose the Footprints pattern. (*Hint*: Look in the second row.)
 d. Change the Opacity to **50%**, then fill the chile stems with the pattern.
 e. Save the file green-chiles.psd.

4. **Paint with the Brush Tool.**
 a. Select the Brush Tool, then change the brush size to **2**.
 b. Set the foreground color to R: **255**, G: **0**, B: **0**, then add polka dots to the bottom knife and fork.
 c. Select the Color Replacement Tool, then change the tolerance to **35**. (*Hint*: Click and hold the Brush Tool.)
 d. Set the foreground color to R: **33**, G: **99**, B: **20**, then recolor the basket in the right corner.
 e. Save the file green-chiles.psd.

5. **Modify Brush Tool options.**
 a. Select the Brush Tool, open the Faux Finish Brushes palette, then choose the Stencil Sponge - Dry (65) brush.
 b. Change the foreground color to R: **161**, G: **96**, B: **48**.
 c. Adjust the zoom and brush size as desired, then paint the inside bottom of the tray.
 d. Save the file green-chiles.psd.

6. Erase pixels.

 a. Select the Eraser Tool, then erase the single top knife.

 b. Select the Magic Eraser Tool, set the tolerance to **3**, then erase the background in the image. (*Hint*: You may need to click the background in multiple places.)

 c. Save your work, compare your image to Figure E-30, then close the file green-chiles.psd.

7. Clone pixels.

 a. Open the file PSE E-9.jpg from the location where you store your Data Files, then save it as **family-farm.psd**.

 b. Reset all tools, select the Clone Stamp Tool, then deselect the Aligned check box.

 c. Adjust zoom and brush sizes as needed, then clone the sky and tree to cover the light poles and wires in the top left corner of the image.

 d. Using Figure E-31 as a guide, clone the cow closest to the pond and stamp it on the right side of the image. (*Hint*: Adjust the Brush size as needed.)

 e. Save and close the file family-farm.psd.

8. Fix imperfections.

 a. Open the file PSE E-10.jpg from the location where you store your Data Files, then save it as **sand-creature.psd**.

 b. Adjust zoom and brush sizes as needed, select the Spot Healing Brush, then drag the pointer vertically from the bottom up to cover the wooden stake on the left.

 c. Drag the pointer to cover the woman in the light blue bathing suit at the top of the image.

 d. Select the Healing Brush Tool, choose a large brush size, then cover the remaining people. (*Hint*: Sample sand from various different areas and alternate brush sizes.)

 e. Save your work, compare your image to Figure E-32, then close the file sand-creature.psd.

9. Correct camera distortion.

 a. Open the file PSE E-11.jpg from the location where you store your Data Files, then save it as **glass-tower.psd**.

 b. Open the Correct Camera Distortion dialog box, then click the Show Grid check box to deselect it and hide the grid.

 c. Set Remove Distortion to **+10**, Horizontal Perspective to **+9**, and Edge Extension Scale to **109%**.

 d. Click OK, then close the Correct Camera Distortion dialog box.

 e. Save and close the file glass-tower.psd, then exit Photoshop Elements.

FIGURE E-30

FIGURE E-31

FIGURE E-32

▼ INDEPENDENT CHALLENGE 1

You own a stained glass studio and just received a commission from the Entomology Department at a private university in Sweden, where the dean is retiring. The faculty wants to present the dean with a large stained glass artwork honoring her research specialty, the cicada. The order came in too late for you to create the piece in time for the dean's retirement dinner, so you e-mailed a preview of a life-size poster they can present instead. Your contact just called to change the color scheme and now wants you to use primarily muted greens with some other muted colors. You need to replace every color with the new color scheme. Because the image will be significantly enlarged, you must make sure that the black outlines remain visible and that color saturates each segment.

a. Start Photoshop Elements, then open Full Edit.

b. Open the file PSE E-12.jpg from the location where you store your Data Files, then save it as **cicada-wing.psd**.

c. Erase the color from each wing segment.

d. Fill each segment with a different color, using muted greens and yellows. (*Hint*: Zoom and use the precision pointer as needed.)

FIGURE E-33

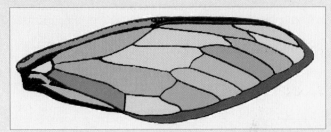

e. Fill the image background with the following color: R: **248**, G: **252**, B: **217**.

f. Compare your image to the sample shown in Figure E-33.

g. Save and close the file cicada-wing.psd, then exit Photoshop Elements.

▼ INDEPENDENT CHALLENGE 2

You're the set designer for a community theater staging a production that requires a forest scene. The producer has asked to see a color sketch of your design.

a. Start Photoshop Elements, then open Full Edit.

b. Open the file PSE E-13.jpg from the location where you store your Data Files, then save it as **set-design.psd**.

c. Set the foreground color to white.

d. Select the Brush Tool, open the Default Brushes palette, then choose the Star 42 brush style. (*Hint*: Look near the Dune Grass and Grass styles.)

e. Open the Brush dynamics palette, change the Scatter to **35%** and the Spacing to **175%**, then paint the sky to create a starry night with constellations. (*Hint*: Alternate between clicking the mouse at selected points and dragging in semi-circles to create an effect you like.)

FIGURE E-34

f. Change the brush style to Grass in the Default Brushes category, change the brush size to **100 px**, then open the Brush dynamics palette and change the following settings: Hue Jitter: **88%**, Scatter: **8%**, Spacing: **16%**.

g. Set the foreground color to R: **16**, G: **119**, B: **16** and the background color to R: **147**, G: **130**, B: **33**.

h. Paint the bottom of the image twice.

i. Select the Paint Bucket Tool, open the Texture Fill 2 Pattern palette, choose the Stucco 3 style, change the opacity to **14%**, then apply the pattern to the brown rocks.

j. Compare your image to Figure E-34.

▼ INDEPENDENT CHALLENGE 2 (CONTINUED)

Advanced Challenge Exercise

- Use the Paint Bucket Tool to apply the Black Marble style in the Rock Patterns palette with opacity of 40% to the purple cliffs in the foreground.
- Use the Paint Bucket Tool to apply the Strands style in the Texture Fill 2 Pattern palette with opacity of 40% to the white space at the bottom and sides of the image.

 k. Save and close the file set-design.psd.
 l. Exit Photoshop Elements.

▼ INDEPENDENT CHALLENGE 3

An urban youth arts coalition, Urban Conversion, was commissioned to install permanent graffiti on a downtown building. They've had a difficult time getting a shot of the entire wall, so they ask you to fix the best shot they have. You use a combination of cloning and healing techniques to eliminate distracting components of the image.

a. Start Photoshop Elements, then open Full Edit.
b. Open the file PSE E-14.jpg from the location where you store your Data Files, then save it as **urban-conversion.psd**.
c. Use combinations of the Spot Healing Brush Tool, the Healing Brush Tool, and the Clone Stamp Tool and various brush sizes to perform the following:

- Remove the air conditioner in the bottom window in the middle column of windows and replace it with the windows above it.
- Remove the man and the open back door of the station wagon.
- Remove the partially visible orange car on the right. (*Hint*: Sample different portions of the building.)

Advanced Challenge Exercise

- Remove the blue car.

FIGURE E-35

d. Examine the sample shown in Figure E-35, then save and close the file urban-conversion.psd.
e. Exit Photoshop Elements.

▼ REAL LIFE INDEPENDENT CHALLENGE

Photoshop Elements provides effective tools to remove small or even large flaws in photos. Not only can you perform minor or extreme makeovers, you can repair damaged photos. Because these skills take practice to fully develop, you spend some time fixing a favorite photo.

a. Start Photoshop Elements, then open a file that has obvious flaws or small objects you'd like to remove. You can take your own photos or obtain images from your computer, scanned media, or from the Internet. When downloading from the Internet, you should always assume the work is protected by copyright. Be sure to check the Web site's terms of use to determine if you can use the work for educational, personal, or noncommercial purposes.

b. Use the Brush Tool, Color Replacement Tool, Clone Stamp Tool, Spot Healing Brush Tool, and/or the Healing Brush Tool to fix the image.

c. Save the file as **flaw-fix.psd**, then exit Photoshop Elements.

▼ VISUAL WORKSHOP

Open the file PSE E-15.jpg from the location where you store your Data Files, then save it as **makeover.psd**. Use the Healing Brush Tools and the Clone Stamp Tool to approximate the appearance of the left side of the image shown in Figure E-36. (*Hint*: Include the hair, mouth, and neck.) When you are finished, press [Print Screen] and paste the image into a word-processing program, add your name to the document, print the page, then close the word processor without saving changes, and exit Photoshop Elements.

FIGURE E-36

Adding Layers, Artwork, and Type

By default, the images you open in Full Edit have one layer. When you add layers to an image, your editing possibilities expand tremendously. Like a sheet of transparent paper, a layer can hold an image or effect which you can manipulate without affecting the other aspects of the image. This gives you greater control over each aspect of your work and lets you express your creativity more freely. You can add content such as graphics, themes, and text to your images using the Content palette and the Horizontal Type Tool. When you create text, the current set of fonts installed on your computer is available to you in Photoshop Elements. Because text and shapes are vector objects, you can modify their attributes without affecting the quality of the image. Wen-Lin assigns you to work with a new client, E-Green Trekking, which markets green and sustainable tour packages to various online travel agencies. They are creating a new series of international tour packages and need some images to use for their Asian tour series. They have a rough idea of what they want, but need you to come up with a few eye-catching designs.

OBJECTIVES

Understand layers

View and modify layers

Group and link layers

Add content to a file

Modify content

Create a shape and adjust a layer

Add text

Edit and modify text

Merge and flatten layers

Understanding Layers

If you've never worked with layers, the concept can be confusing at first, but layers can actually simplify your work. Just as a pen-and-ink illustrator might stack several layers of translucent paper to view a final result, you can stack two or more layers in an image in Photoshop Elements. The final result is a single image, but you can alter any aspect of the image by simply switching from one layer to another and editing the contents of the layer. In your work on the E-Green Trekking project, you'll work extensively with layers. You prepare by honing your understanding of layers and the Layers palette.

DETAILS

To work with layers, you should understand:

- **An image can contain many layers**

 Figure F-1 shows what looks like a simple image, but it is actually composed of three layers: the rocks, the lion cub (which appears to be resting on the rocks), and the text (where the word "Keep" is peeking from behind the cub's head and the word "Wild" seems to be under the cub's paw).

- **Different types of layers offer various design options**

 Most commonly, a **layer** contains pixels, such as a photograph or drawing element, but it can also consist of an effect, filter, or style applied to a filled layer. Each image you open in Photoshop Elements contains at least one layer, usually the **Background layer**. The program automatically creates the Background layer when you open a digital image, or create a new image with a colored background, and locks it to prevent you from moving or deleting it. In addition to containing content, a layer can contain an effect or a style. A **fill layer** contains a solid color, gradient, or pattern. An **adjustment layer** affects the color of one or all layers beneath it in the Layers palette. A **type** or **shape layer** contains shapes or text, both of which are vector based.

- **You manage layers using the Layers palette**

 The **Layers palette** is the control center for activating, adding, copying, deleting, renaming, moving, linking, and locking layers, or changing their opacity or blending mode. Figure F-2 shows major components of the Layers palette and several layers. Table F-1 describes the components in the Layers palette. A thumbnail appears on each layer to help you identify it.

 The **active layer** is the layer currently available for editing in the document window. In the Layers palette, the active layer is highlighted; you activate a layer either by clicking it in the document window or by clicking the layer in the Layers palette. You can temporarily **link** two or more noncontiguous layers by pressing and holding [Ctrl] and then clicking the layers you want, or you can link contiguous layers or all layers by pressing and holding [Shift] and then clicking layers. Once linked, you can move the linked layers as one object and apply effects to them simultaneously.

- **The stacking order in the Layers palette affects appearance**

 Layers are arranged in the Layers palette in a stack. The position of layers in the Layers palette, any effects or filters you have applied to them, and other adjustments all affect their appearance in your image. You can think of the stack as sheets of acetate or glass, each containing an image or effect. If you look at the stack, you see one complete image; if you rearrange the order of sheets in the stack, the look of the image might change. In the image of the cub, for example, the text seems to be behind the cub. However, if you moved the middle layer to the top of the stack, the text would appear to be in front of the cub.

FIGURE F-1: Viewing how layers affect an image

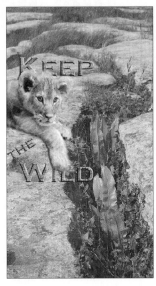

FIGURE F-2: Viewing layers in the Layers palette

Create a new layer button

Create adjustment layer button

Show/Hide icon (indicates layer is visible)

Show/Hide icon (indicates layer is hidden)

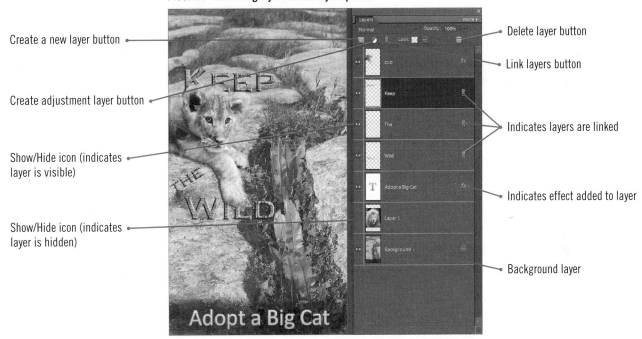

Delete layer button

Link layers button

Indicates layers are linked

Indicates effect added to layer

Background layer

Adopt a Big Cat

TABLE F-1: Components of the Layers palette

component	name	description
	Create a new layer button	Adds a new layer above the active layer
	Create adjustment layer button	Adds a new layer with color or tonal adjustments
	Link layers button	Groups together one or more layers that function as one
	Lock transparent pixels button	Protects transparent areas in layer from editing
	Lock all button	Protects entire layer from editing
	Delete layer button	Deletes the active layer
	Show/Hide (visible) icon	Indicates layer is visible on the canvas; click to make layer invisible
	Show/Hide (invisible) icon	Indicates layer is invisible on the canvas; click to make layer visible
	Indicates layer styles icon	Indicates that layer has an effect (filter, layer style, or photo effect) applied to it

Viewing and Modifying Layers

You may often find it useful to show, hide, or move layers in the Layers palette to compare several possible looks for an image. Renaming layers is an organizing technique that makes it easy to find a specific layer. ▓▓▓ Your contact at the travel agency wants to inspire international travel by adding a fantasy element to an image. You experiment by showing and moving layers to see different looks, and then you rename a layer.

STEPS

QUICK TIP

To lock or unlock layers, click the Lock all button 🔒 at the top of the Layers palette; to make a locked Background layer editable, you must rename the layer.

1. **Start Photoshop Elements, then open Full Edit**

2. **Open the file the PSE F-1.psd from the location where you store your Data Files, then save it as hongkong_dream.psd**

 The image of Hong Kong harbor contains four layers, as shown in Figure F-3. Thumbnails for each layer are visible in the Layers palette, but not all layers are visible in the document window. By default, the active Background layer is locked and cannot be moved or deleted, as indicated by the Lock all button 🔒. You can show or hide the Background layer, draw and paint on it, and apply filters and Enhance menu commands to it. Next you will show the hidden layers of the image.

QUICK TIP

To quickly hide all other layers except the active one, press and hold [Alt], then click 👁 on the active layer.

3. **In the Layers palette, click the Show/Hide icon ▓ on the Rocks layer, then repeat for Layer 1**

 The Rocks layer, which is a picture of a rock formation, is visible on the canvas (the image area of the document window). Layer 1, which is a picture of a boat, is visible, but appears to be sinking beneath the waves. This is because in the Layers palette, it is below the Water layer, which partially obscures it. You can remedy this by moving Layer 1 up in the stack.

4. **Click and hold Layer 1 on the Layers palette, begin to drag the layer up, when the pointer changes to ✋ drag the Layer 1 layer to the top of the Layers palette, then release the mouse button**

 Layer 1 appears transparent as you move it, and once you release the mouse button, it becomes the top layer in the Layers palette. The boat now appears to be floating on top of the water, as shown in Figure F-4. The name "Layer 1" does not describe the image very well, so you rename the layer to something more descriptive.

QUICK TIP

To locate layers quickly, rename layers with names that make sense to you.

5. **Double-click the Layer 1 name label in the Layers palette, as shown in Figure F-5, type Boat, then press [Enter]**

 The layer is renamed "Boat."

6. **Save and close the file hongkong_dream.psd**

Using the Layers palette

When experimenting with different design combinations for an image, you may to need to add, delete, or copy layers. To quickly add a layer, click the Create a new layer button 🗔 in the Layers palette. To delete a layer, drag the layer on top of the Delete layer button 🗑, or press [Delete] and then click OK. To copy a layer, drag the selected layer on top of 🗔. To copy a layer from one file into another, you can click and drag the desired layer to the destination file, or select and copy the desired layer (click a layer, then press [Ctrl] [C]), select a layer in the destination file, then paste it (press [Ctrl] [V]). The pasted content appears on top of the selected layer. You can also access layer commands by right-clicking a layer in the Layers palette and then clicking a command in the list.

FIGURE F-3: Opening a file with layers

Layer
thumbnails

Hidden
layers

Background
layer is
active and
locked; your
active layer
might differ

FIGURE F-4: Moved layer

The boat in
Layer 1
appears on
top of the
water

Layer 1 at
top of
Layers
palette

Water layer
beneath
Layer 1

FIGURE F-5: Renaming a layer

Layer name label; type
new layer name here

Adding Layers, Artwork, and Type

Grouping and Linking Layers

Grouping layers, also known as creating a clipping or layer group, is useful for creating a mask effect. You can use layers to **mask**, or partially obscure, the parts of an image you do not want to appear, while allowing pixels to appear through a shape, such as text. You can think of grouped layers as consisting of an effect created by combining a fill layer and a mask layer. To remove the effect, you simply ungroup the layers. You can link two or more layers so that you can move or modify them as a unit, and you can unlink them whenever you need to edit them independently. █████ You have an idea for a travel poster for central Japan that makes full use of layer features.

STEPS

TROUBLE

If you receive a message box prompting you to update text layers, click Update.

1. **Open the file PSE F-2.psd from the location where you store your Data Files, then save it as kyoto.psd**

 The file opens with five layers; some are visible and some are hidden by the layers above them.

2. **Starting at the top of the Layers palette, click each layer's Show/Hide icon 👁 until you reach the Shape 1 layer**

3. **Click and hold ▧ on the Shape 2 layer, then drag 🖑 up the column to show all the layers**

 All layers are visible.

QUICK TIP

You can also group with previous by pressing [Ctrl] [G].

4. **Click the barrels layer to select it if necessary, click Layer on the menu bar, then click Group with Previous**

 The barrels layer is grouped with the layer beneath it, the KYOTO layer. The pixels on the barrels layer fill the KYOTO layer, and the Grouped layers icon appears on the barrels layer, as shown in Figure F-6. Because the KYOTO layer is stacked just under the initiating grouping layer, barrels, the text is the mask that determines the shape of the pixels from the barrels layer. The image in the barrels layer is the fill. To ungroup layers, click Layer on the menu bar, then click Ungroup.

5. **Make sure the barrels layer is still active, click the Move Tool ▸⊕ in the toolbox, press and hold [Shift], then press the down arrow key twice to move the barrels image down in the mask, as shown in Figure F-7**

 The barrels image moves down 20 pixels and different parts of the image are visible in the text mask. Pressing and holding [Shift] moves a selection in 10-pixel increments. To move a selection one pixel at a time, press the arrow key only.

QUICK TIP

You can also link layers by clicking the Link layers icon 🔗 at the top of the Layers palette.

6. **Press and hold [Shift], click the KYOTO layer to select both layers, right-click either selected layer, then click Link Layers on the shortcut menu**

 A link icon 🔗 appears in both layers, indicating that they are linked. Now you can move the layers as one object. To unlink layers, right-click any linked layer, then click Unlink Layers on the shortcut menu.

7. **On the canvas, press and hold [Shift], drag the linked layers to the location shown in Figure F-8, taking care to move the layers straight up**

 The text and image layers move up together on the canvas.

8. **Save and close the file kyoto.psd**

FIGURE F-6: Results of Group with Previous command

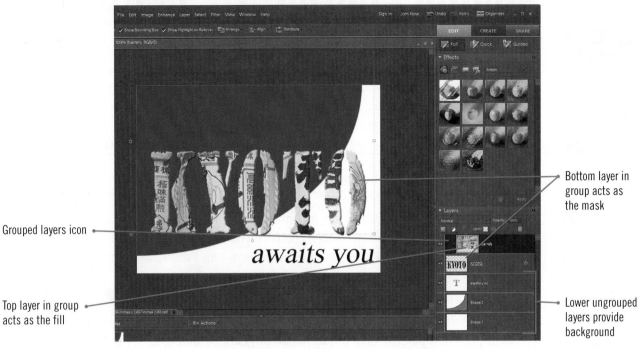

Bottom layer in
group acts as
the mask

Grouped layers icon

Top layer in group
acts as the fill

Lower ungrouped
layers provide
background

FIGURE F-7: Moving a layer in a group

Different pixels are visible
in the mask

FIGURE F-8: Moving linked and grouped layers

New location of
linked layers

Adding Content to a File

Photoshop Elements offers an extensive library of preexisting content you can add to files. From the Artwork panel, you can access the Content palette and select various pieces of artwork, such as themes, shapes, backgrounds, frames, and so on. You can also filter for specific content using Filter buttons in the palette. ▓▓▓▓▓ You decide to explore some of the material available in the Content palette as you begin to build one of the Asian trip posters.

STEPS

1. **Click File on the menu bar, point to New, then click Blank File**
 The New dialog box opens with the default filename, Untitled-1, selected in the Name text box.

> **QUICK TIP**
> By default, blank files are .psd files.

2. **In the Name text box, type dragon_hologram, click the Preset list arrow, click Default Photoshop Elements Size if necessary, compare your dialog box to Figure F-9, then click OK**
 A newly named blank file opens in the document window with a default Background layer. You select a background image for the file using the Content palette.

3. **Click the Create tab in the Task Pane, then click the Artwork button** ▢ Artwork
 The Content palette and the Favorites palette open in the Palette Bin.

> **QUICK TIP**
> You can also double-click a content thumbnail to apply it to the active file.

4. **On the Content palette, click the By list arrow, click By Mood, click the Category list arrow, click Fun, click the Filter for Backgrounds button ▢, if necessary scroll down the thumbnails list box, click Kimono 8, then click the Apply button at the bottom of the Content palette**
 See Figure F-10. A kimono pattern fills the canvas (and becomes the Background layer). The By list box and the Category list box organize the various content options you can choose from. You can also apply specific filter choices using the Filter buttons above the thumbnails of content choices, described in Table F-2. Next you add a frame to this file.

> **QUICK TIP**
> To view all the thumbnails in a category, click the Expand Artwork Panel to full screen button ◀▮▶, then click ◀▮▶ again to collapse the panel.

5. **Click the By list arrow, click By Type, click the Category list arrow, click Frames, scroll down the thumbnails list box, then double-click Rough Mask 02**
 The frame mask appears on the canvas. You can add an image to the frame by inserting it or by dragging it from an open file. You add an image from a folder.

> **QUICK TIP**
> To add a thumbnail to the Favorites palette, right-click a thumbnail, then click Add to Favorites.

6. **Click the text in the frame to open the Replace Photo dialog box, navigate to the location where you store your Data Files, then double-click the file PSE F-3.jpg**
 The image of a dragon appears on the canvas in the shape of the frame mask, as shown in Figure F-11. You can edit the image in the frame using the Frame controls that appear at the upper left corner of the frame mask.

7. **Save the file dragon_hologram.psd in the location where you save your Data Files, but do not close it**

TABLE F-2: Filter buttons in the Content palette

filter	name	description
▢	Filter for Backgrounds	Preset backgrounds
▢	Filter for Frames	Preset frames
♣	Filter for Graphics	Preset graphics
♥	Filter for Shapes	Preset shapes
T	Filter for Text Effects	Preset text styles
▣	Filter for Themes	Preset themes

FIGURE F-9: New dialog box

Type filename here

Preset list arrow

FIGURE F-10: Applying a background using the Content palette

Create tab

Artwork button

Category list arrow

By list arrow

Click Kimono 8 thumbnail

Background applied to file

Apply button

FIGURE F-11: Image inserted in frame

Frame controls

Rough Mask 02 frame; your placement might differ

Image added to frame mask

Modifying Content

In addition to adjusting the image in a frame, you can also use the Move Tool to modify or transform an object on the canvas. Transformation options are described in Table F-3. ▓▓▓▓ Your contact at the travel agency wants the dragon image to be dominant in the poster, so you adjust the photo in the frame and then rotate the frame and photo.

STEPS

TROUBLE

If the Frame controls are not visible, double-click the frame to display them.

1. **Verify that the file dragon_hologram.psd is open, the Artwork panel is selected on the Create tab of the Task Pane, and the Frame controls are visible**
 You can use Frame controls to resize, rotate, or replace the image in the frame.

2. **In the Frame controls, drag the Change the size of the photo slider ▌ one slider width to the right in the slider bar, as shown in Figure F-12**
 The dragon image increases within the frame, but the frame stays the same size.

TROUBLE

Inserting and editing complex content such as frame masks can be resource-intensive; your computer might respond slowly.

3. **Click the Commit button ✅, click the Edit tab on the Task Pane, then examine the Layers palette**
 The file is composed of two layers, the Background (with the kimono pattern) and the Rough Mask 02 1 layer containing the dragon image. You can rotate the frame and image using the Move Tool.

4. **Make sure that the Move Tool ⊹ is selected in the toolbox, position the mouse outside the top left corner of the bounding box until the rotate pointer ↰ is visible, then click the canvas**
 Free Transform options for the Move Tool ⊹ appear on the Options bar, as shown in Figure F-13, replacing the default Move Tool options. You can resize, or **scale**, a selection by one side or proportionately; **skew** a selection, which alters the horizontal or vertical slant; and rotate a selection, either by a set angle amount or by rotating the bounding box. You rotate the frame slightly on the canvas.

QUICK TIP

You can also click the Rotate button ◇ next to the Rotate text box, then drag ↻ to rotate an object.

5. **Double-click the Set horizontal scale text box, type 80, double-click the Set rotation text box, type –5, then click the Commit button ✅**
 The frame and image are reduced in size and rotated slightly to the left.

6. **Click and drag the frame to the left to the location shown in Figure F-14**
 The frame and image are moved to the left side of the canvas.

7. **Save the file dragon_hologram.psd**

TABLE F-3: Free Transform options

filter	name	description
▦	Reference point location icon	Resets the rotation point
⬜	Scale button	Resizes selection
W: 100.0%	Set horizontal scale text box	Adjusts just the width
H: 100.0%	Set vertical scale text box	Adjusts just the height
◇	Rotate button	Rotates selection
⬛	Skew button	Adjusts single edge angle

FIGURE F-12: Using Frame controls to resize an image in a frame

Drag slider to resize image

Click to rotate image in 45º increments

Click to replace image with another

Image is larger in the frame

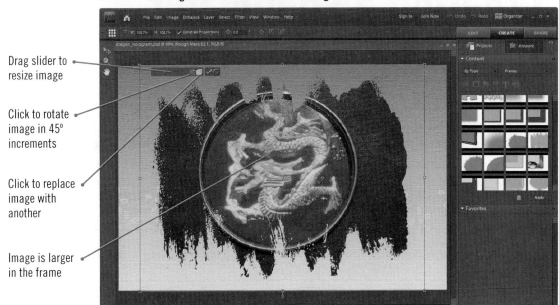

FIGURE F-13: Free transform options for the Move Tool

Set rotation text box

Set horizontal scale text box

Rotate pointer

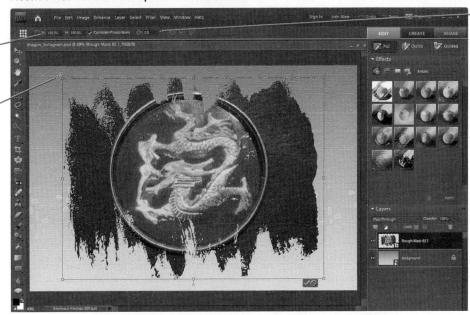

FIGURE F-14: Resized, rotated, and moved content

Creating a Shape and Adjusting a Layer

You can create a variety of geometric shapes, such as rectangles and circles, using the **Shape Tools**. See Table F-4 for a description of these tools. Shapes are vector objects, so you resize them without affecting image quality. Changing the opacity of a layer affects its transparency: how much or how little you see of the layers beneath it. You adjust layer opacity using the Opacity text box in the Layers palette. Adjusting blending mode affects the colors of an object on top of other layers. You further refine the poster by adding a star shape to it and adjusting the star's blending mode.

1. Verify that the file dragon_hologram.psd is open, then click the Default Foreground and Background Colors Tool in the toolbox

2. Click and hold the Rectangle Tool in the toolbox, then click the Polygon Tool

 In addition to polygons, by using this tool you can select options to create a star.

3. Click the Geometry options list arrow on the Options bar, click the Star check box to select this option, double-click the Sides text box on the Options bar, then type 8

> **TROUBLE**
> Select the Move Tool, click the star, then drag a corner of the bounding box to resize it to match the figure, if necessary.

4. Position + over the dragon's eye, then using Figure F-15 as a guide, click and drag + to create a star

 The star is drawn in the foreground color, black, and appears at the top of the Layers palette. Don't worry about its exact size or location.

5. Click the Move Tool in the toolbox, then click and drag the star to the top-left corner of the canvas

 The top and left edges of the bounding box are aligned with the edges of the canvas.

6. Click the Set the blending mode for the layer list arrow in the Layers palette, click Soft Light, then compare your image to Figure F-16

 The star appears as if a soft spotlight were shining through it to the other layers in the image.

> **QUICK TIP**
> You can also click the Opacity list arrow, then drag to change opacity.

7. Double-click the Opacity text box in the Layers palette, type 57, compare your screen to Figure F-17, click a blank part of the document window, then save the file dragon_hologram.psd

 The star appears lighter in color, as more of the underlying layers are visible through it. When you deselect the star, the edges appear smooth.

TABLE F-4: Shape Tool group

tool	tool name	description
	Rectangle Tool	Creates squares and rectangles
	Rounded Rectangle Tool	Creates round-cornered squares and rectangles
	Ellipse Tool	Creates circles and ellipses
	Polygon Tool	Creates multisided shapes or multipointed shapes, such as stars
	Line Tool	Creates lines
	Custom Shape Tool	Creates preset shapes; shapes also available in the Artwork panel on the Create tab
	Shape Selection Tool	Transforms vector shapes

FIGURE F-15: Creating a shape

Geometry options list arrow

Sides text box

Newly created star

Polygon Tool

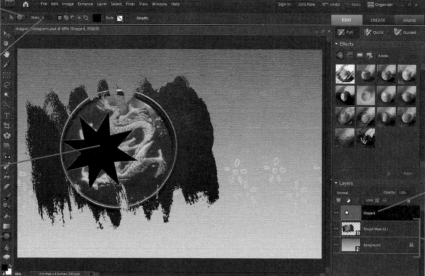

Shape layer in Layers palette

Frame and background layers

FIGURE F-16: Viewing new blending mode

Move star bounding box to this location

Soft light blending mode applied to star

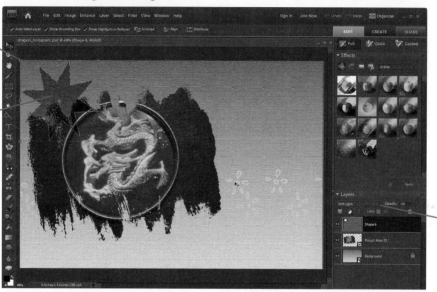

Click to select blending mode

FIGURE F-17: Viewing adjusted opacity

Lower opacity

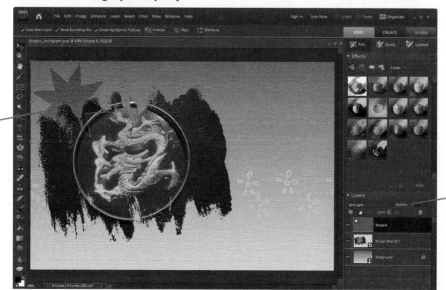

Double-click to adjust opacity

Adding Text

You can create text using any of the Type Tools in the toolbox. The terms "text" and "type" can be confusing. **Text** refers to the words you create, including letters, numbers, symbols, and so on. **Type** refers to the Type Tools and the layers created by those tools. You can format and modify text using settings on the Options bar. A **font** or **font family** is the entire array of letters, numbers, and symbols created in the same shape, known as a typeface. ▰▰▰▰ You add text to the poster and then modify the text so it matches the design.

STEPS

TROUBLE
To change ruler units to inches, if necessary click Edit on the menu bar, point to Preferences, click Units & Rulers, click the Rulers list arrow, then click inches.

1. **Verify that the file dragon_hologram.psd is open, click View on the menu bar, then click Rulers**

 Rulers appear along the top and left sides of the document window. You can use **rulers** to align text and objects.

2. **Click the Horizontal Type Tool ▥ in the toolbox, click the Set the font family list arrow on the Options bar, click Myriad Pro, if necessary, click the Set the font size list arrow, then click 24**

 The font is set to Myriad Pro and the font size is set to 24 pt, as shown in Figure F-18.

QUICK TIP
Previews of each font are shown in the font family list.

3. **Position ⌶ on the canvas to align with tick marks on the rulers at 3 H and 3.75 V, click the mouse, type adventure found, then click the Commit button ▰ on the Options bar**

 The text is aligned to the ruler coordinates, the Type icon appears with the new layer in the Layers palette, and the layer is automatically named with the same words as the typed text. See Figure F-19.

4. **Position ⌶ on the canvas to align with tick marks on the rulers at 4 H and 1 V, then click the mouse**

 You are ready to create a new Type layer.

QUICK TIP
You can also select a font color by clicking the Click to open color menu list arrow on the Options bar, then clicking a color swatch in the color palette.

5. **Click the Set the font family list arrow on the Options bar, click Arial Black, click the Set the font size list arrow, click 60, click the Set the text color box on the Options bar, enter the following RGB values in the Select color dialog box: R: 131, G: 13, B: 2, then click OK**

 The font family is set to a different font, size, and color. Select another font if this one is not available.

6. **Type All, press [Enter], type Asia, click ▰ on the Options bar, then compare your image to Figure F-20**

 The text is set on two lines with the selected attributes.

7. **Save the file dragon_hologram.psd**

FIGURE F-18: Setting Text Tool options

Set font family list arrow

Set font size list arrow

Horizontal Type Tool

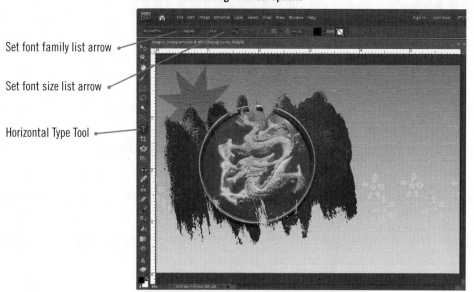

FIGURE F-19: Text added to image

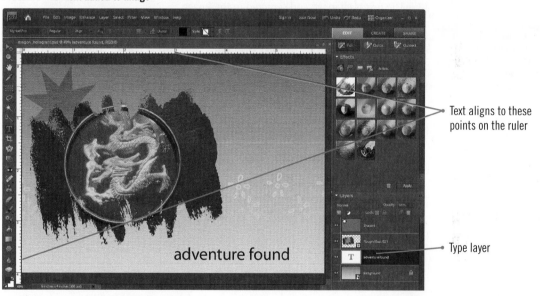

Text aligns to these points on the ruler

Type layer

adventure found

FIGURE F-20: Text set in different font color

Set the text color box

Newly added text

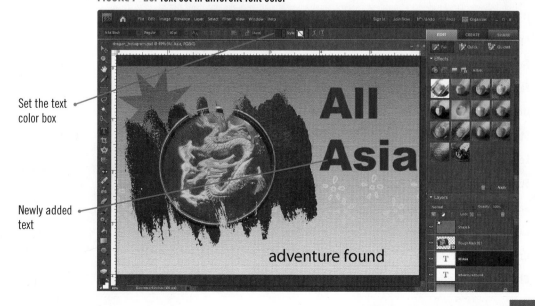

All Asia

adventure found

Adding Layers, Artwork, and Type

Editing and Modifying Text

You can edit type and alter type attributes. Each font in Photoshop Elements has a regular style; some may have bold, italic, bold italic, and so on. To view font styles, click the Set the font style list arrow on the Options bar. Even if a font does not have a specific style listed, you can apply a **faux font**, a computer-generated version of the style, using buttons on the Options bar. See Table F-5 for a description of Type Tool options. You can **warp**, or distort, text in preset shapes to create a special effect. As you complete the message on the poster, you edit the text and modify text attributes.

STEPS

1. Verify that the file dragon_hologram.psd is open and that the Horizontal Type Tool is selected in the toolbox

> **QUICK TIP**
> You can also triple-click anywhere in the line to select all the text.

2. Click ⟨I⟩ in between the "o" and the "u" in the word found, double-click, then compare your image to Figure F-21
 The word "found" is selected.

3. Type comes standard, click the Align list arrow on the Options bar, then click Center Text
 The text is changed and centered in the image.

> **QUICK TIP**
> If you are using Windows XP, you may need to select another font style.

4. Press [Ctrl] [A] to select the text "adventure comes standard," click the Set the font style list arrow on the Options bar, click Semibold Italic, then click the Commit button ✓ on the Options bar
 The alignment, font size, and font style changes are applied to the text, as shown in Figure F-22.

5. Click the All Asia layer in the Layers palette, click the Create warped text button ⟨T⟩ on the Options bar, click the Style list arrow in the Warp Text dialog box, then click Squeeze
 The warp text style is applied to the text, as shown in Figure F-23. You can adjust warp settings, such as amount and orientation, in the Warp Text dialog box.

6. Click OK to close the Warp Text dialog box, then save the file dragon_hologram.psd

TABLE F-5: Type Tool options

button	name
AA	Anti-aliased (smoothes text)
T	Faux Bold
T	Faux Italic
T	Underline
T	Strikethrough
▤, ▤, ▤	Left Align Text, Center Text, Right Align Text
A	Set the leading (space between lines of text)
▢	Set the text color
◩	Layer style
T	Create warped text (distorts text)
IT	Change the text orientation (horizontal or vertical)

FIGURE F-21: Selecting text

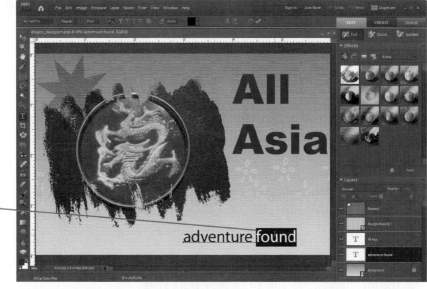

Selected text

FIGURE F-22: Viewing modified text

Click to select
font style

Click to select
font alignment

Edited text

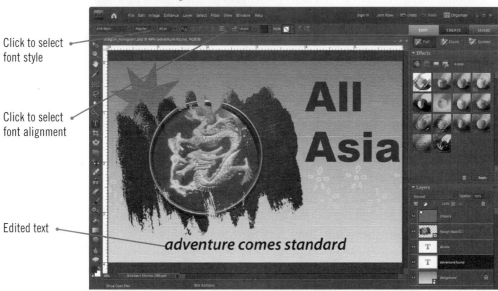

FIGURE F-23: Applying warp text

Click to select warp
text style

Warp text settings

Squeeze style applied
to text

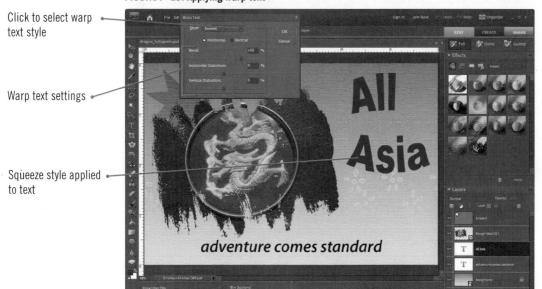

Merging and Flattening Layers

When a file contains multiple layers, the file size can balloon, which can be problematic for storing or sharing files. To reduce file size, you can **merge** layers, which combines the contents of the selected layers into a single layer. You can merge linked layers, merge a layer to the layer directly beneath it (Merge Down), or merge all visible layers (Merge Visible). If you want to combine all the elements in your image, you can **flatten** the image. You cannot edit individual elements after you flatten or merge them, so it is essential to keep an original version of a file with all the layers until you are absolutely sure the image is final. You can also **simplify** a layer, which is like flattening an individual layer by combining any styles, effects, and filters applied to it. Vera tells you that the travel company wants to send the poster image you just created as an e-card. You need a small file to send them and Vera doesn't want them to be able to edit it. You practice simplifying and merging layers before you flatten the image and complete your work on it.

STEPS

1. **Verify that the file dragon_hologram.psd is open, then save it as dragon_flattened.psd in the location where you store your Data Files**

2. **Click the Rough Mask 02 1 layer in the Layers palette, then position 🖑 over the frame layer icon ⊞ until the screentip, "Indicates a frame layer," is visible**

 The icon indicates that the layer is an editable frame layer, as you have seen in previous lessons.

3. **Click Layer on the menu bar, then click Simplify Layer**

 The layer is now a regular image and ⊞ is removed from the layer thumbnail, as shown in Figure F-24. Depending on the speed of your computer, actions you perform in the file will go faster and smoother because the layer has been simplified. Next, you merge the layers that contain images or graphics.

4. **Click the Shape 6 layer in the Layers palette, press and hold [Ctrl], click the Rough Mask 02 1 layer, click the Background layer, right-click any of the layers, then click Merge Layers on the shortcut menu**

 The Shape 6, Rough Mask 02 1, and Background layers are combined, or merged, into the Background layer, as shown in Figure F-25. Finally, you flatten the image to create a single layer.

5. **Click Layer on the menu bar, then click Flatten Image**

 All visible layers are flattened into a new Background layer, as shown in Figure F-26. Flattening affects only visible layers. If an image contains hidden layers, Photoshop Elements prompts you to discard the hidden layers before flattening. Flattening automatically fills any transparent areas of the canvas with white.

6. **Save and close the file dragon_flattened.psd, then exit Photoshop Elements**

FIGURE F-24: Simplifying a layer

Simplified layer no longer contains Frame layer icon

FIGURE F-25: Merged layers

Images from selected layers on merged layer

FIGURE F-26: Flattened image

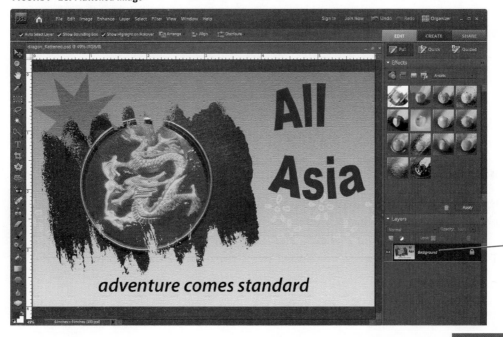

Flattened layers become new Background layer

Practice

▼ CONCEPTS REVIEW

Label the elements of the Editor workspace shown in Figure F-27.

FIGURE F-27

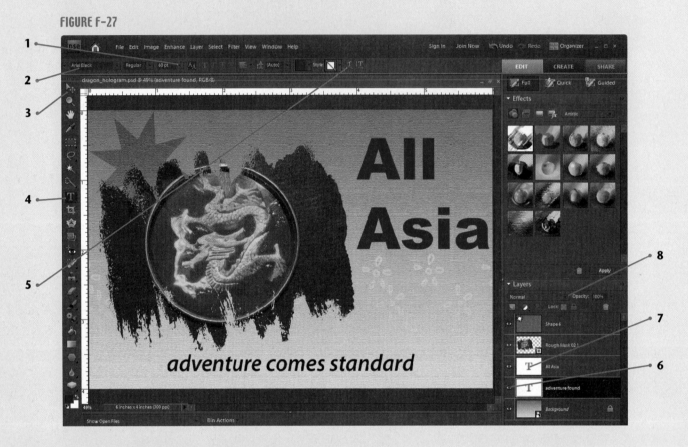

Match each term with the statement that best describes it.

9. Scale
10. Font family
11. Flatten
12. Mask
13. Opacity

a. To resize a selected object
b. Partially obscures areas of an image
c. The amount of transparency in a layer
d. A related collection of letters, numbers, and symbols
e. To combine multiple layers into one layer

Select the best answer from the list of choices.

14. What does changing the blending mode affect in a layer?
 a. Transparency
 b. Fill
 c. Color
 d. Location

15. Which of the following options do you adjust to set the number of points in a star?
 a. Sides
 b. Tips
 c. Ends
 d. Angle

16. **Which of the following could you *not* use to move multiple layers on the canvas?**
 a. Link layers
 b. Flatten layers
 c. Merge layers
 d. Simplify layers

17. **Which of the following methods ensures that a layer will be completely visible on the canvas?**
 a. 100% opacity
 b. Top of the Layers palette and 100% opacity
 c. Top of the Layers palette
 d. Layer is the fill of a layer mask

18. **Which of the following indicates that a layer is hidden?**
 a.
 b.
 c.
 d.

19. **Which command creates a clipping group?**
 a. Link layers
 b. Group with Previous
 c. Simplify layer
 d. Merge layers

▼ SKILLS REVIEW

1. **Understand layers.**
 a. Describe an advantage of using layers when creating or editing an image.
 b. Identify three tasks you can perform using the Layers palette.
 c. Describe how the position of a layer in the Layers palette affects its appearance on the canvas.

2. **View and modify layers.**
 a. Start Photoshop Elements, open Full Edit, open the file PSE F-4.psd from the location where you store your Data Files, then save it as **open-prairie.psd**.
 b. In the Layers palette, show the Rock Silhouette and the Wispy Clouds layers.
 c. Move the Clouds layer to the top of the Layers palette.
 d. Rename the Layer 1 layer to **One Cow**.
 e. Save the file open-prarie.psd.

3. **Group and link layers.**
 a. Select the Clouds layer, then apply the Group with Previous command to this layer.
 b. Move the cow down on the canvas so that the hooves are hidden by the rocks and the bounding box is even with the bottom of the canvas.
 c. Link the One Cow and Windmill layers.
 d. Move the linked layers 20 pixels to the right, click a blank part of the document window, then compare your image to Figure F-28.
 e. Save and close the file open-prairie.psd.

4. **Add content to a file.**
 a. Open the file PSE F-5.psd from the location where you store your Data Files, then save it as **moments-away.psd**.
 b. Select Artwork on the Create tab, then open the Content palette, if necessary.
 c. Select Type in the By list box, select the Themes category, then apply the Casual Party theme to the image. (*Hint*: The theme is near the top of the palette. If prompted to replace an existing theme, click OK.)
 d. Select Color in the By list box, select the Red category, then apply the Food, Pepper graphic to the image. (*Hint*: Click the Filter for Graphics button on the Content palette, then look for a red pepper.)
 e. Repeat Step d three times, then move the peppers to each corner of the canvas.
 f. Save the file moments-away.psd.

FIGURE F-28

5. Modify content.

 a. Open Full Edit.

 b. Increase the size of the top left and bottom right peppers so that each pepper's inside bounding box is even with the black background in the Tijuana object.

 c. Drag the left middle sizing handle of the Casual Party object to the left edge of the canvas.

 d. Save the file moments-away.psd.

6. Create a shape and adjust a layer.

 a. Select the Custom Shape Tool, then display the Rulers, if necessary.

 b. Click the Click to open Custom Shape picker on the Options bar, click the palette arrow, then click Ornaments.

 c. Reset foreground and background colors, click the Point Right thumbnail, position the cursor at 15 H and 5 V, then click and drag to 16.5 H and 5.5 V.

 d. Select the top right pepper, then change the blending mode in the Layers palette to Vivid Light.

 e. Change the opacity of the Shape layer to **55%**.

 f. Save the file moments-away.psd.

7. Add text.

 a. Select the Horizontal Type Tool, then set the following options: Font Family: **Times New Roman**, Font Style: **Bold Italic**, Font Size: **100**, Text color: R: **212**, B: **67**, G: **35**.

 b. Position the cursor at 2.5 H and 8 V, then type **just a few moments away....**

 c. Save the file moments-away.psd.

8. Edit and modify text.

 a. Select the words "just a few" and the blank space after the "w," then press Delete.

 b. Select the Create warped text option, select the Shell Lower style, change the Bend to **+32**, then apply the style.

 c. Save the file moments-away.psd.

9. Merge and flatten layers.

 a. Save the file moments-away.psd as **moments-flattened.psd**.

 b. Simplify the Casual Party 1 layer.

 c. Select the Shape layer and the Background layer, then merge them.

 d. Flatten the image, then compare your image to Figure F-29.

 e. Save and close the file moments-flattened.psd, then exit Photoshop Elements.

FIGURE F-29

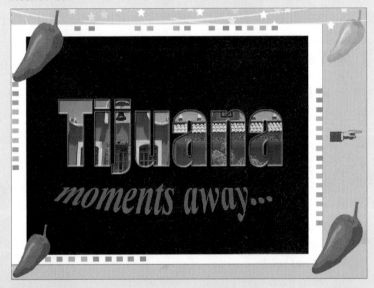

▼ INDEPENDENT CHALLENGE 1

You have volunteered to provide Web graphics for an organization that supports a wild reserve for simians that were removed from their natural habitat. The organization would like you to create a splash screen that gets the visitor's attention.

 a. Start Photoshop Elements, then open Full Edit.

 b. Open the file PSE F-6.psd from the location where you store your Data Files, then save it as **reserve.psd**.

 c. Rename layers as follows: Layer 6: **Table**; Layer 2: **Chimp**; Layer 1: **Orangutan**, Layer 3: **Gradient**, and Layer 5: **Forest**. (*Hint*: You will rename the Layer 4 and Layer 4 copy layers later.)

 d. Move the Gradient layer to the bottom of the Layers palette.

 e. Change the opacity of the Forest layer to **57%**.

 f. Move the Chimp layer above the Table layer.

▼ INDEPENDENT CHALLENGE 1 (CONTINUED)

g. On the canvas, move the grapes in the Layer 4 copy layer in a straight line (10 pixels at a time) to the right edge of the table, partially covering the chimp, then move the Layer 4 and Layer 4 copy layers beneath the Chimp layer in the Layers palette.

h. Merge the Layer 4 and Layer 4 copy layers, then name the merged layer **Grapes**. (*Hint*: Press and hold [Ctrl] to select the layers.)

i. Link the Gradient and Forest layers, then compare your image to Figure F-30.

j. Save and close the file reserve.psd file, then exit Photoshop Elements.

▼ INDEPENDENT CHALLENGE 2

Your company has just completed a long, arduous project for a client, and you won the company lottery to be the first to go on vacation. You decide to make a festive graphic that will remind others that their vacations are coming, but that you are ready to go. You plan to post the image on the company intranet, include it as part of an e-mail message, and print it in flyers you can post all around the office. First, you prepare the basic design.

a. Start Photoshop Elements, then open Full Edit.

b. Open the file PSE F-7.psd from the location where you store your Data Files, save it as **vacation.psd**, then display Rulers, if necessary.

c. Show hidden layers, create a new layer, move it to the bottom of the Layers palette, fill it with a foreground color of R: **107**, G: **16**, and B: **135**, then name the layer **Purple**. (*Hint*: Click the Create a new layer button in the Layers palette.)

d. Move the oranges layer to the top of the Layers palette.

e. Merge the oranges, sailing, and miami layers. (*Hint*: Select the layers first.)

f. Group the merged layer with the Florida layer beneath it.

g. Select the Horizontal Type Tool, then set the following options: Font Family: **Copperplate Gothic Bold**, Font Style: **Regular**, Font Size: **150**, Text color: **black**, and **Center Text**.

h. Type **Vacation**, center the text under the Florida layer, move the text so that the tops of the letters are aligned with **7 V**, then move the layer above the Purple layer in the Layers palette. (*Hint*: Make sure the layer is selected before you proceed to Step i.)

i. Set the following options in the Content palette on the Create tab: **By Type**, Category: **Text**, then apply the **Gradient** thumbnail to the VACATION layer. (*Hint*: Commit the action, if prompted.)

j. Select the Florida text on the canvas, apply the **Bulge** warp text style, set the Bend to **+66**, then set the Vertical Distortion to **+13**.

k. Save your work, then compare your image to Figure F-31.

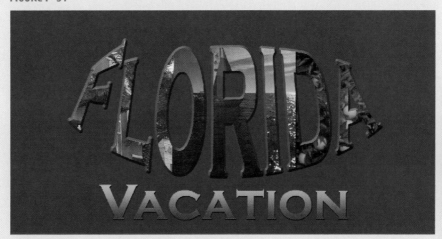

▼ INDEPENDENT CHALLENGE 2 (CONTINUED)

Advanced Challenge Exercise

- Use the Rounded Rectangle Tool to create a shape in the color of your choice that appears behind the Florida and Vacation text on the canvas.
- Apply at least one graphic from the Content palette.
- Add text to or near one of the graphics.

l. Save and close the file vacation.psd, then exit Photoshop Elements.

▼ INDEPENDENT CHALLENGE 3

You work for a company that manufactures flags for countries around the world. Your team is currently filling an order for flags for the Czech Republic. A fourth-grade class is coming to tour the factory, and your manager asks you to create a colorful image that includes the Czech flag he will give to the class. The final design of the image is up to you.

a. Start Photoshop Elements, then open Full Edit.

b. Open file PSE F-8.psd from the location where you store your Data Files, then save it as **czech.psd**.

c. Add the following text to the image: **Czech Republic**, then format the text however you wish, including applying Text content from the Content palette.

FIGURE F-32

d. Add a frame to the image from the Content palette, then add the file PSE F-9.jpg to the frame. Modify the frame and image as you wish.

e. Add other objects from the Content palette as desired.

f. Create a shape using one of the Shape tools in the toolbox.

g. Adjust opacity and/or blending mode for layers as desired.

h. Save your work, then compare your image to Figure F-32.

Advanced Challenge Exercise

- Create a new blank file, apply a frame from the Content palette, then insert the file czech.psd into the frame.
- Flatten the file.

i. Close the file czech.psd, then exit Photoshop Elements.

▼ REAL LIFE INDEPENDENT CHALLENGE

Accumulating layers in a file is easy and can happen quickly, but remember that each layer bulks up the file size. To see the effects that simplifying, merging, and flattening layers can have on file size, you open a file that has multiple layers and compare the file size as you work with the layers.

a. Start Photoshop Elements, open Full Edit, then open a file that has multiple layers and content, such as any of the files you've worked with in this lesson. In this example, the file dragon_hologram.psd will be analyzed.

b. Open a file in a word processing program or create a blank Photoshop Elements file and select the Horizontal Type Tool, then save it as **filesize_comparison**. Type **Original size**, **Simplified layer size**, **Merged layers size**, and **Flattened layers size** on separate lines.

c. Open the file management utility for your computer, note the size of the original saved file you are using (such as dragon_hologram.psd), then type that number next to Original size in the filesize_comparison document. Simplify a layer, save the file, then type the new file size in the filesize_comparison document. Repeat after you merge and flatten the layers.

d. Save and close the file filesize_comparison, then exit Photoshop Elements or your word-processing program.

▼ VISUAL WORKSHOP

Open the file PSE F-10.psd in Full Edit from the location where you store your Data Files, then save it as **ursa_major.psd**. Insert PSE F-11.jpg in the frame in the image shown in Figure F-33. (*Hint*: Move a layer and apply the Stamp 1 frame By Type, Arial font, and the Rise warp text style with default settings.) When you are finished, press [Print Screen] and paste the image into a word-processing program, add your name to the document, print the page, then close the word processor without saving changes and exit Photoshop Elements.

FIGURE F-33

Making Selections and Applying Effects

In Full Edit, you can use the Marquee Tools, Lasso Tools, Magic Wand Tool, and Quick Selection Tool to perform more precise selections for correction work or photo enhancement. These tools select pixels which can then be manipulated based on either an area you define or by a color. If one tool doesn't quite do the job, you can easily use them in combination to select any part of an image. A **composite image** is an image formed by combining different parts of multiple images. Applying a filter or **effect** changes pixels to emulate a visual or photographic effect that might be achieved in traditional photography with a special camera lens, lighting, darkroom retouching, or other expert manipulation. Great Leap Digital is beginning a Web and print ad campaign for stores in the Greenwood, a local shopping center. You help enhance the images using some of the most powerful tools in Photoshop Elements.

OBJECTIVES

Use Marquee Tools

Use Lasso Tools

Use the Magic Wand and Quick Selection Tool

Understanding filters and effects

Blur part of an image

Use the Smart Brush Tool

Sharpen an area

Apply a lens flare

Emulate artistic media effects

Using Marquee Tools

Marquee selections are temporary areas of selected pixels. A marquee area exists until you modify the pixel selection, for example, by cutting, copying, or recoloring it. You create marquee selections using the **Rectangular Marquee Tool** or the **Elliptical Marquee Tool**. Table G-1 describes all the selection tools. ▓▓▓ The Greenwood shopping center wants to tell the sales staff how their quarterly sales can really soar with the new ad campaign. You use the Rectangular Marquee Tool to create and move a selection in a photo for the shopping center's combined ad.

STEPS

1. **Start Photoshop Elements, open Full Edit, then reset all tool settings on the Options bar**

2. **Open the file PSE G-1.jpg from the location where you store your Data Files, then save it as soaring_sales.psd**
 The image shows several hot air balloons.

> **TROUBLE**
> To redraw a marquee, redrag ＋ on the canvas.

3. **Zoom in on the two balloons at the bottom left, click the Rectangular Marquee Tool ▓ in the toolbox, then drag ＋ around both balloons, as shown in Figure G-1**
 The selection marquee appears as a flashing perimeter (sometimes called "marching ants") surrounding the balloons. You can drag a marquee anywhere on the canvas as long as a selection tool is active and ⊾ appears on the marquee.

4. **Press and hold [Ctrl], position ⊾ within the marquee, then drag the selection to the bottom of the canvas**
 The selected pixels are cut and moved from their original location, exposing the background color, white. This is not the effect you wanted, so you undo your actions and redraw a selection.

> **TROUBLE**
> Be sure to double-click the number or the entire value in the Feather text box.

5. **Undo the cut and move, click the canvas to remove the marquee, double-click the Feather text box on the Options bar, type 35, then draw a marquee within the area of both balloons**
 When you drag ＋, the marquee appears as a rectangle. However, when you release the mouse, options such as feathering affect the marquee's shape, and in this case, appears as an oval. See Figure G-2. Increasing the amount of **feathering** creates a soft-edged selection; the edge is blended more with the surrounding pixels.

> **TROUBLE**
> Depending on the background, effects of feathering may not be apparent until you move, copy, or fill the selection.

6. **Press and hold [Ctrl], place ⊾ in the marquee, drag the selection to the bottom of the canvas, click the canvas, press [Ctrl] [0], then compare your screen to Figure G-3**
 The selection is cut and moved, and the large feathering setting results in an image echo effect.

7. **Save the file soaring_sales.psd**

TABLE G-1: Selection Tools

tool	name	description
▣	Rectangular Marquee Tool	Draws square or rectangular selection
▣	Elliptical Marquee Tool	Draws circular or elliptical selection
⬮	Lasso Tool	Draws freehand selection
⬮	Magnetic Lasso Tool	Draws selection that snaps to edges of image
⬮	Polygonal Lasso Tool	Draws selection in multiple straight segments
✶	Magic Wand Tool	Makes selection based on similarly colored pixels
▨	Quick Selection Tool	Makes selection based on color and texture
▨	Selection Brush Tool	Makes a selection by painting freehand
▨	Smart Brush Tool	Simultaneously selects area and applies effects

FIGURE G-1: Drawing a selection with the Rectangular Marquee Tool

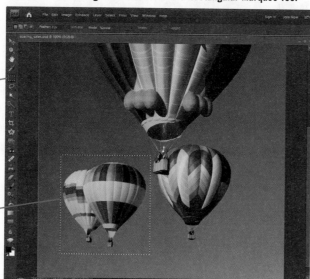

Rectangular
Marquee Tool

Marquee
selection;
yours might
differ
slightly

FIGURE G-2: Drawing a feathered marquee

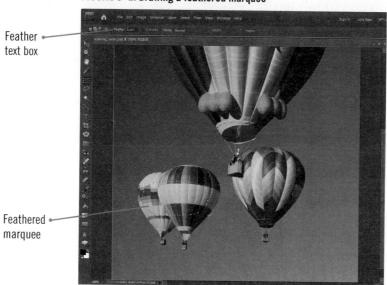

Feather
text box

Feathered
marquee

FIGURE G-3: Viewing moved selection

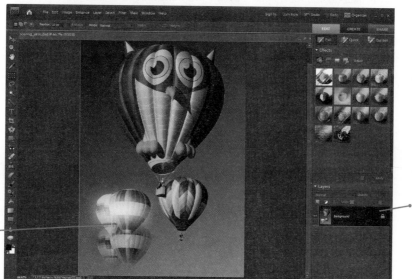

Selections
appear on
active layer

Feathered
selection
cut and
moved

Making Selections and Applying Effects **Photoshop Elements 153**

Using Lasso Tools

The Lasso Tool group consists of the Lasso Tool, the Polygonal Lasso Tool, and the Magnetic Lasso Tool. Each tool allows you to manually trace a shape to create a selection. With the **Lasso Tool**, you draw the selection freely in one motion; you create the selection when you stop dragging the pointer. The **Polygonal Lasso Tool** creates a series of straight line segments each time you click the mouse. The **Magnetic Lasso Tool** responds to areas of contrast and snaps segments where it finds the highest variation between the selection and the background. As you continue to work on the photo for the Greenwood shopping center ad, you use the Magnetic Lasso Tool to make a selection, modify the selection, and extract it from the background.

STEPS

1. **Make sure that the file soaring_sales.psd is open**

 You want to select and remove the owl balloon from the rest of the photo.

2. **Zoom in on the owl balloon, click the Magnetic Lasso Tool 🔲 in the toolbox, type 15 in the Feather text box on the Options bar, type 30 in the Width text box, then type 80 in the Edge Contrast text box**

 Width determines how wide an area the pointer should search for as an edge as you make a selection. **Edge Contrast** determines the amount of contrast between the colors on each edge you select. For high contrast images, high Width and Edge Contrast values work best to "find" the edge; for images with low contrast, set lower values. **Frequency** determines the distance between the points.

QUICK TIP

You can also complete a path by pressing [Enter] or by pressing and holding [Ctrl] and then clicking the mouse.

3. **Position 🖰 along an edge of the balloon, drag around the balloon to draw a path, excluding the basket, as shown in Figure G-4, then double-click the mouse to complete the path**

 Tools in the Lasso group make selections by snapping fastening points along the edge of an object, forming a path. You can also click at any time to set a fastening point or press [Delete] or [Backspace] to remove points as you create the path. You expand the size of the selection to include some of the surrounding sky.

4. **Click Select on the menu bar, point to Modify, click Expand, type 30 in the Expand By text box in the Expand Selection dialog box, then click OK**

 The selection area expands by 30 pixels to include the sky immediately surrounding the balloon.

QUICK TIP

You can also select the inverse of a selection by pressing [Shift][Ctrl] [I].

5. **Click Select on the menu bar, click Inverse**

 The Inverse command switches the current selection, so now the marquee area consists of the image outside of the balloon and the 30 pixels of sky. You want to remove this selection.

6. **Press [Delete], then press [Ctrl] [D] to deselect the selection**

 The owl balloon has a feathered sky border, as shown in Figure G-5.

7. **Save and close the file soaring_sales.psd**

FIGURE G-4: Drawing a selection with the Magnetic Lasso Tool

Width text box

Edge Contrast text box

Magnetic Lasso Tool

Magnetic Lasso Tool pointer

Drag around edge or click to set fastener points

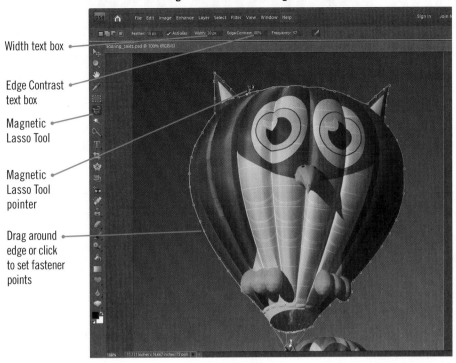

FIGURE G-5: Results of deleting inverse selection

Expanded border

Area deleted after selecting inverse

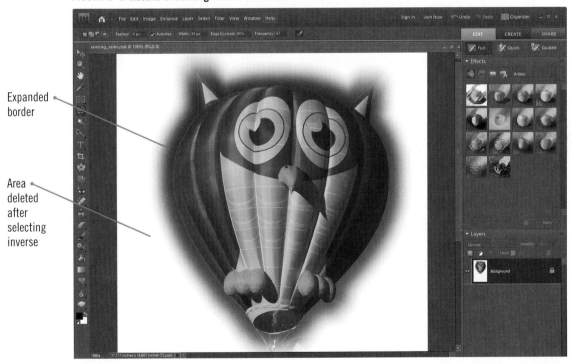

Saving selections

You can save selections you create with the Marquee Tools, Lasso Tools, Magic Wand Tool, and Quick Selection Tool. To save a selection, click Select on the menu bar, click Save Selection, then name the selection in the Save Selection dialog box. To recall a selection, click Select on the menu bar, click Load Selection, then select a name from the list. You can only save selections you've created in the current open file; you cannot load a selection from one open file into another open file. When you load a saved selection, it appears in the image in the same location where you first created it.

Using the Magic Wand Tool and the Quick Selection Tool

The **Magic Wand Tool** is a fast and efficient way to select large areas of similar color. It works best with solid blocks of color. The **Quick Selection Tool** also selects by color, but seeks out an edge and allows you to "paint" your selection with a brush stroke. One of the stores in the Greenwood shopping center specializes in children's footwear. You develop an image to use in an ad for that store.

STEPS

1. Open the file PSE G-2.psd from the location where you store your Data Files, then save it as pinkboots.psd

2. Zoom in on the boots, click the Magic Wand Tool ✺ in the toolbox, then click the purple bar in the left side of the image

 Options for the Magic Wand Tool appear on the Options bar. Some, but not all, of the purple pixels are selected, as shown in Figure G-6.

3. Press [Ctrl] [D] to deselect pixels, click the Quick Selection Tool ✎ in the toolbox, click the left boot, and then click and drag ⊕ over the boots until the boots are selected

 Depending on your selection, pixels outside the boots may also be selected, or not all of the boots may be included. You refine the selection to include just the boots.

4. Click the Brush picker on the Options bar, drag the Set the brush diameter slider ▮ to 10, click areas of the boot not included in the selection if necessary, press and hold [Alt], then click any areas you want to remove

 The selection area includes just the boots, as shown in Figure G-7. You refine the edge of the selection to smooth it out.

5. Click the Refine Edge button on the Options bar, drag the Smooth slider ▮ to 2 and the Contract/Expand slider ▮ to +2, then click OK

 The Smooth option removes the jagged selection edge; Contract/Expand adjusts the size of the selection.

6. Click Layer on the menu bar, point to New, then click Layer via Copy to paste the selection on a new layer, then click the Show/Hide icon 👁 in the Background layer

 The boots appear on their own layer, as shown in Figure G-8.

7. Save and close the file pinkboots.psd

Using the Magic Extractor Tool

You can use the Magic Extractor Tool to easily remove the background in an image. The tool consists of a dialog box where you select the area you want to extract in the foreground and then select the area you want to delete in the background. The advantage of the tool is its simplicity; precision is not required, you just click, drag, or scribble a selection. It is most effective when the image has clear color contrasts. Depending on the selection, it may take a few moments for the tool to display results.

FIGURE G-6: Selecting pixels with the Magic Wand Tool

Contiguous
check box

Magic Wand Tool

Selected pixels;
yours might
differ

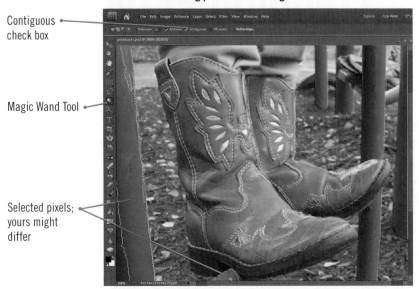

FIGURE G-7: Using the Quick Selection Tool to make a selection

Quick Selection
Tool

Refined
selection

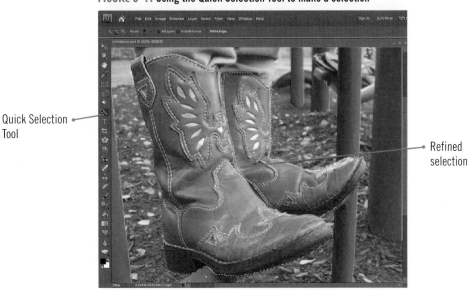

FIGURE G-8: Selection pasted on new layer

New layer

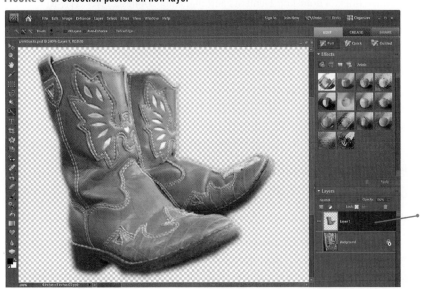

Understanding Filters and Effects

As you have seen, you can add content to a file to enhance images. You can also use filters and effects to create illusions such as movement, light, and frames; to eliminate flaws; and to mimic artistic media such as a charcoal drawing, watercolor, or metallic finishes. You can apply effects and filters to multiple layers or to a selection. Photoshop Elements has dozens of filters, effects, and layer styles available on the Filter menu and in the Effects palette. Filters, effects, and layer styles are described in Table G-2. ▓▓░░ You explore the specifics of filters and effects before applying them to images you will need to create for the ad campaign.

DETAILS

Filters and effects can be created and modified in Photoshop Elements in the following ways:

QUICK TIP

It is most effective to apply a filter or effect after you have scaled the image to its final size.

- **The Filter menu and the Filter Gallery**

 Filters are divided into various categories, accessible from the Filter menu, the Filter Gallery (a command on the Filter menu), and in the Effects palette. Depending on the filter, three things will happen once you select a filter: Photoshop Elements applies the filter automatically with no adjustment options; a small dialog box opens where you can adjust settings; or, usually, the Filter Gallery dialog box opens, as shown in Figure G-9.

 The filter name also appears in the Filter Gallery dialog box title bar. Here you can work in three panes to modify the filter. You can adjust the preview size in the Preview pane. The Filter thumbnails pane lists some, but not all, of the filters listed on the Filter menu. In the third pane, you can adjust individual filter settings and arrange, add, and delete filters in a palette that operates similarly to the Layers palette.

QUICK TIP

To display the names of filters and effects beneath their thumbnails in the Effects palette, click the More button ▶▶ at the top of the palette, then click Show Names.

- **The Effects palette**

 The adjustments, tweaks, and enhancements you can apply to an image are collectively known as **effects**. The Effects palette provides a single location where you can apply most of the filters found on the Filter menu as well as enhancements specific to the Effects palette known as **layer styles** and **photo effects**. You can click buttons in the Effects palette to show a single effect category or all of them. A sample layer style and effect are shown in Figure G-10. Because filters and effects are resource-intensive, you may find it more efficient to first create a selection with a Selection Tool and then apply the effect to the selection so you can quickly assess whether to apply it to more of the image.

- **The Style Settings dialog box**

 Unlike filters, Photoshop Elements automatically applies a layer style to the entire active layer. When you apply a layer style to the locked default Background layer, Photoshop Elements will prompt you to convert it to a regular layer. You cannot adjust layer style options in a dialog box ahead of time, but you can make limited edits to the style or add new styles in the Style Settings dialog box. To open the Style Settings dialog box, double-click the Indicates style setting icon ⓕ on the layer to which you've applied a layer style. The Style Settings dialog box is shown in Figure G-11. You can adjust Lighting Angle, Drop Shadow, Bevel, Glow, and Stroke styles.

TABLE G-2: Filter, Layer Style, and Photo Effects categories

effect	categories
Filter	Artistic, Blur, Brush Strokes, Distort, Noise, Pixelate, Render, Sharpen, Sketch, Stylize, Texture, Video
Layer Styles	Bevels, Complex, Drop Shadows, Glass Buttons, Image Effects, Inner Glows, Inner Shadows, Outer Glows, Patterns, Photographic Effects, Strokes, Visibility, Wow Chrome, Wow Neon, Wow Plastic
Photo Effects	Faded Photo, Frame, Misc. Effects, Monotone Color, Old Photo, Vintage Photo

FIGURE G-9: Filter Gallery dialog box

Selected filter name

Preview pane

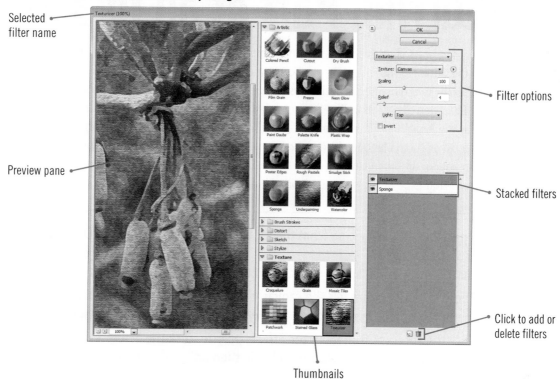

Filter options

Stacked filters

Click to add or delete filters

Thumbnails

FIGURE G-10: Viewing a sample layer style and photo effect

Drop Shadow layer style

Old Photo photo effect

FIGURE G-11: Style Settings dialog box

Making Selections and Applying Effects

Blurring Part of an Image

Blurring part or all of an image can help draw attention to one area, set a mood or aesthetic style, or even create the illusion of movement. Photoshop Elements contains eight blur filters; see Table G-3 for a description of each. Two blur filters especially useful for simulating movement are the Motion Blur filter and the Radial Blur filter. The Motion Blur filter makes it appear as if the object were moving in a straight line, whereas the Radial Blur filter simulates circular movement. To create the illusion of movement, you may find it most useful to blur one object or area in an image. ▰▰▰▰▰ Wen-Lin wants you to create excitement in an image for an urban clothing store ad that will appear on one of the Greenwood shopping center's billboards. You experiment with the Motion Blur filter to enhance the image.

STEPS

1. **Open the file PSE G-3.jpg from the location where you store your Data Files, then save it as** sunset_leap.psd

 The image shows the silhouette of a man jumping in the air.

2. **Zoom in so the figure fills the canvas, click the Quick Selection Tool ▨ in the toolbox, then drag a selection to include the sky behind the figure, as shown in Figure G-12**

TROUBLE

If necessary, drag the dialog box out of the way so you can see the image on the canvas.

3. **Click the Filters button ▣ in the Effects palette, click the Select a type arrow, click Blur, double-click the Motion Blur thumbnail, then adjust the zoom so you can see the sky behind the figure**

 The Motion Blur dialog box opens, as shown in Figure G-13. Options for this dialog box include **Angle**, which sets the direction of the blur, and **Distance**, which controls how far the blur extends (in pixels). You can control the angle setting by typing a value in the text box or by dragging the radial slider clockwise or counterclockwise.

4. **Double-click the Angle text box if necessary, type 44, double-click the Distance text box, type 415, then click OK**

 The back of the figure is blurred.

5. **Press [Ctrl][D], press [Ctrl][0], then compare your image to Figure G-14**

 The motion blur creates the illusion that the figure is moving very rapidly.

6. **Save and close the file** sunset_leap.psd

TABLE G-3: Blur filters

filter	what it does
Average	Averages the colors, then fills in with a single color
Blur	Blends pixels by averaging the color of pixels adjacent to hard edges
Blur More	Blends pixels 3-4 times more strongly than Blur
Gaussian Blur	Blends pixels most strongly in the center of the image, creating a hazy effect that diminishes away from the center; named for an elliptical mathematical formula developed by Karl Gauss
Motion Blur	Mimics an object in motion using angle and distance
Radial Blur	Mimics a camera in motion in a zoom or concentric circle pattern
Smart Blur	Blurs user-selected pixels, such as those based on an edge or radius
Surface Blur	Softens surface while maintaining edges and detail

FIGURE G-12: Selecting an area to blur

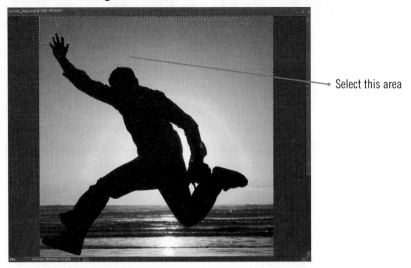

Select this area

FIGURE G-13: Motion Blur dialog box

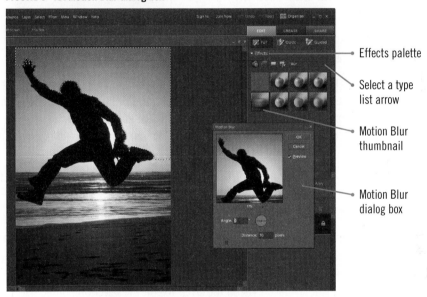

Effects palette

Select a type
list arrow

Motion Blur
thumbnail

Motion Blur
dialog box

FIGURE G-14: Results of applying a motion blur

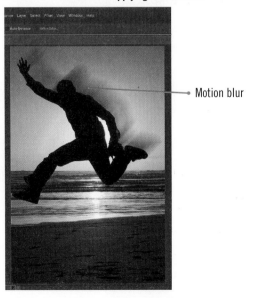

Motion blur

Using the Smart Brush Tool

The **Smart Brush Tool** combines the best elements of the Quick Selection Tool and a filter or effect: You can create a sophisticated effect in a single stroke simply by painting with the Smart Brush Tool. Photoshop Elements provides dozens of Smart Paint presets from which to choose, ranging from practical touchups to dramatic color effects. When you use the Smart Brush Tool, Photoshop Elements automatically creates an adjustment layer in the Layers palette. An **adjustment layer** is a type of color mask that affects the color of the layers beneath it, just as a shape mask affects the shape of the layers beneath it. ███ A magic and science store at the shopping center requires a unique look and feel for their ads. You use the Smart Brush Tool to instantly paint part of a photo in different color effects.

STEPS

1. **Open the file PSE G-4.jpg from the location where you store your Data Files, then save it as reflector.psd**

 The image shows a boy looking at his reflection in a distortion mirror.

2. **Click the Smart Brush Tool ▓ in the toolbox, drag the Smart Paint palette off the canvas, then compare your screen to Figure G-15**

3. **Click the Preset arrow in the Smart Paint palette, click Photographic, then click Film Negative**

4. **Alternate dragging and clicking ⊕ over the boy's reflection to select it**

 The selection is painted in colors that evoke a color film negative, as shown in Figure G-16. An Adjustment layer pin ▓ appears on the selection as a visual indicator that the selection is an adjustment. You can move this icon anywhere on the canvas. While the film negative effect is interesting, you explore a different effect that is equally striking, but less severe.

5. **Click the Preset arrow in the Smart Paint palette, click Reverse Effects, then click Reverse – Black and White**

 In this instance, the reflection remains in color while the rest of the image changes to black and white.

6. **Click the Move Tool ▓ in the toolbox, then compare your image to Figure G-17**

 This effect is not editable, as indicated by the Noneditable adjustment icon ▓ visible on the layer in the Layers palette. Many effects are editable, however. To edit adjustment layer settings, double-click the Adjustment layer icon ▓ on the layer. To edit the selection border, select the Smart Brush Tool in the toolbox, then adjust the size.

7. **Save the file reflector.psd**

FIGURE G-15: Viewing options for the Smart Brush Tool

Choose a Preset arrow

Smart Paint palette

Preset arrow

Presets

Smart Brush Tool

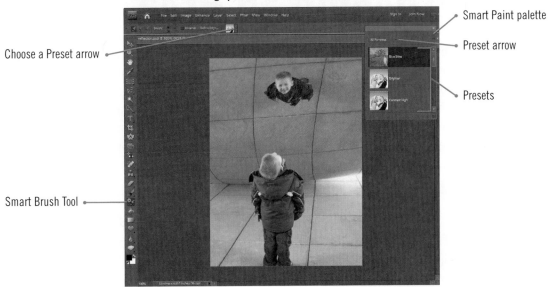

FIGURE G-16: Creating an adjustment layer

Adjustment layer pin

Click this preset

Adjustment layer icon

New adjustment layer

Layer mask

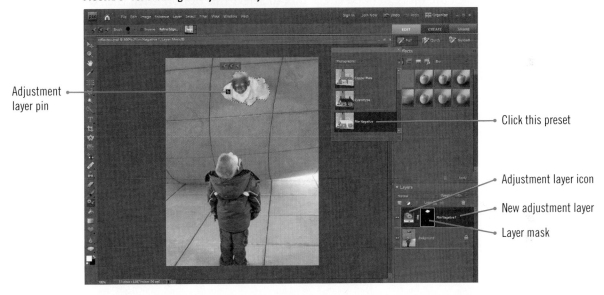

FIGURE G-17: Applying a Reverse – Black and White effect

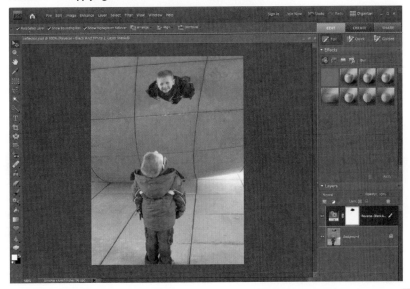

Sharpening an Area

Even with the auto-focus and scene selection features of digital cameras, you may still end up with photos that appear out of focus. You can sharpen images using automatic commands in Quick Edit and Guided Edit, or you can use the Unsharp Mask or the Adjust Sharpness commands on the Enhance menu. The Enhance menu commands open dialog boxes that adjust for Amount, how much to sharpen, and Radius, the number of pixels included around an edge. In the Adjust Sharpness dialog box, however, you can correct for three different blurs: Gaussian, Lens, and Motion. To complete your work on the mirror image, you sharpen it for maximum detail.

STEPS

1. Verify that the file reflector.psd is open, then select the Background layer, if necessary

2. Click Enhance on the menu bar, then click Adjust Sharpness

 The Adjust Sharpness dialog box opens, as shown in Figure G-18. The original image appears in the preview window.

3. Double-click the Amount text box, type 116, double-click the Radius text box, type 1.6, click the More Refined check box to select this option, then click OK

 The More Refined setting sharpens more detail, as shown in Figure G-19. These settings work best on images with broader imagery and less detail, such as a landscape.

4. Save and close the file reflector.psd

Using the Blur Tool and the Sharpen Tool

To soften or sharpen the focus in a small, precise area in an image, you can use the Blur Tool and the Sharpen Tool in the toolbox. By adjusting a small part of an image, you can subtly direct the eye to a certain area. In addition to setting brush size, you can set the Mode, which determines whether the blurring or sharpening blends pixels normally or emphasizes light or dark pixels. You can also set the brush Strength to set the amount of blur or sharpen in each brush stroke. Note that while the Blur Tool can be very beneficial, using the Sharpen Tools can be destructive and not as effective as using a Sharpen command.

FIGURE G-18: Adjust Sharpness dialog box

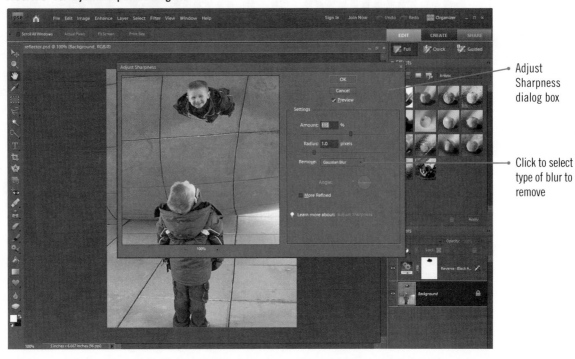

Adjust
Sharpness
dialog box

Click to select
type of blur to
remove

FIGURE G-19: Results of the Adjust Sharpness filter

Applying a Lens Flare

In traditional photography, many a photo has been spoiled by the reflection of light off the lens in circles and rays, in an effect known as **lens flare**. In digital photography, you can add a **lens flare filter** to an image to create the same effect intentionally, establishing a mood or an atmosphere. An example of each lens type is shown in Table G-4. The café in the shopping center wants to use their logo in their ad. You get to work on giving a café photo an edgier look.

STEPS

1. **Open the file PSE G-5.jpg from the location where you store your Data Files, then save it as storefront.psd**

 The image shows the outdoor sign of a café.

2. **Click Filter on the menu bar, point to Render, then click Lens Flare**

 The Lens Flare dialog box opens, as shown in Figure G-20. You can control the brightness of the lens flare and choose its appearance by specifying a **Lens Type**, which re-creates the glare created by certain camera lenses. You can also drag the lens flare pointer in the Preview window to reposition the point of the flare.

3. **Click each Lens Type option button to preview it**

4. **Click the 50-300mm Zoom option button, drag the Brightness slider ■ to 100 if necessary, drag the Lens Flare pointer ✛ to the upper left corner of the Preview window, then click OK**

 The lens flare appears in the image with a rose color cast and refractions throughout the image, as shown in Figure G-21.

5. **Save the file storefront.psd**

TABLE G-4: Lens flare options

lens flare	sample	lens flare	sample
50-300mm Zoom		105mm Prime	
35mm Prime		Movie Prime	

FIGURE G-20: Lens Flare dialog box

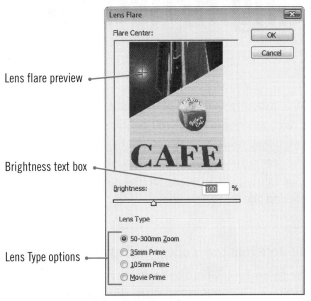

Lens flare preview

Brightness text box

Lens Type options

FIGURE G-21: Lens flare applied to image

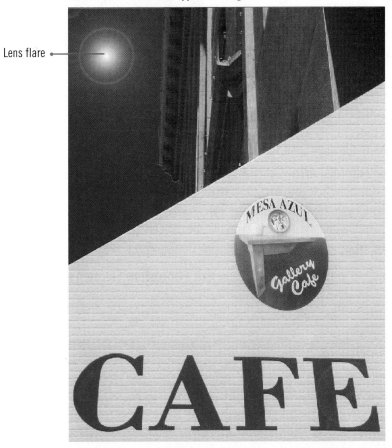

Lens flare

Using lens flare

In traditional photography, a lens flare occurs when light enters the lens, but does not form an image. Although technically considered a flaw, a lens flare can be used to add an abstract design element. To precisely align a lens flare, open the Info palette, note the coordinates where you want the lens flare to appear, open the Lens Flare dialog box, press and hold [Alt], click in the Preview window, then type the coordinates in the Precise Flare Center dialog box that opens. To create a lens flare on its own layer in the Layers palette, create a new layer using the Paint Bucket Tool to fill it with 50% gray (R,G, and B values 128), create the lens flare, then change the Blending Mode to Hard Light.

Emulating Artistic Media Effects

Photoshop Elements has an extensive collection of styles and effects. You can emulate many traditional art techniques and media, such as dry brush, colored pencil, or watercolor. You can also apply a special effect, such as neon glow, plastic wrap, or poster edges. By combining effects, you can produce remarkable results. After seeing your work on the Mesa Azul Café photo, the café owners contact you directly for an image of the café logo they can use for their staff uniform. You extract the logo and preview various filters before choosing one for the uniform.

STEPS

1. Verify that the file storefront.psd is open, then save it as shirt_logo.psd

2. Click the Magnetic Lasso Tool 🐛 in the toolbox, reset tool options, then draw a marquee around the round Mesa Azul logo in the store sign, as shown in Figure G-22

3. Click Select on the menu bar, click Inverse, then press [Delete]

 The area around the logo is deleted. You can crop exactly to a selection using a command on the Image menu, but first you reselect the logo.

4. Click Select on the menu bar, click Inverse, click Image on the menu bar, then click Crop

 The canvas is cropped to the logo. Using this command is quick and ensures the most accurate cropping.

> **QUICK TIP**
> You can click the category arrows in the middle pane to display thumbnails of the filters.

5. Click Filter on the menu bar, point to Stylize, then click Glowing Edges

 The Filter Gallery dialog box opens, as shown in Figure G-23. Because the name of this dialog box changes based on the currently selected filter, Glowing Edges appears in the title bar. The Glowing Edges filter adds a neon glow to the edges in an image. You select and preview another filter.

> **QUICK TIP**
> Previewing uses fewer resources than applying the filter to the image and then undoing or deleting it if you don't like it.

6. Click the Filter list arrow, click Poster Edges, double-click the Edge Thickness text box, type 5, double-click the Edge Intensity text box, then type 4

 The Poster Edges filter is applied to the logo. The Poster Edges thumbnail appears in the Artistic category along with other thumbnails. This seems like the right effect, so you keep it.

7. Click OK, then compare your screen to Figure G-24

8. Save and close shirt_logo.psd, then exit Photoshop Elements

FIGURE G-22: Selected logo

Selection

FIGURE G-23: Glowing Edges filter in the Filter Gallery

Filter list arrow

Glowing Edges filter applied to logo

FIGURE G-24: Poster Edges filter applied to a logo

Making Selections and Applying Effects

Practice

▼ CONCEPTS REVIEW

Label the elements of the Editor workspace shown in Figure G-25.

FIGURE G-25

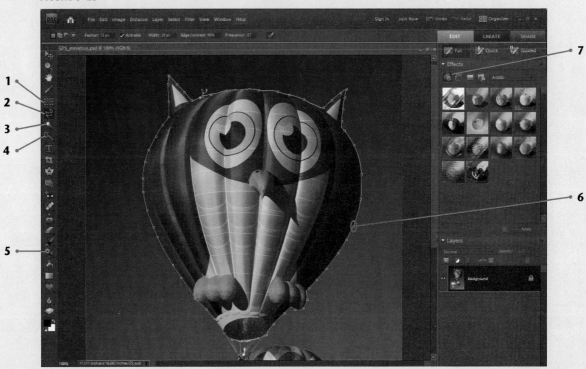

Match each term with the statement that best describes it.

8. **Feathering**
9. **Marquee Tools**
10. **Filter**
11. **Smart Brush Tool**
12. **Lasso Tools**

a. Creates a soft edge
b. Adds an effect as you paint the canvas
c. Manually traces a selection
d. Creates temporary areas of selected pixels
e. Emulates realistic or photographic effect

Select the best answer from the list of choices.

13. **Which blur type simulates circular movement?**
 a. Gaussian
 b. Distance
 c. Radius
 d. Radial

14. **Which tool is particularly effective where there is a strong contrast between the edge of the selection and the background?**
 a. Lasso Tool
 b. Rectangular Marquee Tool
 c. Magnetic Lasso Tool
 d. Magic Wand Tool

15. **What do you click to add smoothing or feathering to a selection?**
 a. Define Edge
 b. Combine Edge
 c. Refine Edge
 d. Design Edge

16. **On which menu can you access the Adjust Sharpness dialog box?**
 a. Select
 b. Enhance
 c. Filter
 d. Effects

17. **Which command selects everything except the selection?**
 a. Reverse
 b. Invert
 c. Inverse
 d. Converse

18. **When selecting an area, how would you increase the number of pixels selected?**
 a. Increase the Tolerance setting
 b. Lower the Tolerance setting
 c. Increase the Smooth setting
 d. Increase the Frequency setting

▼ SKILLS REVIEW

1. **Use Marquee Tools**
 a. Start Photoshop Elements, open Full Edit, open the file PSE G-6.jpg from the location where you store your Data Files, then save it as **cooldude.psd**.
 b. Display Rulers if necessary, select the Rectangular Marquee Tool, reset tool options, then set the Feather option to **55**.
 c. Drag a marquee around the man on the left, then cut and move it to the left approximately ¼" until the foreheads that are visible when you move the selection intersect.
 d. Deselect the marquee, then compare your image to Figure G-26.
 e. Save and close the file cooldude.psd.

2. **Use Lasso Tools.**
 a. Open the file PSE G-7.jpg from the location where you store your Data Files, then save it as **kangaroo_sign.psd**.
 b. Select the Polygonal Lasso Tool, then draw a marquee around the sign and pole.
 c. Set the Contract/Expand setting in the Refine Edge dialog box to –2.
 d. Copy the selection to a new layer, then hide the Background layer.
 e. Save the file kangaroo_sign.psd, but do not close it.

3. **Use the Magic Wand Tool and the Quick Selection Tool.**
 a. Verify that the new layer is selected in the file kangaroo_sign.psd, select the Magic Wand Tool, set the Tolerance to **50**, then deselect the Contiguous check box.
 b. Select the yellow pixels in the sign, copy the selection to a new layer, then show only that layer.
 c. Show only the Background layer, select the Quick Selection Tool, select the entire sign, including the pole, then copy the selection. (*Hint*: Adjust the brush size and zoom as needed.)
 d. Open the file PSE G-8.jpg from the location where you store your Data Files.
 e. Paste the selection in the file, then drag the sign to the left side of the canvas.

FIGURE G-26

f. Compare your image to Figure G-27, then save the file as **kangaroo_crossing.psd**.

g. Close the files kangaroo_sign.psd and kangaroo_crossing.psd.

4. **Understand filters and effects.**

a. Describe three ways Photoshop Elements applies filters to an image.

b. Describe the basic components of the Effects palette.

c. Describe the basic components of the Filter Gallery.

5. **Blur part of an image.**

a. Open the file PSE G-9.jpg from the location where you store your Data Files, then save it as **gotwheels.jpg** using default JPEG settings.

b. Select the car and driver, then select its inverse.

c. Apply a Radial Blur with the following settings: Amount: **13**, Blur Method: **Zoom**, and Quality: **Best**.

d. Compare your image to Figure G-28, then save and close the file **gotwheels.jpg**.

6. **Use the Smart Brush Tool.**

a. Open the file PSE G-10.jpg from the location where you store your Data Files, then save it as **sunflower.psd**.

b. Select the Smart Brush Tool, open the Smart Paint palette if necessary, select the Dark-Sky preset in the Nature category, then paint the sky. (*Hint*: Select as much of the sky in between the leaves and stems as possible.)

c. Save the file sunflower.psd, but do not close it.

7. **Sharpen an area.**

a. Verify that the file sunflower.psd is open, then select the Background layer.

b. Open the Adjust Sharpness dialog box, set the Amount to **155** and the Radius to **2.2**, select the More Refined check box, then close the dialog box.

c. Save the file sunflower.psd, but do not close it.

8. **Apply a lens flare.**

a. Verify that the file sunflower.psd is open, then select the Background layer, if necessary.

b. Open the Lens Flare dialog box, select the 105mm Prime lens type, adjust the Brightness to **100**, move the lens flare to the left edge of the sunflower in the position shown in Figure G-29, then close the dialog box.

c. Save the file sunflower.psd, but do not close it.

FIGURE G-27

FIGURE G-28

▼ SKILLS REVIEW (CONTINUED)

9. **Emulate artistic media effects.**

 a. Verify that the file sunflower.psd is open, then select the Background layer, if necessary.

 b. Display Texture filter thumbnails in the Effects palette, open the Mosaic Tiles dialog box in the Filter Gallery, then adjust the following settings: Tile Size: **11**, Grout Width: **4**, and Lighten Grout: **8**.

 c. Close the Filter Gallery dialog box, then compare your image to Figure G-29.

 d. Save and close the file sunflower.psd, then exit Photoshop Elements.

FIGURE G-29

▼ INDEPENDENT CHALLENGE 1

You work at a laminate company that develops unique designs for cell phones. Your company sponsors a Best Idea of the Month contest, where the winner gets an extra day off. You have an idea for a new application of the technology: musical instruments. You want to work up a visual example to include with your suggestion.

 a. Start Photoshop Elements, then open Full Edit.

 b. Open the file PSE G-11.jpg from the location where you store your Data Files, then save it as **blue_notes.psd**.

 c. Use the Smart Brush Tool to select the white keys, then apply the Paint It Blue preset to it. (*Hint*: Look in the Color category.)

 d. Open the Distort filter gallery on the Effects palette, then apply the Glass filter to the Background layer with the following settings: Distortion: **7**, Smoothness: **6**, Texture: **Frosted**.

 e. Compare your image to the sample shown in Figure G-30.

 f. Save and close the file blue_notes.psd, then exit Photoshop Elements.

FIGURE G-30

▼ INDEPENDENT CHALLENGE 2

You own Ex Post Retro, a household supply and furnishing store. You just received several bolts of vintage shag carpeting. Hoping to start a trend, you're going to run ads advertising your Shag is Back promotion. For the ads, you want to include a minimalist photo.

a. Start Photoshop Elements, then open Full Edit.

b. Open file PSE G-12.jpg from the location where you store your Data Files.

c. Use the selection tools of your choice to select and delete the grass background, then copy the layer.

d. Open file PSE G-13.jpg from the location where you store your Data Files, then save it as **shag_is_back.psd**.

e. Paste the selection in the file, then move the new layer up to be fully visible, if necessary.

f. Display Drop Shadows layer styles in the Effects palette, then apply the Soft Edge style to the new layer.

g. Select the Background layer, then display Stylize filters in the Effects palette.

h. Open the Wind dialog box, select Wind as the method, if necessary, and From the Left as the direction, then close the dialog box.

i. Save the file shag_is_back.psd, then compare your image to Figure G-31.

FIGURE G-31

Advanced Challenge Exercise

■ Apply the Rivet layer style to Layer 1. (*Hint*: Look in the Complex category.)

■ Modify the Bevel settings in the Style Settings dialog box to Size **16**. (*Hint*: Double-click the Indicates layer styles icon.)

j. Close the files PSE G-12.jpg and shag_is_back.psd without saving changes.

k. Exit Photoshop Elements.

▼ INDEPENDENT CHALLENGE 3

One of your friends takes photos at children's birthdays. She's just finished working five birthday parties in three days, and needs some help putting together a few special shots. You begin extracting a party guest and placing her in a "celebrity red carpet" scene.

a. Start Photoshop Elements, then open Full Edit.

b. Open file PSE G-14.jpg from the location where you store your Data Files.

c. Use the selection tool(s) of your choice to extract the girl from the background. (*Hint*: Be sure to exclude the background under her arms.)

d. Set the following Refine Edge settings: Smooth: **3**, Feather: **1.5**, and Contract/Expand: **3**, then copy the selection.

e. Open file PSE G-15.psd from the location where you store your Data Files, then save it as **redcarpet.psd**.

f. Paste the selection in the file, move the selection over the white space, and align the hat to the top of the canvas.

g. Apply the High Drop Shadow layer style to Layer 1.

▼ INDEPENDENT CHALLENGE 3 (CONTINUED)

h. Apply the lens flare of your choice to the Photographers layer.

i. Close the file PSE G-14.jpg, save the file redcarpet.psd, then compare your image to Figure G-32.

Advanced Challenge Exercise

- Select the glasses frames with the Smart Brush Tool, then apply the Red All Over preset in the Color category to it.

- Select the Photographers layer, then apply the Radioactive Inner Glow layer style to it. Open the Style Settings dialog box, then change the Inner Glow size to **32**.

FIGURE G-32

j. Close the file redcarpet.psd, then exit Photoshop Elements.

▼ REAL LIFE INDEPENDENT CHALLENGE

The filters, layer styles, and photo effects in Photoshop Elements can add excitement and interest to any image and are quite fun to use. With so many choices and little way to anticipate the results, experimentation may be the best way to learn what they can do. You find a photo that has many objects to which you can apply effects.

a. Start Photoshop Elements, then open a file that has multiple objects in it or areas you can copy and paste. You may also apply different effects to the same photo by copying the Background layer. You can take your own photos or obtain images from your computer, scanned media, or from the Internet. When downloading from the Internet, you should always assume the work is protected by copyright. Be sure to check the Web site's terms of use to determine if you can use the work for educational, personal, or noncommercial purposes.

b. Use the selection tools of your choice to isolate parts of the image, then apply Smart Brush presets, filters, layer styles, and photo effects to several selections.

c. Save the file as **effects_experiment.psd**, then exit Photoshop Elements.

Open the file PSE G-16.jpg from the location where you store your Data Files, then save it as **lone_cactus.jpg**. Apply three filters using default settings to match the image shown in Figure G-33. (*Hint*: For the sky, look in the Texture category; for the rocks, look in the Brush Strokes category; and notice the position of the lens flare effect in the upper left corner.) When you are finished, press [Print Screen] and paste the image into a word-processing program, add your name to the document, print the page, then close the word processor without saving changes and exit Photoshop Elements.

FIGURE G-33

Creating and Sharing Projects

Files You Will Need:

Cattle folder
Halloween folder
Ocean folder
Rock Formations folder
Structures folder
PSE H-1.jpg through PSE H-18.jpg

Photoshop Elements allows you to create images even the best camera couldn't capture: panoramic images or the perfect shot. Using the Adobe Photoshop Elements Slide Show Editor gives you the opportunity to be producer, director, cinematographer, and special-effects manager all at the same time. You can combine still images, graphics, video, and audio to create a distinctive and exciting multi-media experience. And, once you're ready to share your photos, you can email them, post them online in galleries, order print copies, create sophisticated slide shows with music or narration, even burn them to a CD or DVD. ▓▓▓ Great Leap Digital bids on many projects online and submits a digital portfolio. Wen-Lin wants to train all staff in distributing media electronically. She asks you to help with training. You begin by familiarizing yourself with various ways to create and distribute exciting images and projects.

OBJECTIVES

Create a Photomerge Panorama
Create a Photomerge Scene Cleaner image
Email a photo
Use Photo Mail
Create an online album
Build a slide show
Edit a slide show
Customize a slide show
Output a slide show

Creating a Photomerge Panorama

Photomerge uses two or more photos to create stunning images using four features. Group Shot allows you to include your subjects' best expressions; Faces allows you to create a unique composite image using different faces; Scene Cleaner erases unwanted objects in an image; and Panorama blends the best-matched portions of images to create a seamless panorama. ▓▓▓▓▓ Having panoramic offerings in the company portfolio is a must. You create a panorama of an iconic New York City bridge using the Photomerge Panorama feature.

STEPS

1. **Start** Photoshop Elements, **open** Full Edit, **then reset all tool settings on the Options bar**

QUICK TIP

When shooting the photos to use as source files, lock the exposure, if possible, use a tripod, and do not alter zoom or focus.

2. **Open the files** PSE H-1.jpg, PSE H-2.jpg, **and** PSE H-3.jpg **from the location where you store your Data Files**

 The images show different sections of the George Washington Bridge taken at sunset. These images are the source files for the panorama image you want to create.

3. **View each image in the document window to preview it, click** File **on the menu bar, point to** New, **then click** Photomerge Panorama

 The Photomerge dialog box opens. Here you can select the layout and source files to use for the panorama. Layout options are described in Table H-1.

QUICK TIP

You can add source files by clicking the Browse button, then navigating to the files you want.

4. **Click the** Cylindrical option button **in the Layout section, click** Add Open Files, **then compare your dialog box to Figure H-1**

5. **Click** OK

 It may take several moments for Photoshop Elements to create the panorama. Do not interact with the workspace until the Align Selected Layers Based on Content progress bar in the Adobe Photoshop Elements dialog box has completed multiple cycles and the source file layers and layer masks appear in the Layers palette. Photoshop Elements creates the panorama in a cylindrical shape, as shown in Figure H-2. Blank areas of the canvas are created to accommodate the shape. Next you crop the panorama to the image area.

6. **Click the** Crop Tool 🔳 **in the toolbox, crop the sides and bottom of the canvas as shown in Figure H-3, then press** [Ctrl] [0]

7. **Save the file** Untitled_Panorama1 **as** GW_Bridge.psd, **then press** [Ctrl][Alt] [W] **to close all open files**

TABLE H-1: Photomerge Panorama layout options

name	what it does
Auto	Detects seams between source images
Perspective	Matches the middle image to the other images
Cylindrical	Keeps middle image the largest
Reposition Only	Does not alter perspective in the source images
Interactive Layout	Allows manual positioning of source images

FIGURE H-1: Options selected in the Photomerge dialog box

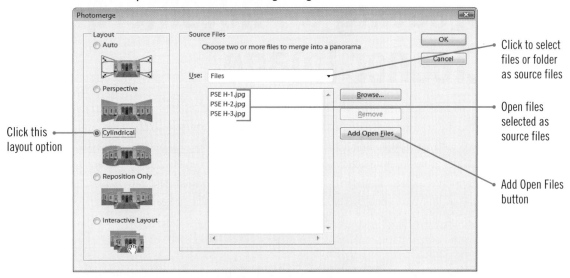

Click this layout option

Click to select files or folder as source files

Open files selected as source files

Add Open Files button

FIGURE H-2: Creating a Photomerge panorama

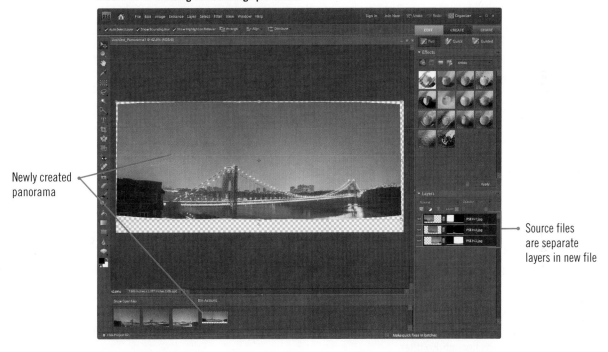

Newly created panorama

Source files are separate layers in new file

FIGURE H-3: Cropped panorama

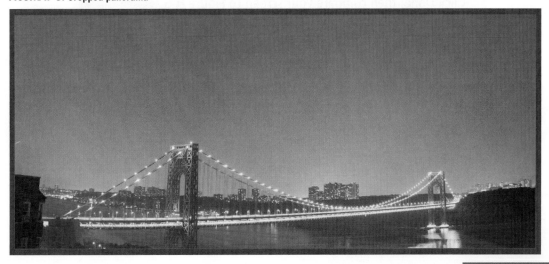

Creating a Photomerge Scene Cleaner Image

When you take photos with people, animals, or objects in the frame, you can never be assured that you'll get the right shot, no matter how many times you click the shutter. With Photomerge Scene Cleaner, you can open two or more images and select the best areas in each image to patch together to create one perfect image. You use the Pencil Tool in the Photomerge Scene Cleaner Task Pane to select the good areas in one photo, and Photoshop Elements copies that area to the final image. This way, accidental tourists, animals, and unwanted objects are simply erased. Great Leap Digital helped prepare a report on raptor migration, so you use individual photos from that project to create a very impressive Photomerge image.

QUICK TIP

You can also select an album to use for Scene Cleaner source and final files.

1. **Open the files PSE H-4.jpg and PSE H-5.jpg from the location where you store your Data Files**

 These source files show images of a solo hawk and a hawk and raven in flight.

2. **Click File on the menu bar, point to New, click Photomerge Scene Cleaner, then click Open All in the Editor – Photoshop Elements 7.0 dialog box**

 It may take a few moments for the Photomerge Scene Cleaner Task Pane to open, as shown in Figure H-4. The first file opened is automatically selected as the source file and displays in the Source window. You can drag another file from the Project Bin to the Final window, making it the final, or destination, file. You use the Pencil Tool to draw the selection in the Source window that will replace the flawed pixels in the final image in the Final window; you use the Eraser Tool to modify the selection in the Source or Final windows. By default, the Show Strokes check box is selected so you can see what you draw in the photo. To view the areas replaced in the final image, click the Show Regions check box. You use the sky in the left corner of the Source window to replace the raven in the Final window.

QUICK TIP

You can load up to 10 photos into the Palette Bin to use to improve the final image.

3. **Drag PSE H-5.jpg to the Final window, click the Pencil Tool 🖉 in the Task Pane if necessary, then paint the sky in the top-left corner of the Source window, as shown in Figure H-5**

 The raven is replaced by the unobstructed sky. Photoshop Elements includes a large selection area around the pixels you paint in the Source window to replace the matching area in the Final window. You view the replaced area.

4. **Click the Show Regions check box to select this option**

 The replacement area is visible in the Final window; the unreplaced area appears as if viewed through a yellow photo filter.

5. **Click Done, then compare your screen to Figure H-6**

6. **Save the file Untitled-1 as redtailed_hawk.psd, then press [Ctrl][Alt] [W] to close all open files**

FIGURE H-4: Photomerge Scene Cleaner

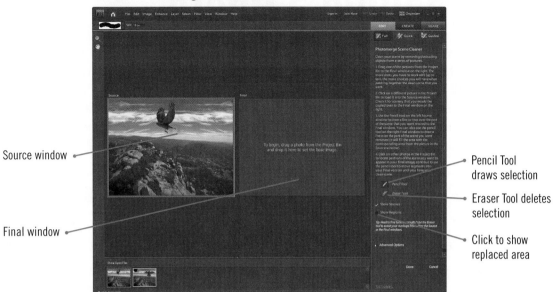

Source window

Final window

Pencil Tool draws selection

Eraser Tool deletes selection

Click to show replaced area

FIGURE H-5: Selecting source area

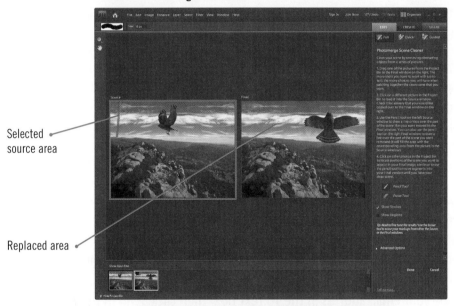

Selected source area

Replaced area

FIGURE H-6: Viewing results of Photomerge Scene Cleaner

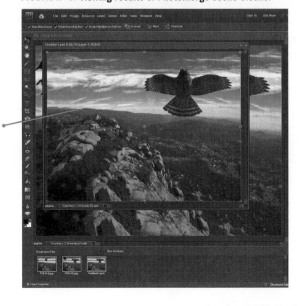

Newly created file

Emailing a Photo

Photoshop Elements can easily generate photo attachments for email, so you can send photos from directly within the program. The message is sent using the default email client on your computer. An **email client** is the software your computer uses to send and receive email messages. At times, Great Leap Digital staff needs to work on images in a client's office and email them to other employees. You familiarize yourself with the email component and mail yourself a photo used for the Inn of the Laughing Llama.

STEPS

 This lesson requires you to have an active email account. If you do not have an email account, skip this lesson.

1. **Verify that your computer is connected to the Internet and that you can receive email**

2. **Open the file PSE H-6.jpg from the location where you store your Data Files**

 A photo of a llama opens. In this case, the email function is performed in Organizer, but is accessible from the Editor as well.

3. **Click the Share tab in the Task Pane, click E-mail Attachments, then show the image in Single Photo View in Organizer**

 After a few moments, Organizer opens with the llama photo in the Items section of the E-mail Attachments palette. See Figure H-7. In this palette, you can select the size and quality of the photo. You can also convert file types to JPEG files if they are another file type, and view the estimated file size.

4. **Click Next in the E-mail Attachments palette, type Likes: Grass, Dislikes: Crossing Water in the Message pane, then compare your screen to Figure H-8**

 The panes are similar to the fields you use in your email program. You can edit this information before you send the email. A sample contact name is in the Select Recipients section; if you have not entered contacts in the Contact Book, this section will be blank. To add names to the Contact Book, click the Edit recipients in contact book button 👤 in the Select Recipients section.

5. **Click Next**

 The New Message email window opens, as shown in Figure H-9. The attached file appears in the Attached section. In this example, the email client is Microsoft Outlook. If you are using a different default email client, that program's new message email window will open.

6. **Type your email address in the To text box, then click Send in the New Message email window**

 The email window closes and Photoshop Elements sends you an email message with the selected photo as an attachment. Check with your instructor or technical support person if you have trouble sending or receiving messages containing pictures; certain types of email accounts do not accept files over a certain size, and some email programs strip pictures out of the message body depending on computer or network security settings.

7. **Switch to Editor, close the file PSE H-6.jpg, exit Editor, then delete the file PSE H-6.jpg from the catalog in Organizer**

FIGURE H-7: Attaching a file to an email message

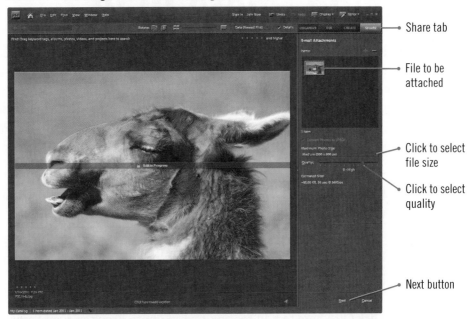

- Share tab
- File to be attached
- Click to select file size
- Click to select quality
- Next button

FIGURE H-8: Entering details for email attachment

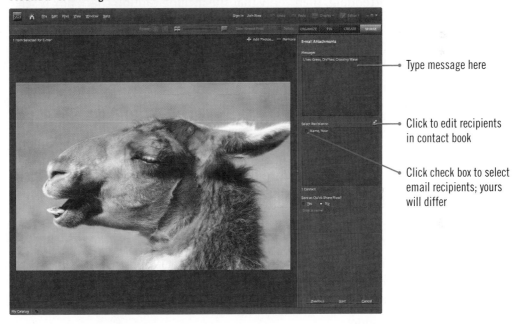

- Type message here
- Click to edit recipients in contact book
- Click check box to select email recipients; yours will differ

FIGURE H-9: New message window

Your email window might differ

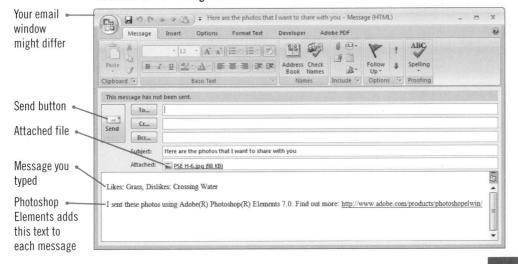

Send button

Attached file

Message you typed

Photoshop Elements adds this text to each message

Here are the photos that I want to share with you - Message (HTML)

Message Insert Options Format Text Developer Adobe PDF

Paste | Clipboard | Basic Text | Address Book | Check Names | Names | Include | Options | Proofing

This message has not been sent.

To...
Cc...
Bcc...

Subject: Here are the photos that I want to share with you
Attached: PSE H-6.jpg (98 KB)

Likes: Grass, Dislikes: Crossing Water

I sent these photos using Adobe(R) Photoshop(R) Elements 7.0. Find out more: http://www.adobe.com/products/photoshopelwin/

Photoshop Elements 7

Using Photo Mail

Sending an image by **Photo Mail** allows you to create colorful **stationery** for your image and message. You can choose themes, font styles, and other options. Photo Mail sends your message as **HTML Mail**, which means that it supports the sophisticated formatting made possible by HTML code, which is the programming language used to create Web pages and enable them to display in a Web browser. Wen-Lin would like to send quarterly updates to Great Leap Digital's established clients using Photo Mail. You use the pet supply store Urban Dogz as your first example.

STEPS

1. **Verify that Organizer is open, get the file PSE H-7.jpg from the location where you store your Data Files, then show the image in Single Photo View**

 The image shows a corgi in a hotdog costume.

2. **Click the Share tab in the Task Pane, if necessary, then click Photo Mail in the Share palette**

 The dog photo appears in the Items section of the Photo Mail palette. You add a caption to the photo.

3. **Click Click here to add caption text in Photo Browser, type Sometimes we do hotdog for attention!, then verify that the Include caption check box is selected in the Photo Mail palette**

 See Figure H-10. The caption will appear in the email message.

4. **Click Next in the Photo Mail palette, type Greetingz From Urban Dogz in the Message pane, then click Next**

 The Stationery & Layouts Wizard window opens to the first step, Choose a Stationery, as shown in Figure H-11. Here you can select a theme for the stationery.

5. **Click the Animals category in the left pane of the wizard window, then click Dog**

 A colorful dog theme is applied, as shown in Figure H-12.

6. **Click Next Step**

 The options for Step 2: Customize the Layout appear next. Here you can adjust the layout, font, and font color. You're satisfied with the default settings and are ready to send the Photo Mail.

7. **Click Next**

 The New Message email window opens, as shown in Figure H-13. The photo and applied stationery appear in the message area.

8. **Type your email address in the To text box, then click Send in the New Message email window**

9. **Delete the file PSE H-7.jpg from the catalog**

FIGURE H-10: Entering a caption for Photo Mail

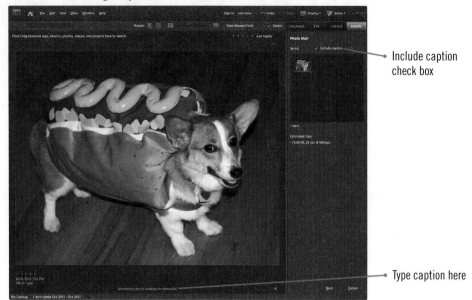

Include caption
check box

Type caption here

FIGURE H-11: Stationery and Layouts Wizard

Themes

FIGURE H-12: Selecting a theme for the Photo Mail

FIGURE H-13: Viewing Photo Mail in the New Message window

Creating and Sharing Projects

Creating an Online Album

In Unit B, you added images to an album so you could more efficiently find and organize them. When you create an online photo album, you use many of the same steps, but you can create a truly unique viewing experience by selecting from many distinct and interactive album templates. ▓▓▓▓ As part of its community involvement, Great Leap Digital hosts a Halloween party for the children of the neighboring businesses in its building. You show the neighboring businesses how impressive a photo album can be.

STEPS

1. **Verify that the Share tab is displayed in Organizer, get the files Halloween1.jpg through Halloween6.jpg in the Halloween folder from the location where you store your Data Files, then adjust the image size so they fill Photo Browser**

 The images show several children and two dogs dressed up for Halloween.

2. **Select the first three photos in Photo Browser, then click Online Album in the Share palette**

 The images are added automatically to the Items section. You add the remaining images.

3. **Select the last three images, then click the Add button ➕ in the Album Details palette to add them**

4. **Type Happy Halloween in the Album Name text box, then compare your screen to Figure H-14**

 Once you add the items to include in the album, Photoshop Elements assigns them to a default album template. You change the template for the album.

 TROUBLE
 Some templates are not available until you sign in to Photoshop.com.

5. **Click the Share button at the bottom of the palette, click Change Template, click the Category arrow, click Fun, click the first template in the Select a Template section, Comic Book template, then click Apply**

 The images appear as panes in a comic book, as shown in Figure H-15. Template names and descriptions appear at the bottom of the Album Details palette. You can adjust album settings by clicking Background, Border, Images, and Graphics above the album, and then making the relevant changes. You preview the album to see how it appears.

6. **Click Play at the top of the album, then watch the album**

 Each template has a different appearance and set of effects.

7. **Click Next**

 Options for sharing appear in the Album Details palette, as shown in Figure H-16. You can upload the album to your Photoshop.com account, burn it to a CD or DVD, or upload it to a **File Transfer Protocol (FTP)** site. FTP is a type of file transfer program for Internet files. Each Share To option has specific instructions on using it. Photoshop Elements does not save an online album to the catalog; if you do not select a Share To option, the album will be "lost." You decide not to share the album at this time.

 TROUBLE
 Uploading files to Photoshop.com automatically turns on the Backup/ Synchronization feature, which may take a while to upload your files.

8. **Click Cancel to close the Album Details palette, then delete the photos used in this lesson from the catalog**

FIGURE H-14: Creating an online album

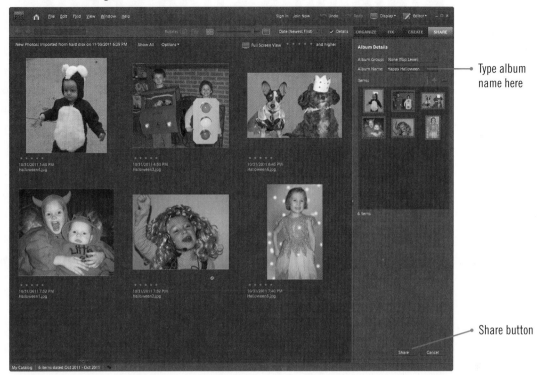

- Type album name here
- Share button

FIGURE H-15: Comic Book template applied to album

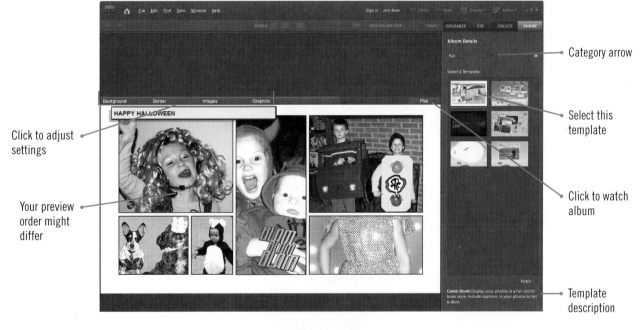

- Category arrow
- Select this template
- Click to watch album
- Template description
- Click to adjust settings
- Your preview order might differ

FIGURE H-16: Viewing sharing options for an online album

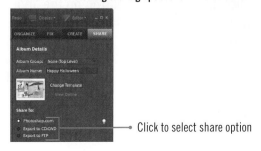

- Click to select share option

Building a Slide Show

With the Photoshop Elements Slide Show Editor, you can be your own movie production company. You can combine still images, graphics, video, and music or narration to create attention-grabbing slide shows. You can pan and zoom onto subjects, and use professional effects to transition from slide to slide. A **transition** refers to the way a slide replaces the previous one in a slide show. ▓▓▓▓ Wen-Lin wants to inspire the staff to keep current on this new skill set. You use images from an oceanographic environmental protection organization to create a basic slide show.

STEPS

1. **Verify that Organizer is open, then get the files Ocean1.jpg through Ocean5.jpg in the Ocean folder from the location where you store your Data Files**

 Images of sea slugs, starfish, and sea anemone appear in Photo Browser.

2. **Click the Create tab in the Task Pane, select all the images in Photo Browser, then click Slide Show in the Create palette**

 The Slide Show Preferences dialog box opens, as shown in Figure H-17. You can adjust default settings such as Static Duration, the length of time the slide appears; Transition, how one slide replaces another as the slide show progresses; and Transition Duration, the length of time the transition appears, as well as background color. You can also set slide movement, whether slide attributes such as captions and narration appear, whether a soundtrack plays throughout the slide show, and cropping options. The Preview setting is independent of the final output quality; a lower preview setting uses fewer computer resources, but the slide show may play less smoothly.

 > **TROUBLE**
 > Resize the Slide Show Editor window so you can see all the slides in the Storyboard, if necessary.

3. **Click OK to accept the default Slide Show Preferences settings**

 The Slide Show Editor window opens, as shown in Figure H-18. The Slide Show Editor window contains all the controls, palettes, and features you need to enhance your slide show: preview area; playback controls; sizing and order controls; the Extras palette, where you select clip art or text styles and record narration; the Properties palette, where you adjust settings for a selected item; and a Storyboard that displays slides and transition icons, or thumbnail images, of the transition's effect.

4. **Click the Play button �▶ to preview the slide show**

 The slide show plays using default settings. After the last slide, the screen fades to black. You add a video to the slide show.

 > **QUICK TIP**
 > To quickly rearrange the slides in a slide show, drag a slide onto a transition icon until a blue vertical bar appears.

5. **Click Slide 3 (the starfish) in the Storyboard, click the Add media button on the Shortcuts bar, click Photos and Videos from Folder, navigate to the location where you store your Data Files, open the Ocean folder, click the Files of type list arrow, click Videos, then double-click Fish.wmv**

 A slide containing the movie is added to the Storyboard following the starfish slide, as shown in Figure H-19. Video slides are indicated by a video icon ▦.

 > **TROUBLE**
 > Depending on your computer's processing speed and memory, the movie may not play smoothly.

6. **Click ▐ ▶**

 The slide show automatically begins playing at the selected slide or transition.

7. **Click the Save Project button on the Shortcuts bar, type Seascapes in the Name text box, click Save, then move the Slide Show Editor dialog box so you can see the images in Photo Browser**

 The slide show is a creation saved in Photo Browser. Until you are ready to output the slide show, you can access slide shows and other creations only from Photo Browser.

FIGURE H-17: Slide Show Preferences dialog box

Slide and
transition settings

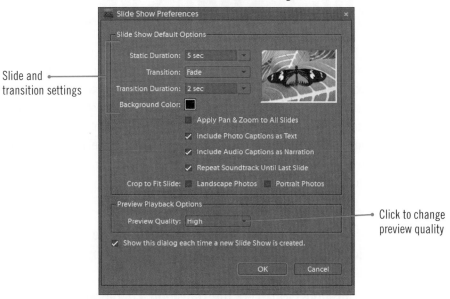

Click to change
preview quality

FIGURE H-18: Slide Show Editor window

Shortcuts bar

Extras palette

Preview window

Properties palette

Playback controls

Transition icon

Storyboard

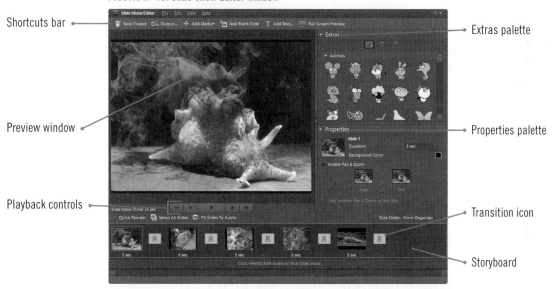

FIGURE H-19: Adding a video as a new slide

Add Media button

New video slide

Selected slide

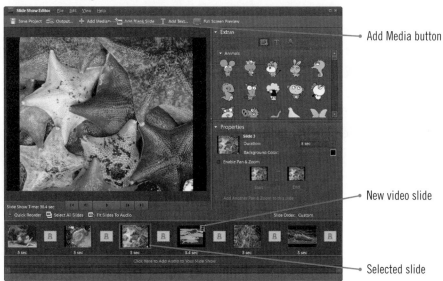

Photoshop Elements 7

Editing a Slide Show

The Slide Show Editor includes nearly two dozen transitions you can apply to slides to control how scenes change from one to the next. Effects range from understated to striking. You add a transition by clicking the transition icon arrow in the Storyboard or in the Properties palette and then selecting a transition. To give your slide shows a documentary feel, you can apply the **Pan & Zoom** effect to a slide, where you identify the starting and ending areas of the image and the "camera" appears to sweep across, close in on, or pull away from an area. ▨▨▨ The transition into and out of the Seascapes video needs improvement, and some of the images could be more dramatic. You adjust the transition duration and type, and add a pan and zoom to a slide.

STEPS

1. **Verify that the Seascapes slide show is open in the Slide Show Editor window, click Slide 1, click the Slide 1 duration list arrow ▼ in the Properties palette, then click 7 sec**

 Slide 1 will appear onscreen for seven seconds instead of five.

2. **Click the Transition 3 icon, click the Transition 3 duration list arrow ▼ in the Properties palette, then click 3 sec**

 Options for transition duration and type appear in the Properties palette, as shown in Figure H-20. The transition from slides 3 to 4 will last for three seconds now instead of two.

3. **Click the Transition 4 icon, click the Transition 4 duration list arrow ▼ in the Properties palette, click 4 sec, click the Select a transition type list arrow, scroll down to locate and then click Stretch**

 The transition thumbnail changes to the Stretch thumbnail. You preview the changes.

4. **Click the Play button** [>]

 The transitions before and after the video slide are slightly longer, and the Stretch transition occurs between the video and Slide 4. The transition between the slides is shown in Figure H-21.

5. **Click Slide 1, then click the Enable Pan & Zoom check box in the Properties palette**

 The Pan & Zoom feature is a two-step process: start and end. First you drag a start bounding box over the area where you want the pan and zoom to begin, and then you drag an end bounding box over the area where you want it to stop. You can use buttons in the Properties palette to reverse and copy bounding boxes and add multiple pan and zoom effects.

6. **Drag the bottom-right handle of the green Start bounding box to the location shown in Figure H-22**

 The bounding box is centered over the red ink released by the sea hare, a type of sea slug.

7. **Click the End thumbnail in the Properties palette**

 The End bounding box is in a good location, so you do not need to adjust it.

8. **Click the Go to First Slide button** [ᴹ]**, then click** [>]

 The "camera" appears to zoom out from the red ink above the sea hare and move to the right. Setting a longer slide duration as you did in Step 1 can enhance a pan and zoom.

9. **Click the Save Project button on the Shortcuts bar**

FIGURE H-20: Viewing transition properties

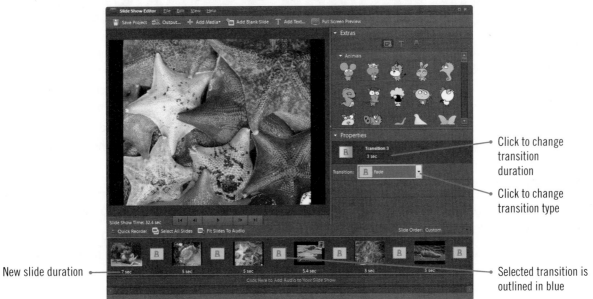

New slide duration

Click to change transition duration

Click to change transition type

Selected transition is outlined in blue

FIGURE H-21: Viewing the Stretch slide transition

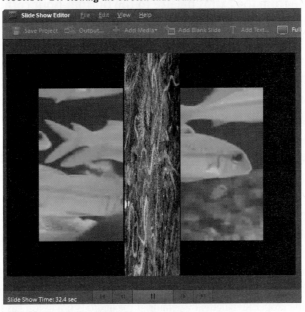

FIGURE H-22: Setting the Start Pan & Zoom bounding box

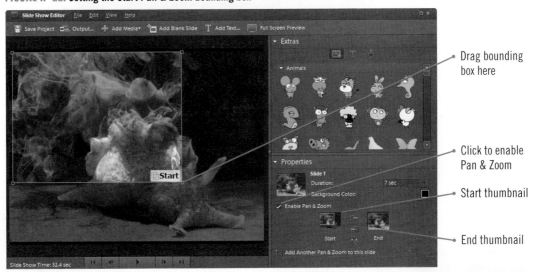

Drag bounding box here

Click to enable Pan & Zoom

Start thumbnail

End thumbnail

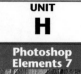

Customizing a Slide Show

You can customize your slide show by adding text, clip art, and narration from the Extras palette in the Slide Show Editor window. The Graphics section of the Extras palette contains various clip art such as animals, objects, thought and speech bubbles, and backgrounds. The Text section has several fonts and effects. To add narration, you must first have a microphone hooked up to your computer. To add music or other audio files, you can use the Add Media button or the Click Here to Add Audio to Your Slide Show command located beneath the Storyboard. **▄▄▄** You complete the slide show by adding a title slide, graphics, and music.

STEPS

QUICK TIP

You may need to resize the Slide Show Editor to see all the slides in the Storyboard.

1. **Verify that the Seascapes project is open in the Slide Show Editor, click the Add Blank Slide button on the Shortcuts bar, click and drag the new slide to the beginning of the Storyboard, then when the blue vertical bar appears, release the mouse button**
 A new slide is added to the Storyboard as Slide 1.

QUICK TIP

You can always resize a graphic on the slide by dragging its sizing handles on the slide.

2. **Verify that the Animals category is open in the Extras palette, then drag the green seahorse from the Extras palette to the bottom-right corner of the slide**
 See Figure H-23. Options for graphics appear in the Properties palette, where you can resize graphics using the Size slider and apply black and white or sepia color effects. You add text to the title slide.

3. **Click the Text button** T **in the Extras palette, then drag the pink text style to the top of the slide**
 The default text, *Your text here*, appears in the text box. You can edit font attributes in the Properties palette.

4. **Double-click the text box, type seascapes in the Edit Text dialog box, click OK, then center the text at the top of the slide, as shown in Figure H-24**

QUICK TIP

If the audio is longer than the slide show, you can click the Fit Slides To Audio button above the Storyboard to expand the duration of the slide show to match the length of the audio.

5. **Click the Click Here to Add Audio to Your Slide Show command beneath the Storyboard, navigate to the location where you store your Data Files, open the Ocean folder, then double-click the file Oceantrack.mp3**
 When you add audio to a slide show, it appears beneath the Storyboard on the Soundtrack bar, as shown in Figure H-25. You can adjust, or trim, the start and end points of the soundtrack using the Trim Audio controls in the Properties palette. By default, if the audio is not as long as the slide show, it will repeat until the end. Now you're ready to preview the entire slide show full screen.

6. **Click the Full Screen Preview button on the Shortcuts bar, then when the slide show is done, click the Save Project button on the Shortcuts bar**

Using audio in a slide show

To add an additional audio track to a slide show, right-click Soundtrack Will Repeat Until End on the Soundtrack bar, click Add Audio From Organizer to open the Add Audio dialog box, or click Add Audio from Folder to open the Choose your audio files dialog box, where you can navigate to where the audio file is stored. Note that many programs, such as iTunes, have sample music you can use in your projects.

FIGURE H-23: Graphic added to new slide

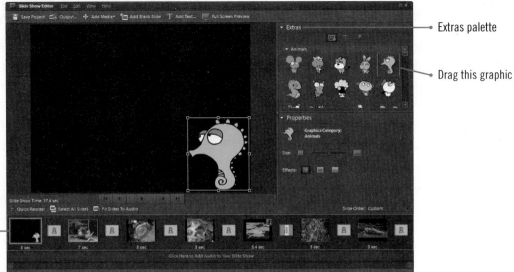

Extras palette

Drag this graphic

Newly added slide

FIGURE H-24: Text added to slide

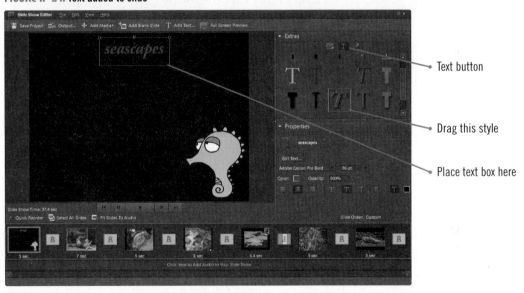

Text button

Drag this style

Place text box here

FIGURE H-25: Soundtrack added to slide show

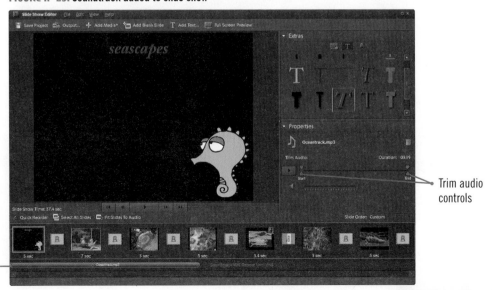

Trim audio controls

Soundtrack bar

Outputting a Slide Show

You can share a slide show using any sharing option Photoshop Elements offers, although you first need to save it as a specific file type. You output a slide show from the Slide Show Output dialog box, where you can select the file format and quality that will work best on the computers of your viewers. Photoshop Elements has three output types: Save as a File, Burn to Disc, and Send to TV. Table H-2 describes each output type. You are ready to output the slide show in a format easily transferable to a regular CD.

STEPS

1. **Verify that the Seascapes project is open in the Slide Show Editor**

2. **Click the Output button on the Shortcuts bar to open the Slide Show Output dialog box, then click each choice in the What would you like to do with your slide show? section and read the option descriptions that appear**

 The Slide Show Output dialog box is shown in Figure H-26. You can click the Help Me Decide link or the Details button to learn more about each choice. When you select the Burn to Disc option, you have the choice of selecting multiple slide shows to burn to disc.

3. **Click Save As a File, verify that the Movie File (.wmv) option and (Web 320×240) file size are selected, then click OK**

 The Save Slide Show as WMV dialog box opens. WMV is the file extension for Windows Media Video, a video file format that creates smaller files, which allows for faster transfer.

4. **Navigate to the location where you store your Data Files, click Save, then click Yes in the Windows Media File Save dialog box to import the file into your catalog**

 The Adobe Photoshop Elements dialog box opens and a progress bar displays the time it takes to save the file. It may take several moments for Photoshop Elements to save the WMV file, especially if the slide show file is large. If you don't keep the slide show in your catalog, you won't be able to edit it at a later time.

5. **Navigate to the location where you store your Data Files, double-click the file Seascapes.wmv, then watch the slide show in Windows Media Player**

 Transitions and the video play smoothly.

6. **Close Windows Media Player, close the Slide Show Editor window, then exit Photoshop Elements**

FIGURE H-26: Slide Show Output dialog box

Output options

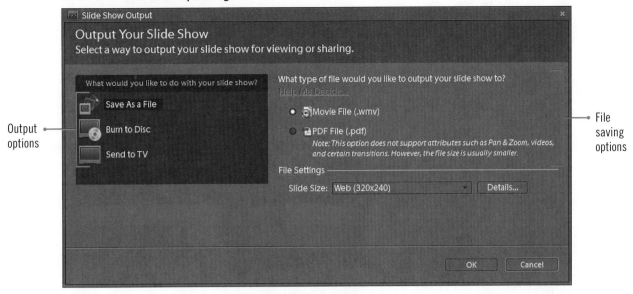

File saving options

TABLE H-2: Slide Show Output Options

name	description
Save As a File	WMV or PDF file options; WMV size affects quality; PDF does not support pan and zoom or video
Burn to Disc	VCD or DVD file options; if burning a DVD, Premiere Elements must be installed on your computer
Send to TV	Uses Windows XP Media Center Edition, which allows you to watch digital files on your TV or computer

Practice

▼ CONCEPTS REVIEW

Label the elements of the Editor workspace shown in Figure H-27.

FIGURE H-27

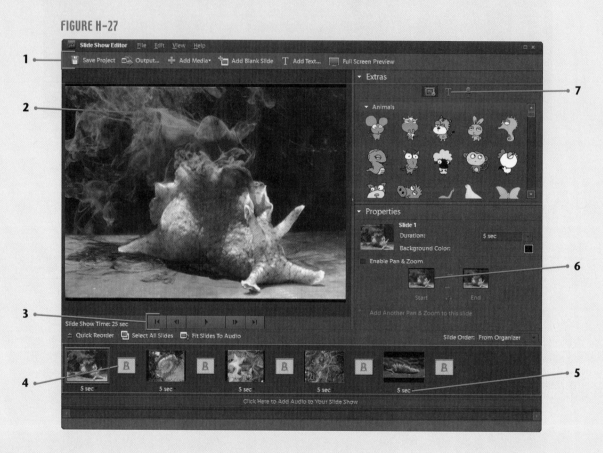

Match each term with the statement that best describes it.

8. Pan & Zoom
9. Photo Mail
10. Transition
11. Slide Show Output
12. Photomerge

a. The way a slide replaces a previous one
b. Email that uses HTML code
c. Creating one image out of two or more
d. Dialog box for selecting how a slide is viewed
e. Emulates a close up, pull away, or sweep of a slide

Select the best answer from the list of choices.

13. **Which of the following is not a Photomerge option?**
 a. Group Shot
 b. Panotool
 c. Panorama
 d. Scene Cleaner

14. **What does the filtered part of Show Regions show?**
 a. The source file being used
 b. The replaced region
 c. The stroke color
 d. The unreplaced region

15. **With which feature is the Stationery & Layouts Wizard dialog box associated?**
 a. Photo Mail
 b. Online Album
 c. Slide show
 d. Share tab

16. **Which slide(s) are visible the longest when a slide's transition is set to 8 seconds?**
 a. Both slides
 b. The slide leaving the slide show
 c. The slide entering the slide show
 d. The title slide

17. **Which adjustment can best improve a pan and zoom slide?**
 a. Decreasing transition duration
 b. Decreasing slide duration
 c. Increasing slide duration
 d. Increasing transition duration

▼ SKILLS REVIEW

1. **Create a Photomerge Panorama.**
 a. Start Photoshop Elements, open Full Edit, then open the files PSE H-8.jpg through PSE H-10.jpg from the location where you store your Data Files.
 b. Open the Photomerge dialog box, use open files as the source files, then apply the Auto layout to create the panorama.
 c. Crop the image to remove blank pixels.
 d. Save the file as **rocksteps.psd**, then keep all files open.

2. **Create a Photomerge Scene Cleaner.**
 a. Select the files PSE H-8.jpg and rocksteps.psd in the Photo Bin, then open the Photomerge Scene Cleaner window.
 b. Drag rocksteps.psd to the Final pane.
 c. Use the Zoom Tool to zoom in on where the man is walking up the steps in the Final pane.
 d. Use the Pencil Tool to mark in the Source file the section of wall that corresponds to where the man is walking in the Final pane. (*Hint*: You may need to undo and redo your selection a couple of times.)
 e. Show regions, then complete the photomerge.
 f. Crop the image to the image area, then save the new file as **rocksteps_cleaned.psd**.
 g. Compare your screen to Figure H-28, then close all files.

FIGURE H-28

3. Email a photo.

 a. Verify that your computer is connected to the Internet and that you can receive messages containing attachments.

 b. Open the file PSE H-11.jpg from the location where you store your Data Files.

 c. Open the E-mail Attachments palette from the Share tab of the Task Pane.

 d. Type **Cairn mark the way** in the Message pane, then add your email address in the To text box.

 e. Send the email message, close the file PSE H-11.jpg, then exit Editor.

4. Use Photo Mail.

 a. Start Photoshop Elements, open Organizer, get the file PSE H-12.jpg from the location where you store your Data Files.

 b. Open the Photo Mail palette from the Share tab of the Task Pane, add the open file, then click Next.

 c. Type **Florida Keys** in the Message pane, then click Next.

 d. In the Stationery & Layouts Wizard dialog box, select the Waves theme in the Outdoors category.

 e. Type **National Marine Sanctuary** as the caption, then click Next Step.

 f. Select the largest Photo Size icon in the Layout palette, then click Next.

 g. Change the Subject text in the New Message window to **Parrot fish**.

 h. Add your email address, compare your New Message window to Figure H-29, then send the email message.

5. Create an online album.

 a. Get the files Structure1.jpg through Structure4.jpg in the Structures folder from the location where you store your Data Files.

 b. Click the Share tab in the Task Pane, then click Online Album.

 c. Add all the files you opened in Step a to the Items section, name the album **Structure**, then click Share.

 d. Change the template to 4×5 Transparency, click Apply, then click Next.

 e. Change the title to **Diverse Building** and the subtitle to **Swell Dwellings**, click Refresh, compare your screen to Figure H-30, then cancel the album.

6. Build a slide show.

 a. Get the files Cattle1.jpg through Cattle5.jpg in the Cattle folder from the location where you store your Data Files.

 b. Select the files in Photo Browser, click the Create tab in the Task Pane, click Slide Show, set the Transition Duration to 4 sec, then click OK.

 c. Preview the slide show.

 d. Click the last slide, then add the file curiouscow.mpg in the Cattle folder from the location where you store your Data Files.

 e. Preview the slide show.

 f. Save the slide show as **At home on the range**.

7. Edit a slide show.

 a. Verify that the At home on the range slide show is open, then change the duration for Slide 3 to 7 seconds. (*Hint*: Slide 3 should be the photo of grazing cattle.)

 b. Change the duration for the remaining still image slides to 5 seconds.

FIGURE H-29

FIGURE H-30

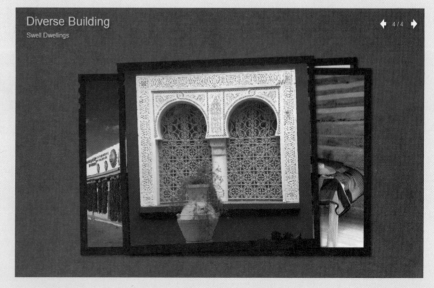

Diverse Building
Swell Dwellings
4 / 4

 c. Change all the slide transitions to Barn Doors. (*Hint*: Click a transition icon's arrow in the Storyboard, select the transition, then click Apply to All at the top of the menu.)

 d. Preview the slide show.

 e. Enable Pan & Zoom for Slide 3, then move and resize the start point so it only covers the grazing cows at the right.

 f. Preview the slide show from the beginning, then save the slide show.

8. Customize a slide show.

 a. Verify that the At home on the range slide show is open in the Slide Show Editor, then move the photo with yellow flowers to the beginning of the slide show, if necessary.

 b. Select Slide 6, add a new blank slide, then change the duration to 5 sec.

 c. In the Extras palette, scroll down to the Thoughts & Speech Bubbles section, then add the first thought bubble to the blank slide and center it.

 d. Select the Text button, drag the first text style on top of the thought bubble, click Edit Text in the Properties palette, type **from moo to you**, change the font size to **24**, then center it on the thought bubble. (*Hint*: Use the Properties palette.)

 e. Add the file cattlecall.mp3 in the Cattle folder from the location where you store your Data Files.

 f. Preview the slide show from the beginning, then compare your screen to Figure H-31.

 g. Preview the slide show in full screen, then save the slide show.

9. Output a slide show.

 a. Open the Slide Show Output dialog box, output the slide show as a .wmv file, then save it to your catalog.

 b. Close the Slide Show Editor, then exit Photoshop Elements.

FIGURE H-31

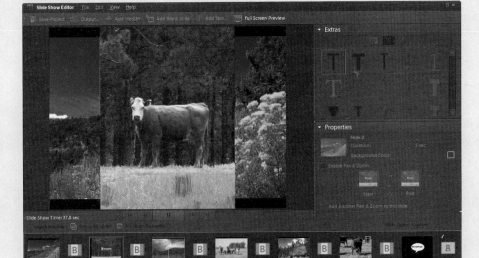

▼ INDEPENDENT CHALLENGE 1

You're preparing a presentation to the city council about how easy it would be to green-up open space in the city. You want to grab their attention with a full-screen example that fits your goal, so you create a panorama.

 a. Start Photoshop Elements, then open Full Edit.

 b. Open the files PSE H-13.jpg through PSE H-16.jpg from the location where you store your Data Files.

 c. Create a panorama using the Perspective layout.

 d. Crop to remove the blank pixels.

 e. Save the panorama file as **fort_tryon.psd**.

▼ INDEPENDENT CHALLENGE 1 (CONTINUED)

 f. Compare your image to the sample shown in Figure H-32.

 g. Close the file fort_tryon.psd.

Advanced Challenge Exercise

- Flatten the image, then save the file as **fort_tryonACE.jpg** with a Quality setting of **6**.
- Email the image to yourself as an email attachment.

 h. Close all open files, then exit Photoshop Elements.

FIGURE H-32

▼ INDEPENDENT CHALLENGE 2

You're planning a mountain biking fundraiser for a Share the Road With Bikes organization. You've taken a series of photos of the challenging parts of the course, and now want to create an online album so other committee members can view them.

 a. Start Photoshop Elements, then click the Share button in the Welcome Screen.

 b. Get the files Rock1.jpg through Rock6.jpg in the Rock Formations folder from the location where you store your Data Files.

 c. Create an online album and give it the title **Mountain Bike Scenes**.

 d. Apply the Road Trip template from the Travel category, then preview the album. (*Hint*: Click the up arrow on the map to play automatically or click the left or right arrows to view images manually.)

 e. Compare your album to Figure H-33.

Advanced Challenge Exercise

- Cancel the album, then add related captions to the photos in Photo Browser.
- Create an online album, then name the album **Mountain Bike ScenesACE**.
- Apply the Photo Book template from the Classic category, then preview the album. (*Hint*: Turn the pages.)

FIGURE H-33

 f. Select a Share To option, if applicable; otherwise, cancel the album.

 g. Exit Photoshop Elements.

▼ INDEPENDENT CHALLENGE 3

You work at EcoTourist Adventurama, a travel company specializing in sustainable tourism. They want to offer their customers a digital memory of their trips. You start by creating a slide show.

a. Start Photoshop Elements, then open Organizer.

b. Get the images for the slide show. You can obtain images from your computer, from the Internet, from a digital camera, or from scanned media. You can also obtain audio from the Internet. When downloading from the Internet, you should always assume the work is protected by copyright. Be sure to check the Web site's terms of use to determine if you can use the work for educational, personal, or noncommercial purposes.

c. Create the slide show, varying slide and transition duration times.

d. Apply slide transitions as desired.

e. Add a blank slide, then add Extras such as text and/or graphics to it.

f. Add a pan and zoom to at least one slide.

g. Add music or audio to the slide show.

h. Change the background color for one or more slides.

i. Play the slide show.

j. Save the slide show as **ecotourist.wmv** and import it into your catalog.

Advanced Challenge Exercise

■ Add a video to the slide show.

■ Add additional audio to the slide show, then save the project.

k. Exit Photoshop Elements.

▼ REAL LIFE INDEPENDENT CHALLENGE

Recently, an interesting scene or event caught your attention, and you took several photographs that would make a great slide show.

a. Start Photoshop Elements, then click the Create icon in the Welcome Screen.

b. Get the images for the slide show. You can obtain images from your computer, from the Internet, from a digital camera, or from scanned media. You can also obtain audio from the Internet. When downloading from the Internet, you should always assume the work is protected by copyright. Be sure to check the Web site's terms of use to determine if you can use the work for educational, personal, or noncommercial purposes.

c. Create the slide show, then change slide and transition duration times as desired.

d. Apply a slide transition to the slide show.

e. Add a blank slide, then add Extras such as text and/or a graphic to it.

f. Add two pan and zoom effects to the same slide. (*Hint*: The Slide Show Editor creates a duplicate of the slide for the second pan and zoom.)

g. Add music or audio to the slide show.

h. Change the background color for any slides that do not fill the screen. (*Hint*: Use the Properties palette.)

i. Preview the slide show.

j. Save the slide show as **myslideshow.wmv** and import it into your catalog.

Advanced Challenge Exercise

■ Save the slide show as a pdf file with default settings.

■ Experiment finding a slide transition that will play when the slide show project is saved as a pdf. (*Hint*: Use something other than Fade. Save the preview the pdf until you find something that works.)

k. Exit Photoshop Elements.

▼ VISUAL WORKSHOP

Open the files PSE H-17.jpg and PSE H-18.jpg from the location where you store your Data Files, then create a slide show. Using Figure H-34 as a guide, change the slide duration, slide transitions, and add text as shown. Save the slide show as **hawkmoth**. Output the slide show as a pdf file, deselect the Loop check box, import it in your catalog, then open hawkmoth.pdf, print the pages, and exit Photoshop Elements. (*Hint*: The slide transition in the slide show project will not translate or appear in the pdf.)

FIGURE H-34

Glossary

Active layer Layer on the Layers palette selected and available for editing.

Additive primary colors The primary colors red, green, and blue, which combine to form all other colors in light.

Adjustment layer Layers palette layer that affects the color of the layers beneath it.

Album group High-level album category in Organizer.

Albums Digital photo albums used to group photos.

Angle Motion blur filter option that controls the blur direction.

Aspect ratio The ratio between an image's width and height.

Auto Color Correction Modifies highlights, shadows, and midtones in an image; accessed from Photo Browser Auto Fix Window, Quick Fix General Fixes pane, or from the Enhance menu in Full Edit.

Auto Contrast Modifies the contrast without affecting color in an image; accessed from Quick Fix General Fixes pane in the Photo Browser Auto Fix Window, or Enhance menu in Full Edit.

Auto Levels Modifies the contrast and color in an image.

Auto Sharpen Increases the contrast between contiguous pixels in an image.

Auto Smart Fix Performs overall improvements in an image in contrast, color, lighting, shadows, and highlights; accessed from Photo Browser Auto Fix Window, Quick Fix General Fixes pane, and Full Edit.

Background color The color in an image revealed when you use the Eraser Tool.

Background Eraser Tool Removes pixel color with a brush stroke.

Background layer The default layer in the Layers palette.

Barreling Distortion that causes the appearance of outward curve; also known as fish-eye distortion.

Bit The smallest piece of computer information.

Bit depth The number of bits used to describe a pixel.

Bitmap image Represents a picture image as a matrix of dots, or pixels on a grid.

Blacks Camera RAW setting that increases the shadows in an image.

Blending Mode Color mixture option in the Layers palette for starting, blending, and result colors; controls how pixels in a layer blend with other layers using the original and foreground colors.

Blog A publicly accessed online journal.

Blur Tool Blurs pixels, reducing contrast.

Bounding box A marquee that encloses a selected area in an image.

Camera RAW Unprocessed camera file format.

Captions Descriptive text you can add to photos.

Card reader A device that reads the memory card from a digital camera.

Catalog A feature that includes information about image files.

Channel A category of information related to a color range.

CMYK Cyan, Magenta, Yellow, Black; colors used in four-color process printing.

Color cast Dominance of one color or tone appearing in an image as a tint.

Color field Element of the Color Picker you use to select a particular hue or shade of color.

Color Picker Dialog box where you can select a foreground or background color.

Color slider Control in the Color Picker you use to adjust color.

Community Help An online feature accessible from Help that links to tutorials, articles, and blogs about Photoshop Elements.

Composite image Image created by combining two or more other images.

Contrast The difference between the darkest and lightest portions of an image.

Cool Light that has blues, purples, and greens added to it.

Copyright The exclusive right of a creator of intellectual property to control its use.

Copyright infringement The unauthorized use of one or more rights of a copyright holder.

Crop To remove unwanted portions of an image.

Crop Tool Trims areas from an image in a rectangular form.

Cropping handles Small boxes used to resize a bounding box.

Darken Amount Red Eye Removal Tool option that determines how much red eye is removed.

Date View Calendar-based Organizer workspace where you can view photos in chronological order by file date.

Distance Motion blur filter option that controls the blur distance.

Document window Area in the Editor where the active image displays.

DPI Dots per inch; used to measure print resolution.

Drawing program Software that digitally creates or alters vector images.

Edge Contrast Magnetic Lasso Tool option that determines the amount of contrast between the selected edge.

Editor Workspace containing Guided Edit, Quick Fix, and Full Edit modes where you edit and improve images.

Effect Changes an object's or layer's appearance.

Electromagnetic spectrum The full range of wavelengths that compose light.

Elliptical Marquee Tool Tool that creates round or elliptical marquee selections.

E-mail client Computer software that reads, retrieves, and sends e-mail messages.

Eraser Tool Changes pixels to the background color or makes them transparent.

Fair use A limited exception in copyright law that allows use of copyright material without permission of the copyright holder.

Faux font Computer-generated simulation of a font style.

Feathering Smoothes or softens the edges of an image.

Fields Alternating horizontal lines in a video created when recording.

Fill layer Layer in the Layers palette containing a gradient or solid color.

Filter In Editor, a feature that alters the appearance of an image by adding visual effects to it. In Organizer, a feature that displays only certain photos based on criteria you select.

Filter Gallery Window where you can preview, add, rearrange, and edit filters.

Fish-eye distortion Distortion that causes the appearance of outward curve; also known as barreling.

Fix tab Tab in the Organizer Task Pane that contains tools to fix common problems.

Flatten Merges all visible layers into a single bitmap; also known as rasterizing.

Font A related set of symbols, letters, and numbers.

Font family The collection of all styles and size of a font.

Foreground color The color applied when you add a shape, text, or border to an image.

Frequency Magnetic Lasso Tool option that determines the distance between selection points.

FTP File Transfer Protocol; used to transfer files across the Internet.

Full Edit Editor mode offering full range of editing tools.

Graphics program A bitmap- or vector-editing software application.

Grouping layers Creates a mask effect between layers.

Grow or Shrink Canvas to Fit Straighten Tool option that resizes the canvas.

Guided Edit Editor mode providing a natural language-based interface for making automatic changes to an image.

Hand Tool Moves the visible image area within the workspace.

HDTV High-definition television.

Healing Brush Tool Replicates pixel color and texture; useful for larger areas in an image.

Hexadecimal Alphanumeric system for defining color for the Web.

Highlights The lightest part of an image that still has visible detail.

Histogram A vertical graph showing the brightness levels in an image, ranging from darkest (left) to lightest (right).

HSB Hue Saturation Brightness; color mode based on how humans perceive color.

HTML Mail Hypertext Markup Language Mail; e-mail sent using the programming language HTML, which is the programming language used to display Web pages in a browser.

Hue A specific wavelength of light forming a color.

Hue jitter Brush dynamics option that affects the degree to which the brush stroke switches between foreground and background color.

Image fixing options Automatic fix options in Quick Fix.

Image-editing program Sophisticated graphics programs.

Intellectual property The areas of law that govern creative expressions of ideas.

Interlacing How video recording combines fields.

JPEG Joint Photographic Experts Group; a versatile file format for photographic images.

Keyword tag categories An Organizer feature that allows you to create a higher-level category within which you can attach words or phrases to multiple photos or create subcategories or keyword tags.

Keyword tags An Organizer feature that allows you to attach words or phrases to multiple related photos.

Lasso Tool Draws a selection in one motion.

Layer A component of the Layers palette that contains image content.

Layer style Effects added to a layer from the Effects palette.

Layers palette Full Edit component that contains layers in an image.

Lens flare Reflection of non-image-producing light in a camera lens.

Lens flare filter Filters that emulate the glare affects created by light that enters and reflects around a camera lens.

Lens Type Shape of the lens used when applying a lens flare filter to an image.

Levels Feature that modifies contrast and color in an image.

Link The process that links layers on the Layers palette; when linked, you can edit and move linked layers simultaneously.

Liquify filter Array of powerful tools for distorting an image.

Lossy compression A file compression technique for JPEG files that sacrifices some quality for compression.

Magic Eraser Tool Erases the color where the mouse is clicked in an image.

Magic Wand Tool Selection tool that selects pixels based on color.

Magnetic Lasso Tool Draws a selection by snapping segments to an edge.

Mask Uses a shape on one layer to block certain pixels on the layer beneath it from view.

Megapixels Millions of pixels.

Menu bar Contains Photoshop Elements commands in pull-down menu format.

Merge Combining the contents of two or more layers; results in reduced file size.

Metadata Information embedded in a digital camera file, such as time and date the photo was taken and model of the camera used.

Midtone The gray or mid-range of tones in an image.

MPEG Moving Pictures Experts Group.

Opacity The opaqueness (100%) or transparency (0%) of pixels or a layer.

Options bar Area where options for the selected tool appear in the Editor.

Organizer Workspace for organizing, sharing, and locating files, and performing common fixes.

Paint Bucket Tool Fills an area with pattern or a solid color.

Paint program Software that digitally alters pixels in a bitmap image.

Palette Bin Area of the Task Pane where palettes that monitor and alter images are stored and accessed.

Palettes Panels of options, commands, and features available in Quick Fix and Full Edit.

Pan & Zoom Slide show feature that sweeps across a slide while zooming in or out.

Perspective Alters the back and forward position in three dimensions.

Photo Browser Organizer workspace for organizing and structuring files and for performing basic edits.

Photo effect Color effect added to a layer from the Effects palette.

Photo filter An Adjustment filter that mimics the effect of warm, cool, or color cast filters.

Photo Mail E-mail option that allows you to embed an image in a template.

Photo-editing program A software program that includes tools for editing, organizing, and enhancing digital photographs and other bitmap images.

Pin-cushion Pinched distortion.

Pixel A small discrete square of color used to display an image on a grid.

Polygonal Lasso Tool Draws a selection in straight-line segments.

PPI Pixels per inch; used to measure onscreen resolution.

Project Bin The area in the Editor where you view thumbnails of open photos, slide shows, video, or audio files.

Properties palette Displays information about the active photo.

PSD Photoshop document; the native Photoshop Element file format.

Public domain Work you can use or copy without permission of the owner.

Pupil Size Red Eye Removal Tool size option that determines the ratio between the pupil and the iris.

Quick Fix Editor mode with tools for making simple improvements to an image.

Quick Selection Tool Selects pixels by color by painting the selection to an edge.

Rate Feature in Organizer that uses a scale of one to five stars to rank photos.

Rectangular Marquee Tool Creates square or rectangular marquee selections.

Red Eye Removal Tool Removes red pixels caused by camera flash reflecting in a subject's eyes.

Redo Re-executes a previously undone action.

Reset button Resets options and settings.

Resolution The sharpness and clarity of an online or print image.

RGB Red, Green, Blue; the default additive color model for any medium that emits light, such as a television or computer monitor.

Sampling Selecting a color in an image.

Saturation The intensity or purity of a color in an image.

Scale To resize an item.

Scatter Brush dynamic control that affects the distribution of the brush marks.

Secondary subtractive colors Pigments created by subtracting cyan, magenta, yellow, and black from white.

Shadow The darkest part of an image that still has visible detail.

Shape layer Layer created by the Shape Tool.

Shape Tools Tools that create basic shapes such as rectangles and circles.

Simplify Converts vector and gradient layers to a bitmap layer.

Skew Applies a horizontal or vertical slant to an image.

Slider Control that changes a setting by dragging it to the left or right.

Smart album An album created using specific criteria.

Smart Brush Tool Simultaneously applies a preselected filter as you select an area.

Spot Healing Brush Tool Replicates pixel color and texture; good for smaller areas.

Stack Organizer feature that groups together related photos.

Stationery Photo Mail option that provides themes for Photo Mail e-mail message.

Text The letters, symbols, and numbers that you type with the Type Tool.

Tonal range The range between the lightest and darkest parts of an image.

Toolbox Set of tools you use to edit images in Guided, Edit, Quick Fix, and Full Edit.

Transition The way one slide replaces another one in a slide show.

Transparency The absence of pixels indicated by a gray and white checkerboard pattern on the canvas.

Trim Background Straighten Tool option that trims canvas to the image area.

Type Text you create with Type Tools; also, a type of Layer created when you use a Type Tool.

Type layer Layer in the Layers palette created by the Type Tool.

Undo Reverses the previous action.

USB Universal Serial Bus; a connection port on a computer.

Vector image An object-oriented image that can be resized without losing image quality.

Version set A linked group of one original file and its edited copies.

Vibrance Camera RAW setting that increases saturation in lower-saturated pixels.

Vignette A Correct Camera Distortion setting that adjusts the dark or faded corners of an image.

Warm Light that has reds, yellows, or oranges added to it.

Warp text Options that distort type into preset shapes.

Watermark In photography, a physical impression or digital information that identifies the copyright holder and other information.

Welcome Screen Default screen that opens when you start Photoshop Elements.

White balance Camera RAW setting that adjusts color to appear under specific lighting conditions.

White light Wavelengths of light visible to the human eye.

White Point The color temperature at which your computer produces pure white; the brightest part of an image.

WIA A Microsoft standard driver for downloading images; stands for *Windows Image Acquisition*.

Width Magnetic Lasso Tool option that sets the margin for an edge.

WMV Windows Media Video file format.

Work area Area within the Editor or Organizer workspace where you work with an image.

Work of authorship Content that is protected by copyright.

Workspace buttons Buttons on the shortcuts bar of each workspace that allow you to switch to or open another workspace.

Workspaces Components of Photoshop Elements where you edit and enhance images: Editor and Organizer.

Zoom Tool Increases or decreases the magnification of your view of an image in the document window or workspace.

Index